MW00800911

DAVID

ROCK 'N' ROLL WITH ME

BOWIE

I'd like to thank my wife Jo; the team at ACC Art Books for their work and for allowing us into the creative process of this book; George Underwood, Carrie Kania and Martin Pel for their contributions.

DAVID
ROCK 'N' ROLL WITH ME
BOWIE

GEOFF MACCORMACK

ACC ART BOOKS

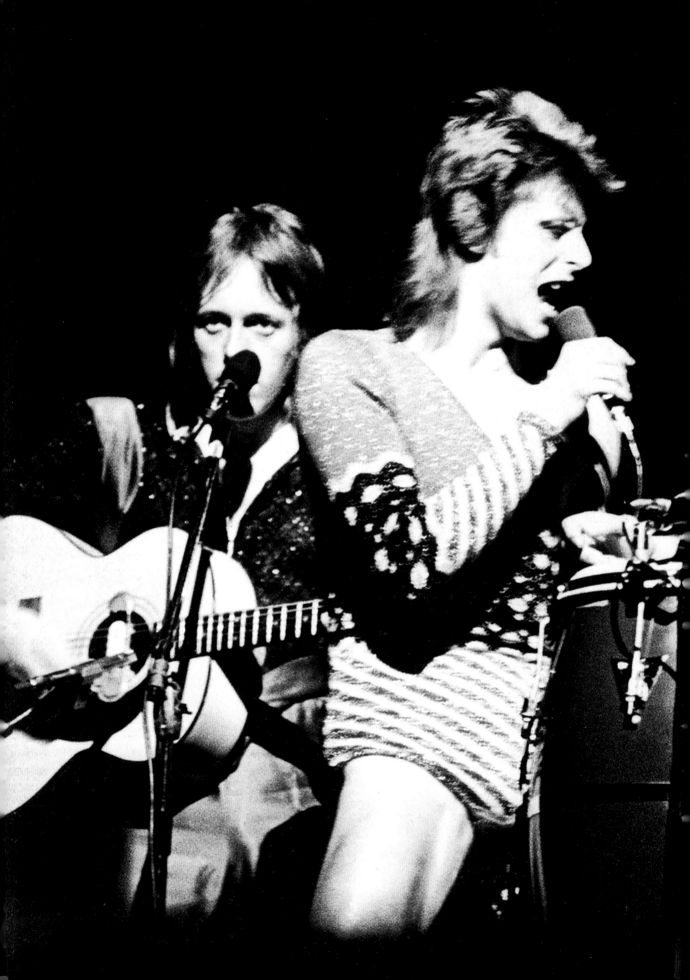

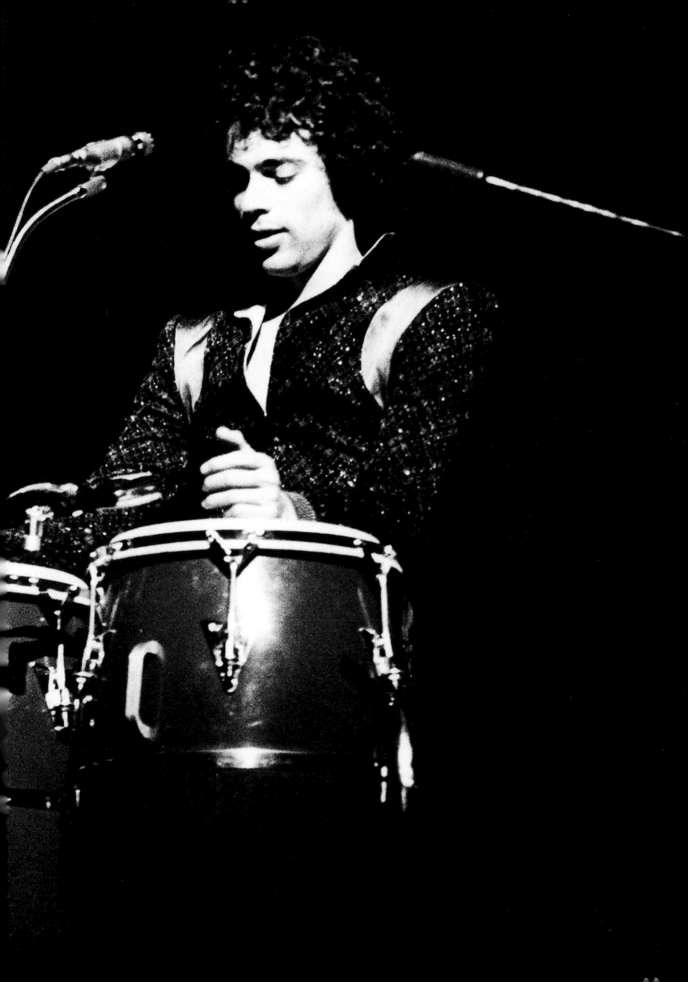

David Bowie: Rock 'n' Roll With Me

Foreword

The expression 'thinking outside the box' was something that David did with such aplomb that it could have been invented especially for him. Geoff and I were constantly bemused and astounded at some of the directions he would eventually take.

Earlier on, we were all searching for ways to be noticed – be it through the way we looked or the way we behaved. After a lot of experimentation David managed to take it to another level. Geoff and I were there from the start with David. We preened ourselves in front of the mirror, making sure we looked the part before we set off to the youth club or the Wimpy bar.

Later, for me and David, it was Soho, Eel Pie Island and anywhere a good band was playing. We would sometimes bump into Geoff whose journeys took him further afield to Brighton or Paris.

I remember David and I bumping into Geoff outside Bromley South station one time. I think he had just come back from seeing Georgie Fame at the Flamingo in Soho. Geoff had an LP of Mose Allison, the American jazz and blues pianist, under his arm. We were always discussing musicians we admired. They could have been country, folk, rock, soul, R&B and jazz. Nothing was excluded. We would listen to records for hours on end.

I must admit, David's musical choices were the most 'unusual' out of the three of us. Geoff was into James Brown and Otis Redding, I was into Muddy Waters and Bob Dylan, and David was into the Legendary Stardust Cowboy and The Fugs. Okay, so I have exaggerated somewhat, but you get the idea.

After touring with David in the '70s, Geoff formed a business creating music for advertising. It was called 'Paradise' and was very successful. I was doing illustration and painting. One time, I was working on a large canvas – a sort of abstract piece – on the floor of my living room, when Geoff called round one day. He loved what I'd done and wanted to use it on the cover of a record he was releasing. So, it became the cover of the single 'Only You' by Praise – Geoff still has the painting on his wall at home.

We have had some hilarious times together. When you have known someone for 71 years there is an unbreakable bond which is formed from experiences and memories only the three of us have. Geoff has decided to share a few with you.

Enjoy.

George Underwood, 2022

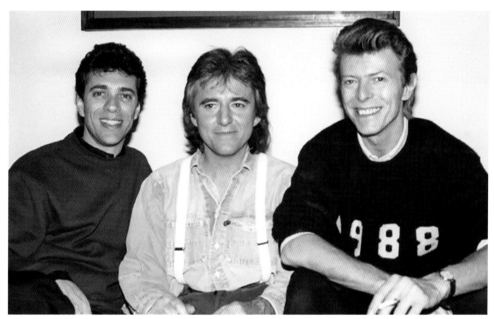

L–R: Me, George and David, 1988.

Prologue

'Louie Louie', The Kingsmen, 1963

'It's a mess! A pre-Punk car crash, not even original, sloppy, badly recorded, badly played and sung. A Glorious, Devine Mess!'

Phil's got the horrors. Clomp splash, clomp splash, walking with one foot on the kerb and one foot in the gutter. It doesn't occur to him to walk on either the pavement or the road because he's too blocked on his favourite uppers/downers, 'black bombers', so there he goes, clomp splash, clomp splash, eyes on stalks, staring straight ahead like he's going somewhere. He's not going anywhere really, none of us are. We're all blocked by varying degrees, mostly on the Mods' favourite diet of 'purple hearts' and not functioning so well. Ray Morton found a pebble behind his right ear – he studied it for a moment with mild suspicion, shrugged, then put it back exactly where he'd found it. We've come down to Brighton from London Bridge station just for something to do after a night up west in Soho.

There were a whole bunch of us at one point, but we've managed to splinter off into smaller groups as we went in and out of different West-End nightclubs. Now there's just a handful of us: me, Phil, Ray, Jeff Russell, Alan White and Richard Barrett.

We chose London Bridge because it was easier to travel free; none of us ever bought a full ticket to Brighton. We'd either buy a platform ticket, which people would buy to wave their family off or carry their luggage, or we'd buy a ticket to the next station and just stay on the train. The station guards got wise to us and used to patrol the next station, East Croydon, walking up and down the platform looking through the windows to throw us off. But they didn't have the idea to look up where we'd be giggling like small children high up in the luggage racks. The station staff were well on to us at Brighton station, so we'd get off at Preston Park, the station before, where there were usually no station workers around at that time, and walk the couple of miles on to Brighton.

Early in the morning there was nothing open except the laundromat, so we'd hang out there, take some more pills, roam about a bit and wait for places to open like The Scan, the Scandinavian coffee bar on Western Road. We'd put some tunes on the jukebox, maybe have a little dance to Martha and the Vandellas' 'Heat Wave' with some of the Brighton girls, talk endlessly and chew our Wrigley's gum 'til it turned to powder, then we'd head back to Brighton station and pull the same trick in reverse.

Not far from The Scan was The Starlight Rooms situated on the corner of Sillwood street and Montpelier Road. Housed in the dark and damp basement of a derelict hotel that, nowadays, any half decent Health and Safety Officer worth his salt would have condemned without bothering to enter. What The Starlight did have, along with many other dingy basement clubs up and down the country, was atmosphere. We would go there, mostly, to dance to records played by a DJ, but the club was known more for its live bands.

My old pal from childhood, David Jones, played there in June 1965 as Davy Jones and The Lower Third. Around five months later, both Davy Jones and The Starlight Rooms were no more. The Starlight tried, unsuccessfully, to re-launch under a new name and Davy Jones re-launched himself, in time more successfully, as David Bowie.

> **Around five months later, both Davy Jones and The Starlight Rooms where no more. The Starlight tried, unsuccessfully, to re-launch under a new name and Davy Jones re-launched himself, in time more successfully, as David Bowie.**

THE PALACE PIER, BRIGHTON

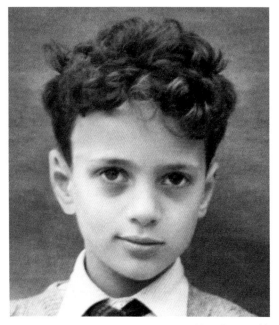

Me at 8-years-old.

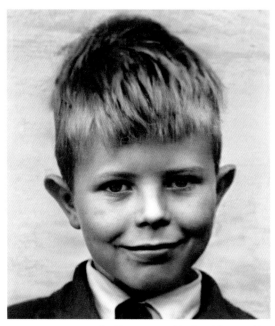

David at 8-years-old, when I first met him.

The Early Years (1957–1965)

'I'm not a Juvenile Delinquent', Frankie Lymon & The Teenagers, 1956

I met David when we were both eight years old, at Burnt Ash Primary School in Bromley, Kent. His family – mum Peggy, dad Haywood, and half-brother Terry – had just moved there after Haywood had taken a job with the children's charity Dr Barnardo's, which allowed them to move from the house they shared with another two families in Brixton to their own home in the more respectable neighbourhood of Bromley. David is, in fact, my second oldest pal. The first is George Underwood, who I met at my first school, St. Mary's Infants, also in Bromley. George would go on to design some of David's album covers – I remember him having a talent for drawing even when he was very young.

For some reason, my mother thought that Burnt Ash Primary was a better and more challenging school than St Mary's and that it would, somehow, turn her faltering second son and third child into the gifted student she knew me to be. It didn't. For some reason it left me even more uninspired. I've a sneaking suspicion it was the school uniform; it was brown. My mother also decided a little

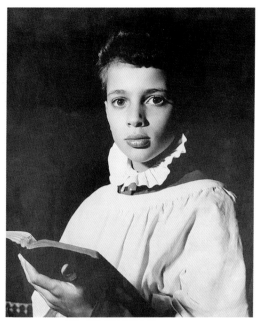

Me as a choirboy at St Mary's Church, Bromley, 1957.

godliness wouldn't hurt my moral development and enrolled me into the St Mary's Church choir. The Jones and Underwood clans must have been under the same heavenly guidance, for all three of us ended up in cassocks, surplices and ruffles, singing at choir practice and in church on Sundays. Weddings were the best gigs: not only were you paid two shillings – a princely sum in those days – but if the ceremony took place mid-week, you got time off school. Another activity bringing the three of us together was the 18th Bromley Cub Scouts. The meetings were held, naturally, at St Mary's Church hall. Uniform: green. I wouldn't knock the cub scout movement where we had our first big adventures as 10-year-olds. In 1957, we went on a camping trip to the coast in Bognor Regis, West Sussex. Unfortunately, the only things that stand out about the trip are George having a hollow plastic Superman toy that flew aided by an elastic launcher (which David managed to get in the way of and cut his finger) and a few assorted compliant 10-year-olds grouped together to sing some songs around the campfire.

I didn't go to the Isle of Wight camping trip, which was the occasion where David and George entertained the troops with George on guitar and David on a homemade double bass made from a tea chest, broom handle and a piece of string. Truth was, my mother didn't have the money, bless her. From the age of 11 onwards, I would earn my own money doing paper rounds, milk rounds, help packing-up at the local market after school and, my favourite job, driving around the streets of Bromley selling fruit and vegetables from the back of a truck.

Young David Jones lived around the corner from me, about 300 metres (as the crow flies) in a small, two-up two-down terraced house in a street with almost identical houses, at 4 Plaistow Grove. It had a small front garden about eight feet by fourteen. Inside there was a staircase straight ahead as you walked in, leading to the bedrooms. To the right, there was a small lounge where, sometimes, David's mother would be sitting scowling. Whatever lay beyond the lounge I knew not, nor indeed anywhere else in the house other than David's own room. The road that David lived in was an elongated U-shape so that if you walked the length of it, you arrived back at the same place you started from but

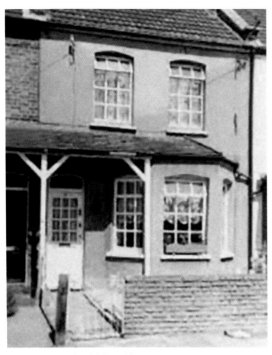

David's childhood house, 4 Plaistow Grove, Bromley. Me around 12 years of age outside 20 Cambridge Road, Bromley.

further down the road. If you knew the area, you'd know there was a tiny (almost invisible) opening at some point on his road; an alley that led out of Plaistow Grove, like a secret escape route. That was how I navigated my way from David's house back to mine at 20 Cambridge Road.

The house I used to visit at 4 Plaistow Grove, as a nine- or ten-year-old, was not a house of great joy. Sometimes David's mother Peggy would open the front door with some annoyance and begrudgingly let me in with no hint of a smile but, rather, the demeanour of someone at a funeral who'd lost somebody they didn't much care for. Indeed, the only thing cheerful about number 4 was David's bedroom, which was at the back of the house overlooking the narrow garden. The room had some posters on the wall, but I can't remember of what. I do remember he had a single bed, lots of magazines, and superhero crime and detective comics, many of which were American. David would sometimes read me excerpts from the more interesting tales, and I remember one gruesome story in which two wrestlers fought to

their death, gouging out eyeballs etcetera. David loved to see the reaction this created, the more wide-eyed and captivated he sensed I was, the more dramatic his delivery became.

The most important and prized possession David had in his small bedroom was an electric record player. I think it was a Dansette, and the fact that he had one in the mid-Fifties was quite something. Best of all, his dad, Haywood, who had 'show biz' connections through his work with the charity organisation Dr Barnardo's, used to buy him, as well as the magazines, the latest rock-and-roll hits from the USA. These were the R&B-flavoured tunes you could hear on Radio Luxembourg. As for me, I listened on a crystal set that was archaic and very basic, and would receive radio waves that constantly fazed in and out from a coherent reception to an inaudible hiss.

Some of the 78 rpm discs that David had in his small collection were, without exaggeration, life changing. It was as if some secret joy had escaped from the gods that had hitherto been withheld.

THE BIRTH OF ROCK 'N' ROLL
'Tutti Frutti', Little Richard, 1955

'Wop bop a loo bop a lop bom. What does it mean? Everything!'

The birth of rock and roll in England had started in a pretty mundane way, against a backdrop of post-war austerity, greyness, smog and bombsites, which we would scramble around in complete ignorance of the dangers therein. The singles charts in the early Fifties were full of ballads, or even worse, bad British cover versions of ballads that were already hits in the USA.

In 1955/56, Scottish born Lonnie Donegan became the forerunner of a type of country style music called Skiffle. The instruments for Skiffle were made up of items one could access from around the home, like a washboard for percussion or, as David had used at the cub-scout campfire, a tea chest with a broomstick and string to make a crude but effective double bass. Add a guitar and you had the basic ingredients for a band ready to go. That was the inspiration for many future British recording artists to start a band. For this, Lonnie Donegan should be greatly thanked.

It was from America that all the exciting music came in the Fifties. Bill Haley's 'Rock Around the Clock' (1954, Decca), a great up-tempo number perfect for dancing to, especially suited for jive dancing carried on from the jazz bands of the late Forties. Bill, who at 30-odd years of age and somewhat rotund sporting a tartan dinner jacket and a ridiculous kiss curl, didn't convey the merest semblance of youth or rebel. Set this against hearing and seeing, for the first time, the energy of Little Richard's 'Tutti Frutti' or Elvis Presley's 'Hound Dog' or the mad and dangerous Screamin' Jay Hawkins' 'I Put a Spell on You' (my mother wouldn't let me play it!), the difference was total. It wasn't just that Richard, Presley and Hawkins put out great tunes, they looked stunning as well – Little Richard

with his heavy make-up and big hair, drape jackets and wide trousers; Elvis Presley, handsome and vibrant, outraging everybody except those in their teens. The performances of these artists seemed wholly new and original. I'm sure it wouldn't have mattered had we known that Little Richard borrowed his act from the even more outrageous Billy Wright, or that a brilliant version of 'Hound Dog' was recorded three years before Elvis by blues artist Big Mama Thornton; we were entranced. In my opinion, it wouldn't be until 1960 that we'd hear a truly great British rock and roll song: the incredible Johnny Kidd & the Pirates' 'Shakin' All Over'. An absolute favourite 78 of mine and David's was by Frankie Lymon and the Teenagers called 'I'm Not a Juvenile Delinquent' (1957) with 'Baby, Baby' on the other side. 'I'm Not a Juvenile Delinquent' was a track that David and I often sang in harmony quite authentically as Frankie Lymon's 15-year-old voice was pretty close to our 10-year-old ones.

BOYHOOD AND BEYOND
'This Ole House', Stuart Hamblen, 1954

Being at the same school and our mutual love of music weren't the only things David and I had in common. We both had absent older brothers who served in the RAF and were into modern jazz. I still have a few albums that my brother Bruce gave me, *Jazz Goes to College* by The Dave Brubeck Quartet (with Paul Desmond on alto sax) and *Monk's Mood* by Thelonious Monk with Art Blakey and Max Roach on drums, and Percy Heath and Gary Mapp on bass. These influences that Bruce passed on to me were part of the development of new music that I was discovering and, similarly, these same influences were being passed down to David from his brother, Terry. We were to discover the vocalists who seemed to play their voices like instruments: Mel Tormé, Chet Baker, Frank Sinatra, 'The Queen' Ella Fitzgerald, and the daddy of them all, Louie Armstrong; all holding on to their phrasing just that little bit longer.

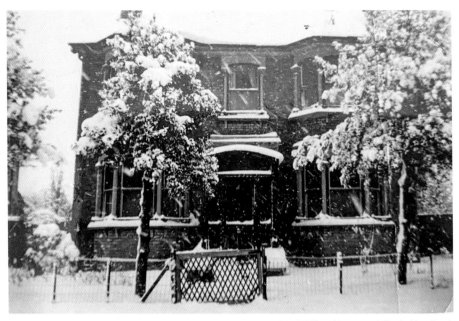

My childhood house, 20 Cambridge Road.

Music was always at the centre of our household and at any one time you could be hearing Miles Davis from my brother, pop music like Paul Anka from my sister, or classical music from my mother who hated housework and preferred to play the baby grand piano that stood in the corner of the drawing room. My family home, in contrast to David's, was an enormous, six-bedroom, double-fronted affair which sat in a third of an acre of unkempt garden. The house, in truth, had seen better days. My father had died of cancer when I was seven and the house had fallen into the kind of disrepair that gave it a certain feel of 'faded grandeur'. On the ground floor at the front was a wide hallway with a drawing room on one side and a dining room on the other. At the back was the kitchen which still had the original servant bells connected to all the rooms, with a scullery (utility room) beyond that. Opposite the kitchen was the south-facing breakfast room overlooking the large garden; when the sun shone, as it always does in childhood memories, the room became extremely hot. Not a place to leave 78-rpm records made from shellac, like the two records David had lent me – his beloved copies

of 'Hound Dog' by Elvis Presley and Frankie Lymon's 'I'm Not a Juvenile Delinquent'. When David came round to collect them, I went to the breakfast room to retrieve said tunes only to be greeted with the sorry sight of the melted remains of what had once been playable 78s, which now resembled an amateur Salvador Dali installation. Nothing was said about the incident for about 50 years.

Towards the end of the Fifties, everyone our age took an exam called the eleven-plus, which would determine which type of secondary school we would attend for the next five years. The eleven-plus was a three-tier system where the super-bright kids went to grammar schools, the semi-bright ones went to technical schools and the dimwits, or those who'd screwed up the exam, went to secondary modern schools. I was in the latter category and went to a secondary modern school which was less than half a mile from my house. George and David went to the technical school nearly four miles away. In retrospect, I'm glad I went in a different direction to David and George; glad I went to a different school, became a Mod and had different friends.

The Downham and Bromley Crew in Brighton, c.1964/1965.

George and David were highly competitive and I'm not sure where I would have fitted in with that dynamic. It also meant, later in life, that I had a different viewpoint. However, keeping up with George (who by all accounts was the guy that had it all) probably gave David that little bit of extra drive which would serve him well later on in his chosen career.

I left school as soon as I could at the age of 15. I couldn't wait to get out into the big world and be free. I never felt stimulated enough to stay on and do A levels. David and George stayed on and did their O levels and George, who'd shown a huge talent for art at an early age, achieved an A level in art at the age of just 16. He, quite rightly, went to art school while both David and I took office jobs, an occupation we would both detest. On the bright side, it was the beginning of the Sixties so we had that and a good chunk of the next decade to look forward to. The fact that we'd attended different schools had not only separated us socially but somewhat tribally. I became a Mod while David and George went for a more artistic, long-haired look. The term Mod came (loosely) from the modernist movement which covered new ideas in architecture, design, art and fashion between the First and Second World Wars. The latter-day modernist look of the late Fifties was sharp Italian suits and short hair, and reading Kerouac accompanied by modern jazz, like Brubeck. The Sixties Mods were into slightly dandyish fashion and (mostly) Black American soul music. Despite our differences in fashion, the three of us would always have the bond of friendship and music, then and throughout our lives.

ONCE WE WERE MODS
'You Got Your Finger in My Eye',
Willie Parker, 1967

I would bump into David around Bromley High Street. Sometimes, at the record department at Medhurst's department store, I'd run into him in one of the soundproof cubicles listening to records or flirting with Jane Greene, the pretty shop assistant behind the counter. More usually I'd see him at the other end of the high street, where he had a part-time job at Vic Furlong's shop.

Bromley High Street in 1957.

A.T. Furlong & Sons was a strange little ramshackle shop which looked like somebody's hobby rather than a business enterprise. Furlong sold (somewhat reluctantly) hi-fi equipment, musical instruments and jazz and blues records, which was to give David an added grounding in American music. It also had a noticeboard with information on bands looking for players or singers, or the other way 'round. Across the road was our popular hangout, the Wimpy Bar, where the youth of Bromley would nurse disgusting milkshakes or soft drinks for hours on end or, if we had the money, one of their sad little burgers with anaemic skinny fries – our first grown-up independent past time.

A few doors down from the Wimpy Bar was a gentlemen's outfitters called Harry Fenton. The store was a godsend for us as it had at least one foot in modernity. Better yet, you could pay for your clothes in installments which is what, as a fresh school leaver of 15, I did when I bought my first outfit for my first job as a filing clerk at a cement manufacturer. This was a truly soul-destroying job, filing thousands of never-ending invoices, which I hated even more than David hated his first job a year later in 1963 when he joined Nevin D. Hirst Advertising in New Bond Street, London, doing something equally boring. Harry Fenton sold some pretty sharp clothing (almost Mod!) at reasonable prices, and they also sold Denson fashion shoes for men. I bought a whole outfit at Mr Fentons; an Italian-style dark-blue three-buttoned suit with three buttons on each cuff and slim tapered trousers (not mohair but it did have a sheen to it), a shirt with a cut-away collar, a dark-red woven tie and some Denson shoes with a buckle on the side. This was all paid for 'on tick' (in weekly instalments), marked off in a little Harry Fenton credit book. When you'd paid a certain amount off you could extend your credit with more purchases.

In 1963, I saw George and David on stage at Justin Hall in West Wickham, a few miles out from where we lived in Bromley. They were in a band called The Konrads, George having joined first as the singer. Later, by virtue of him owning and playing a saxophone, George was able to get David involved. I think the idea was that David would play sax and sing a couple of numbers. By the time I saw them, our Davy had somewhat upped the ante and was doing quite a bit more, thus showing the early beginnings of a strong desire to perform, plus a steely determination to succeed. Eventually, George had a major falling out with the drummer and left the band and David left sometime later.

After The Konrads broke up, George and David formed a duo called The Hooker Brothers, which

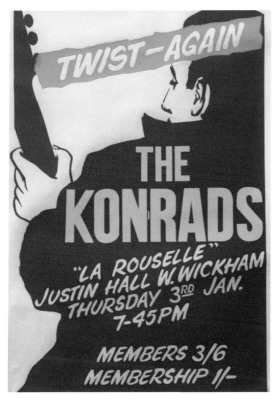

TWIST-AGAIN
THE KONRADS
"LA ROUSELLE"
JUSTIN HALL W. WICKHAM
THURSDAY 3RD JAN.
7-45PM

MEMBERS 3/6
MEMBERSHIP 1/-

Phone: REG 3207 No 5403
Paul's
Sportive Male
47 CARNABY STREET,
REGENT STREET, W.1

M...........21/12/63..........

David and George were members of The Konrads in 1963.

My receipt from a Carnaby Street Boutique, early 1963.

later became The King Bees around 1964. They played R&B with some blues covers. I remember thinking that both David and George looked really good on stage. At one point, David changed into knee-high boots like Robin Hood and a loose shirt, becoming someone else. Was it David Jay or Screaming Dave Jay? My memory on this is not great but I do recall he performed a Little Richard number with great gusto, which could have been 'Lucille'. The King Bees looked like they were taking off when they released a record in June 1964 titled 'Lisa Jane' but unfortunately it bombed, and David left the band sometime in July.

By this time David had acquired a manager, Les Conn, who represented another ambitious young singer (and top Mod) called Mark Feld, later to be Marc Bolan. Les Conn sometimes subsidised their meagre existence and, in return, the boys (now friends) painted Conn's office. The thought of teenagers Marc Bolan and David Bowie splashing white emulsion around the office walls

together in 1964 and speculating about how successful they were going to be is pretty surreal.

In the mid-Sixties, our generation was the first to have the money and the time to indulge ourselves. You could walk out of one job and straight into another with ease. We lived for the weekends and every Friday night seemed like a celebration. We had very few financial commitments – after giving our mothers something for our keep, the rest of the money in our pockets would be blown on clothes, clubbing, music, amphetamines and maybe a bit of weed for listening to music.

Most teenagers my age in the early-to-mid-Sixties couldn't afford the high-end shops like Austins or Cecil Gee, both on Shaftesbury Avenue in Soho, London. Sometimes you'd save up for an item like a decent shirt from, say, Sportique on Old Compton Street. Mostly we'd be canny and cut our cloth to our financial means. One of my favourite ensembles was a red, white and blue outfit,

consisting of a long white double-breasted trench mac with all the straps and buckles you'd ever need, a scarlet red roll-neck sweater, royal blue trousers bought from one of John Stephen's shops in Carnaby Street, and dark green Hush Puppies shoes, which I sometimes wore with a dark green soft suede/shammy zip-up. None of those items came from mega expensive shops but still looked great and made me feel great. Each item bought with the hope it would make one a better and happier person which of course, it did.

Certain items like Hush Puppies shoes and desert boots were quite common as standard dress, which was a blessing because the distance one could cover on foot with a few pills inside you was Olympic. It would not be considered unusual to walk the 10 miles home from Soho, sometimes via the El Partido club in Lewisham, slightly dazed but still blocked, listen to a few tunes, including the very appropriate 'Come Down' by Lord Tanamo, then home to a Sunday dinner you couldn't eat and a puzzled mother quizzing you over whether you were, 'ill or something'.

The main thing that united Mods, apart from fashion, was music. Blues, R&B, soul, blue beat and jazz. The stuff we really liked didn't come easy, it had to be searched out through imports (from America and Jamaica) in specialised record shops or, in the case of Blue Beat records, it was Brixton market. There was a record shop in Granville Arcade and the guys in the store used to play new imports from a high counter and you'd just stick your hand up if you wanted it. I still have a couple of tunes from those days, including Derrick Morgan's 1962 *Forward March* album which contained the track 'Blazing Fire'. This track was a response to Prince Buster's 'Black Head Chinaman' as part of a feud that erupted in Kingston, Jamaica, between the pair after Morgan left Buster's label to join producer Leslie Kong for more money. The issue of musicians getting properly paid for their work has, unfortunately, come full circle as I write.

SOHO, CLUBS AND GIGS
'The In Crowd', The Ramsey Lewis Trio, 1965

Soho had always attracted those not welcome elsewhere: the undesirables and the deviants. In the Twenties, it was the Gargoyle Club; in the Thirties, it was the Windmill Theatre with its nude shows; after the Second World War, it became the centre of London's sex industry; and from the Eighties, London's gay village. But for us suburban kids in the Sixties it was new and exciting.

My first taste of Soho would have been around 1962, when I was about 15 years of age. My pal from school, John Sherman, and I used to go to club nights at Justin Hall where we'd seen David and George play. We got to know the club promoter Chris Longman, and his pal Eugene Fynn. After the various gigs had finished at Justin Hall, we'd jump into Chris's motor and head up to a coffee house in Soho on the corner of Berwick Street called The Freight Train. We'd drink coffee or Coca Cola and swallow a couple of little blue heart-shaped pills (speed) – the very same pills armies used to keep alert in the Second World War – which would keep us awake and slightly tripping. The place was full of Soho night people – duckers and divers, bohemians and prostitutes – who'd sit together laughing at their private jokes about their punters and tricks until the boldest one would say, 'OK girls, back to work'. We'd hang around for a while, then we'd drive back home. A couple of years later in Soho, we'd buy the same little pills from a dealer who turned out to be Jack (The Hat) McVitie, who was later killed by Reggie Kray in 1967 for reneging on a contract killing.

When we first hung out in Soho in the early 1960s, it was pretty laid back, with jazz singer and writer, George Melly, artists like Francis Bacon or Lucian Freud, and musicians and singers like Georgie Fame, whose set we'd catch at 'The Mingo' (Flamingo) Club on Wardour Street. Music writer

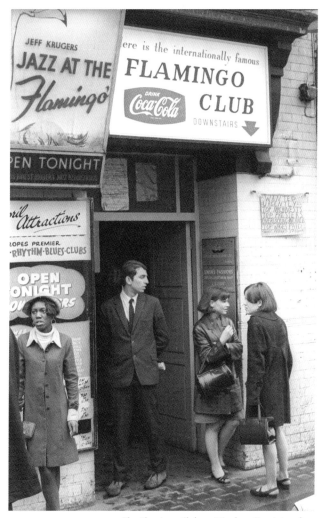

The Flamingo Club on Wardour Street, London.

Lionel Bart – usually with a posse of young men – would wander in and out of the clubs. The streets of Soho felt edgy but safe. You didn't get much for your money, though. The clubs were dirty, dark and crowded and the streets were filthy with rubbish, cigarette butts and chewing gum. But, for all that, we loved it. The décor of the clubs, like The Scene Club in Ham Yard, didn't matter once you were absorbed in the atmosphere. As soon as we hit the dance floor to the sound of The Kingsmen's 'Louie Louie' or James Brown, we were buzzing.

The first James Brown track most of us heard and bought in the UK was an instrumental –

the superb 'Night Train', which was played in all the clubs by all the decent DJs in and around London and will be played probably forever. But it was the incredible album recorded in 1962, *Live at the Apollo*, which created the real buzz. We'd play it on our parents' radiograms at home and it would magically transport us to the Apollo in Harlem where 'The Hardest Working Man in Show Business' went through his repertoire in double time to an ecstatic audience. Ironically, the best James Brown album I bought on spec was the fantastic 1964 album *Tell Me What You're Gonna Do*. This included one of Brown's most incredible performances on the track 'The

> '**My old schoolmate Geoff MacCormack brought this around to my house one afternoon, breathless and overexcited. "You have never, in your life, heard anything like this," he said. I made a trip to see Jane Greene that very afternoon. Two of the songs on this album, "Try Me" and "Lost Someone," became loose inspirations for Ziggy's "Rock & Roll Suicide." Brown's Apollo performance still stands for me as one of the most exciting live albums ever. Soul music now had an undisputed king.**'

– David Bowie, Vanity Fair, 2003

Bells', which even outspooked Screamin' Jay Hawkins' 'I Put a Spell on You'. It also included classic songs like 'I Love You, Yes I Do', 'I Don't Mind', 'Lost Someone', and the wonderful title track 'Tell Me What You're Gonna Do', which in many ways reflected the style of brass punctuation he'd use on later offerings such as 'Papa's Got a Brand New Bag' in 1965. I saw James Brown in March '66, at the Walthamstow Granada, the day after he'd appeared live for the first time on British TV in a weekly show called 'Ready, Steady, Go'. The compere was Keith Fordyce who, although only in his late thirties, looked fifty plus. His image for presenting one of the 'Mods' Gods' was completely at odds with the moment, he was simply too old school and square, poor sod. As soon as he came out onto the stage the audience booed as one and heckled obscenities; thankfully for him, he had the common sense to retreat hastily before objects were thrown. Naturally, when 'Soul Brother Number 1' came on stage to do his work, he totally blew us all away.

A SOCIAL REVOLUTION
'Help Me', Sonny Boy Williamson, 1963

You didn't always have to travel into town to see gigs; there was a really good venue in Bromley called the Bromel Club, formally Bromley Court Jazz Club, where the original line up of Manfred Mann often played, as did the great Bo Diddley, Yardbirds, and of course my pals David and George performing as the Hooker Bros. But the best of the best was the legendary Sonny Boy Williamson. The great man would shuffle onto the stage in a suit, bowler hat, rolled-up umbrella, a briefcase containing several harps (harmonicas) and a bottle of Johnnie Walker whisky. The crowd fell silent as Sonny Boy selected his favoured axe, introduced it to his mouth and blew a heavenly visceral tone that came from the gods! For those who think that's an exaggeration, go find and play – loudly – Sonny Boy's 'Help Me'.

Our music appreciation wasn't solely for Black musicians, although it has to be said: Why would

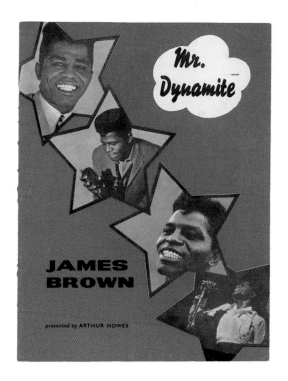

you want 'Time is On My Side' by The Rolling Stones when you already had the Irma Thomas version, or 'Just One Look' by The Hollies when you had the superior version by Doris Troy?

The Beatles changed everything, not by luck or some masterplan but by natural, sublime talent and ability. While America had many successful writing partnerships – Goffin–King, Holland–Dozier–Holland and Bacharach–David – England had Lennon–McCartney. The difference was that it was all wrapped up in a hugely likeable/saleable band. The Beatles not only re-invented popular music, but they also opened the doors (in fact, they blew the bloody doors off!) for other bands to conquer America and reverse the dominance of the US market to a British one.

The Tigers Head pub in Downham, South East London, was the usual meeting place for our group of South London Mods. It was a huge sprawling place with a public bar, saloon bar, off-licence, and a club at the rear. It was a proper South London boozer where the older generation would get dressed up on a Saturday night and have a good 'sing song' around the piano. The male customers used to drink stuff like a pint of bitter or 'brown and mild'. Our mob, the teens, would drink 'light and bitter', which was a half pint of bitter (beer) and a half-pint bottle of light ale. This worked well because, when the bitter went flat (which it invariably did), you could pour in some more light ale to liven it up again. Plus, the bitter would be poured into the glass without a measurement (not like today) so you'd always end up with more than a pint.

One of our favourite places to listen to good tunes was the Roaring Twenties on 50 Carnaby Street, hosted by DJ Count Suckle. Suckle arrived in England in the Fifties as a stowaway with two friends, one of which was Duke Vin 'The Tickler'. By the time the ship's captain became aware of their presence on board, the voyage was too far out of Jamaica to turn around. When the two friends got to London, they started hosting

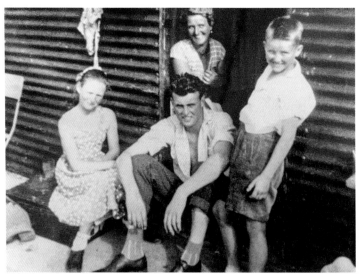

The Barretts 'hopping' in Kent in the mid-1950s.

dances with home-made 'Sound Systems' – basically, powerful amplified record players with huge speakers. This may have been the birth of DJ-ing. First, they played soul and blues tracks, then introduced more and more blue beat/ska records, which were sent over from Jamaica. Later, champion of Jamaican music, Chris Blackwell, arrived in London and set up his hugely successful company, Island Records. Blackwell, who would forge the careers of major artists such as Bob Marley and Toots and the Maytals, started his business by selling records from the back of his car to the Jamaican community.

Suckle had a residency at The Flamingo Club in Wardour Street for a while but it was the Roaring Twenties on Carnaby Street that became a mecca for us in terms of hearing the best imports from the West Indies and the USA. Sometimes the records were disguised with the titles scratched out, or sometimes they just had plain white labels. Suckle would spin his tracks with his turntable positioned high up, like an alter to the gods of soul, R&B and ska, closely guarded by the Count and his crew. The club was an all-nighter with a mixed Black and white crowd. A glitter ball threw out shafts of light onto the packed dance floor, through the dense smoke of cigarettes and weed of punters who loved his 'tunes'. Billy and Johnny

Cranstoun would sit listening until the very last tune around seven in the morning, which was always Billy Stewart's 'Sitting in the Park'.

The Cranstoun brothers were inspired to emulate something like the vibe of the Roaring Twenties on Carnaby Street and so opened a club night with 'The Duke Lee Sound System' at The King Alfred on Southend Lane in south London, which became a must for Thursday nights. The King Alfred was not too far from the Downham Estate in Lewisham, a part of which was in Bromley, so it was on the border of London and Kent (although it all became London with the creation of Greater London in 1965). Downham was a cottage estate of over 7,000 dwellings built between the war years. Some of the parents of the kids I knew from the estate came out of Rotherhithe and Wapping and had formerly worked on the River Thames docks as lightermen or stevedores. They began to leave when the docks activity began to wind down or they were bombed out in the Second World War, as was the case with my friend Richard Barrett's family. The Barretts were one of the many London families who took working holidays picking hops in Kent (known as 'hopping'). This was an old tradition going back to the 1700s, and by 1870 special overnight trains would run from London stations down to Kent where families

would work a long day to be paid by the amount of hops they picked. By the 1960s, the conditions had improved dramatically from the shacks or sometimes pigsties they were offered in the old days, with a lot of families driving down with their furniture and belongings to the farms in Kent. They would visit year after year, sometimes in the same purpose-built brick- and corrugated-iron dwellings (some built in the Forties by Italian prisoners of war), kitting them out with tables, chairs and beds. Some families had televisions running off car batteries, and some even wallpapered the walls to make a home from home. I had the pleasure of going down to Kent sometimes in the summer to visit Richard's parents when they were working at a place called Shingle Barn Farm in Yalding. I find it utterly amazing how much can change in just one generation: from his parents working the summer hopping to Richard (who, as I write, is away skiing) owning a most desirable Oast house in Yalding with land; something that would have been well beyond his parents' dreams.

That was the mindset in the mid-Sixties; a social revolution was taking place. We had cars, overseas travel, expensive made-to-measure suits – all before our 21st birthdays. Young men like Richard didn't want to work for the man – they wanted to *be* the man. That's why he started his own company, as did other regulars from The Tigers Head like my pal Alan White; and Paul Jones who founded the homewares and furniture outlet, Practical Styling, with Tommy 'Mr Freedom' Roberts, at London's Centre Point Building.

Just up the road in Bromley, David Jones was also plotting his own route to success. Although David's parents' house was only three miles away, because it bordered the countryside of Kent, it was neither in nor out of London, and so felt (and was) suburban. Even the pubs in Bromley closed half an hour before our local – The Tigers Head in Downham – which sometimes meant that if we were in Bromley or Beckenham, we would rush over the border for one last pint! On the plus side, the sense of isolation and boredom of being young and living in Bromley or Beckenham (and even Lewisham, which was further towards London and had an extra half hour of drinking time), would encourage budding young artists and writers, like David to come up with their own entertainment, stimulating their creativity.

I'd kind of lost contact with David for different periods during the mid-Sixties, although I'd bump into him at the music venues and pubs like The Bell, The White Hart, The Bromley Court Hotel or The Swan. One night I bumped into David at The Swan, and he was exceptionally excited about a book he was currently reading called *The Third Eye*, written by Lobsang Rampa. Lobsang (real name Cyril) claimed to have been brought up in Tibet from the age of seven where he'd undergone an operation in which a small hole was drilled into his forehead to stimulate 'the third eye' and enhance his powers of clairvoyance. As he was imparting this story to me and a few others, David sat cross-legged on the floor of the pub in hippie/student attire. With the air of a mystic, he enthusiastically embellished the (tall) tales of Lobsang Rampa, describing mummified bodies, Tibetan monks and astral travelling to a growing and wide-eyed captivated audience. This impromptu performance reminded me of all those years ago, in the bedroom of the little house in Plaistow Grove, Bromley, where David told me the riveting story of the wrestlers fighting to their deaths, in all its gory detail. Nice one Cyril.

> That was the mindset in the mid-Sixties; a social revolution was taking place. We had cars, overseas travel, expensive made-to-measure suits – all before our 21st birthdays.

TEENAGE AND TWENTIES
(1967–1969)

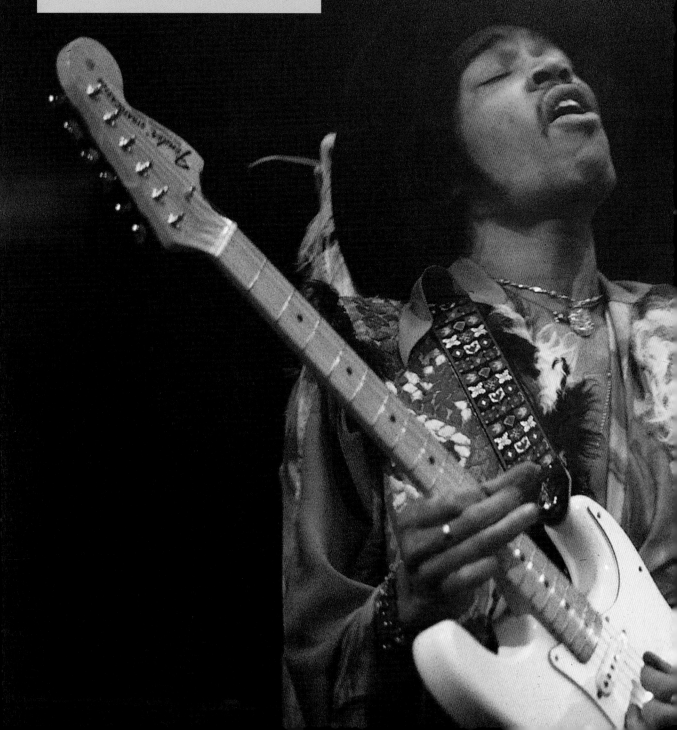

'Hey Joe', The Jimi Hendrix Experience, 1966

'Life changing...'

I got a job in Brighton in 1967. This wasn't a sought-out career move, it was more that one of my mates said something like, 'They're looking for more workers where I work' or that someone had heard of a job going. Previously, I'd been working at a company fitting heating and ventilation units, from small ductwork to giant factory extractors. I worked at this for a while, then the Brighton gig turned up. The job was to last over a year, so I moved there. The Scan coffee bar on Western Road was still going, so I managed to find a few faces I'd met from the days when we'd come down to Brighton, still buzzing, from Soho.

The Brighton crowd were either at Brighton School of Art or knew somebody who was. Others were at University of Sussex and some, like me, were kind of drifting along doing stuff their hearts weren't really into. The pace of life was less frenetic, and the Brighton crowd were much more chilled and open, so I was glad to make some other good friends. I was still, if only half-arsed, a Mod. The Mod thing had turned a bit middle-aged, which is exactly what it tried to escape in the first place. It had become a smart-suited look, sharp suits made from Dormeuil's Tonik mohair – more Locarno Ballroom in Streatham than the Scene Club in Soho. I was therefore quite happy to adopt the pseudo-French (Pseuds for short) 'minet' look that some of the Brighton mob wore. New town, new look.

The look was straight, wide(ish) trousers or 'New Man' cords, brogue- or Bass Weejuns-type shoes, Cacharel shirts and tight Shetland jumpers. In Paris, the guys that wore this look were known as 'minets'. This look was actually the second-wave minets; the first was from around 1963 and was based on the Mod look – I'm not really sure why we copied a dress style from people who had originally copied us. I even had one of those stupid French motorised bicycles with the engine on the front called 'VeloSoleX'. Naturally, I smoked Gitanes cigarettes, mainly because of the sexy artwork by Max Ponty. A few years later David, after seeing my choice of poison, would adopt the same brand. Sorry Davy!

I stayed in digs in Brighton (well, Hove actually) on Nevill Road, which is a long street of almost identical terraced four-bedroomed houses, neither old nor new, but true suburbia. After a night out, I would sometimes walk back from Brighton centre, which would take 30 to 40 minutes. I tried hitchhiking a couple of times but late at night it was a bit of a 'crap-shoot' as you'd get all the cruisers.

The landlady would only let me watch one television program a week – Top of the Pops on Thursday nights. One cold January night in 1967, while watching offerings from the likes of Des O'Connor, Val Doonican, Engelbert Humperdinck and other cheesy crooners that were in the charts at that time, something quite incredible happened. Suddenly, without warning, in glorious black-and-white (before most homes had colour television in England), a sound emitted from the television that I'd never heard before and in a form never seen before: Jimi Hendrix performing 'Hey Joe'. He had only been seen by a chosen few before this. John Lennon, Paul McCartney,

Jeff Beck, Pete Townsend, Brian Jones and Mick Jagger had all been amazed by him when he performed at the Bag O'Nails in Kingly Street, Soho; but for the rest of us, his performances on Top of the Pops were a brand-new phenomenon. For me, listening to one of the greatest tracks ever recorded was made all the more exciting by watching the spectacle unfold in a suburban house on a suburban street with a middle-aged landlady tut-tutting and shaking her head in total horror. David would cause a similar level of revelation and revulsion in 1972 performing his single, 'Starman', on Top of the Pops. Wearing his multicoloured jumpsuit with make-up and bright orange hair and pointing knowingly to the camera with his arm round Mick Ronson, David ignited horror in anyone over the age of 20, and devotion in those teenagers desperate for connection. In so doing, he created another seminal moment in television, music and social history.

David ignited horror in anyone over the age of 20, and devotion in those teenagers desperate for connection. In so doing, he created another seminal moment in television, music and social history.

Even more astounding, for me, was hearing the magical voice of the great Otis Redding for the first time – this was in 1965, two years before my 'Hendrix' experience. Somehow, I'd missed Redding's preceding and brilliant album *Soul Ballads* (1965, Volt/Atco), so the first track I heard was 'My Girl' from his (perfect) album *Otis Blue* (1965, Volt), a song originally recorded beautifully by The Temptations in 1964. I was driving in my little car (a Mini) when 'My Girl' came on the radio. I remember distinctly turning up the volume and pulling off to the side of the road to listen to Redding's voice. The fact that this was a cover of an already great recording by a famous group, and my tiny speakers in my tiny car were poor, didn't diminish the impact of his unique vocal performance with its passion and phrasing. There were some good vocalists a little later with a similar style like James Carr and Oscar Toney Jr., but nobody could 'worry a line' quite like Otis, except (his original influence) Sam Cooke. Just like Jimi Hendrix two years later, Otis would get the seal of approval from the same top musicians, followed quickly by the public (especially Mods) and the album *Otis Blue* rose to number 6 in the UK charts (silver). Like 'Mr Dynamite' (James Brown), Otis was given a whole episode of the weekly show Ready, Steady, Go! to himself (with some additional guests) which went out on a Friday evening with the slogan 'The weekend starts here!'. The show, which started in 1963 on ITV and lasted for three years, was aimed at the rapidly growing and uncatered-for teenage market and was so much sharper than the BBC's Top of the Pops. A similar cultural gap to the one that occurred with the 'James Brown' compere at the Walthamstow Granada, happened when Otis appeared on a TV chat show here in the UK. One of the other guests was a mediocre old television and radio star called Jimmy Edwards (although, to be fair to Mr Edwards, he was a war

veteran who'd been awarded the Distinguished Flying Cross). However, when Otis finished his up-tempo number and the camera panned back to old Jimmy, he said to the presenter – and indeed the whole country – 'It looks like he's got St Vitus Dance' (a form of illness characterised by rapid, uncoordinated jerking movements). Such a crass and unconsidered comment live on air truly highlighted the massive gulf between the older and younger generation. Naturally, we went to see the great Otis the same year at the Orchid Ballroom in Purley. He was, of course, sublime. Both Otis Redding's and James Brown's recordings would be frequently sampled in later years, sometimes with good taste, sometimes not.

In 1967, another source for what would become classic R&B tunes was Mike Raven's Sunday night show on Radio 1. Mike was multi-talented: apart from being a very cool DJ, he was an actor, dancer, guitarist, sculptor and photographer. I still have a few 45s that I eagerly purchased after listening to his show, like, 'I Got What it Takes' (Brooks & Jerry), 'Open the Door to Your Heart' (Darrell Banks) and the fabulous 'Ain't Nobody Home' (Howard Tate) – the man had taste!

DIGGING THE LONDON VIBES
'Raga Megha' (Indo-Jazz Suite), Joe Harriott and John Mayer, 1966

I was fired from the heating and vent gig on a building site in Croydon, South London, close to Fairfield Halls where I'd seen The Beatles back in 1963. It was an open and shut case, bang to rights! I had returned late from lunch, inebriated with a broken cigar hanging out of my stupid mouth. The foreman, Paddy McGurk, a man of great patience, said to me somewhat sympathetically, 'Geoff, I think I'm going to have to let you go'.

I was out of work and skint, so I went on the dole (social security) in Beckenham where I'd gone

home to stay with my mother. It was good to hang out with my sister Rosemary again. She was always very supportive. She and her boyfriend John (who was like an older brother) liked going to see jazz and knew some of the players. I'd go with them to Klooks Kleek in West Hampstead, where one time I saw Lou Johnson ('A Message to Martha'), or to The Bulls Head in Barnes where I heard the wonderful *Indo-Jazz Suite* by Joe Harriott and John Mayer. The pub is still, I'm happy to say, going strong.

After being offered crappy dead-end jobs from the social security office for a while, I was finally considered for a job in London as a sales representative selling office equipment, with a decent salary and a company car. A couple of my Brighton friends, Bud and Phil, had also been offered jobs in London, so we decided to share accommodation. Finding a flat in town in 1968 was pretty easy and the apartment we found, although tired decoratively, was a wonderful find, being located in a handsome street in South Kensington at 67 Onslow Gardens. It was on the first floor of the building with good-sized rooms, high ceilings, a huge balcony at the front overlooking the street and another, even larger balcony at the rear overlooking communal gardens. The location of the flat was just a short walk from the shops, bars and restaurants on Kings Road, Chelsea, where we would hang out, people-watching, at the Picasso coffee bar or the Markham Arms pub. Our favourite club at that time was Le Bataclan on Princes Street in Soho, which wasn't too far away from where we were living.

David turned up at Le Bataclan one night at the beginning of 1969. I hadn't seen him for ages. We chewed the fat a bit and, lo and behold, he said he was living down the road from me at the north end of Onslow Gardens in Clareville Grove. The house, number 22, was easy to find – just a couple of hundred yards in a straight line from

where I was living. It was the second in a row of five or six three-story terraced houses, handsome but not ostentatious. He greeted me at the door and led me, rather solemnly, to a room on the top floor. The room was quite pleasant with a slight sweet smell of incense. It was sparsely furnished with a metal fireplace, double bed, a chair, a wardrobe, scattered cushions and a twelve-string guitar. David didn't look too happy. He had the same look on his face that he'd had when I gave him back the melted 78s all those years ago, so I gave him a hug, and next thing I know he's having a major sob. I'm talking premium upset. But, as much as it took me by surprise, I was pleased that I could be on hand as an old and trusted friend. It turned out that his girlfriend Hermione had walked out on him. Hermione Farthingale and John Hutchinson had been in a short-lived group called Feathers, with David performing songs with movement and mime. She'd walked out on his band and so now there were only two of them. This meant that not only had he lost a whole girlfriend, but also a third of a band in one go. One good thing to come out of his heartbreak episode was that he wrote a great song, 'Letter to Hermione', which I consider to be one of his best soulful vocal recordings. When I went back to see him a couple of days later, he played me a new song called 'Space Oddity', which I thought was both clever and commercial. Little did we know then, but this would be his first longed-for hit.

Sometimes, David hung out with me and my then-girlfriend Rosie, nicknamed 'The Countess' (she was rather grand), then we moved to Chelsea and I lost touch with him for a while. Rosie had quite a few gay male friends and she and I would go with them to a club on Kensington High Street called El Sombrero, otherwise known as Yours or Mine. The guy on the door, Amedeo, would greet us with a big hello and a peck on each cheek, which felt entirely appropriate. The club had a sweeping staircase from which you could make a

great entrance and the crowd was a mix of Black and white, young and old, rich and not so rich, with a few straight couples like me and Rosie. A couple of years later, in 1970, Yours or Mine was where David met the 19-year-old Freddie Burretti. He was a self-proclaimed seamstress and the man who would go on to dress David (and his bands) for the first half of the 1970s.

David would move from Clareville Grove – and the memories of Hermione – sometime around the middle of March '69. At first, he went back to live in his parents' house at Plaistow Grove in Bromley. This must have seemed like a step backwards for him, from one unhappy abode to another. David then went to stay with his old friend from Plaistow Grove, Barrie Jackson, who'd moved two miles away to 24 Foxgrove Road in Beckenham. From this address, he moved a further two yards from upstairs at 24 to the ground floor, the home of writer/journalist Mary Finnigan. Not long after this, he met an American girl called Angie Barnett.

I never went to The Beckenham Arts Lab that they created, nor did I ever meet Mary, but I suspect the move from 'Jackson Heights' to 'Finnigan's Cave' was a fascinating and creative period in all their lives. Plus, the importance of the industrious, do-it-yourself attitude that Angie was to take forward into helping re-launch David's career cannot be undervalued.

My flatmates and I moved in March '69, from Onslow Gardens to Kings Road – not just anywhere on Kings Road but bang in the middle where all the action was. Our flat was directly opposite the uber-fashionable restaurant Club Dell'Aretusa and Alice Pollock's clothes shop, Quorum, which featured the designs of Ossie Clark and Celia Birtwell. A bit further down the road was a shop with the naffest name – Squire – a clothes shop which was where my friend Richard Young, another pseudo-French dresser,

Me with my friend from the '60s, Richard Young, in 2018.

worked as manager. I met Richard at Le Bataclan and we'd see him around Chelsea. My flatmate, Philip, replaced Richard at his old job down the road at Just Men, another clothing store with a naff name. Richard took up photography in 1974, becoming London's top paparazzi. He's still in demand to this day.

The flat we moved into was a bit of a dump and not big enough for three people, but it was so cool leaning out of the window checking out the action on Kings Road. It was fascinating seeing all the stars of the day coming and going in and out of the shops and Club Dell'Aretusa, although we did feel sorry for the doorman when Sammy Davis Jr. drove up in his ultra-groovy luxury beach buggy, all finished off with metallic paint and gleaming chrome work. The great man pulled up, leapt out of the buggy, tossed the keys to the doorman and sauntered into the club – all in one cool movement, or so it seemed. It didn't bode well when the doorman sat in the driving seat looking at the controls like it was a Boeing 747. He made what he thought was an educated guess, but unfortunately the odds weren't with him as he revved up and hurtled backwards into a Rolls-Royce.

There was great excitement on Kings Road when we acquired our very own drugstore, which was very much inspired by Le Drugstore on the Boulevard St Germain in Paris. The Chelsea Drugstore was mentioned in the 1969 Rolling Stones' track 'You Can't Always Get What You Want' and made an appearance in Kubrick's 1972 film *A Clockwork Orange* as the Musik Bootick. The Chelsea Drugstore was purpose built, replacing a Victorian pub on the corner of Royal Avenue. It was on three floors and had a pharmacy, bar, boutique, eatery, newsstand and a record shop, where I vividly remember listening to Dr John's wonderful track 'Mama Roux' before buying the album, *Gris-Gris*. We were truly spoilt for great music in the late '60s. The Beatles just seemed to get better and better, and we'd all wait for their latest album which became a national fixture. Later in the '60s, The Stones would get into their stride too, but The Beatles' real competition, as far as experimental creativity was concerned, came from the American band, The Beach Boys. For me The Beach Boys' 'Don't Worry Baby' from two years' earlier is one of the most uplifting and sublime tracks ever recorded, and one I still occasionally play loudly.

ROADIE FOR ROSKO
'Strawberry Fields Forever', Richie Havens, 1968

For a period of three years running, from 1968 to 1971, there was a series of free concerts staged in Hyde Park, London. These gigs were headlined by huge and successful British and US bands: Pink Floyd, Traffic, Jethro Tull, Canned Heat, Richie Havens, and many more.

The Stones' free concert at Hyde Park in 1969 was more of a rehearsal for an upcoming tour of the USA, as they hadn't played for a couple of years and never before with Brian Jones's replacement, Mick Taylor. The concert was to be a comeback gig but as fate would have it, Brian Jones, who had been sacked from The Stones in June of that year, was (inconveniently) found dead in his swimming pool two days before, so their comeback gig was hastily turned into a wake.

A few of us went along and we must have got there early as we were quite near the front of the stage when the estimated 249,997 others also turned up. Not to look a gift horse in the mouth, but the gig wasn't great musically and Mick Taylor looked too nice to be in The Stones. Having said that, he was just 20 years old, and it was pretty impossible to fill Brian Jones' shoes, a man with great stage presence. Mick Jagger came on stage wearing his now infamous white-cotton smock dress from the boutique Mr Fish, requesting that we all cool it as he'd like to read *Adonais: An Elegy on the Death of John Keats* by the poet Shelley, which he hoped expressed what he and we all felt about Brian. Obviously, we hadn't cooled it enough for Mick as he chastised the crowd saying, 'Are you gonna be quiet or not?'. All this was delivered in a mockney drawl which, bizarrely, reverted to his (natural) middle-class accent when he read the line, 'I weep for Adonais – he is dead! Oh, weep for Adonais!' At this point, the management and associates released a few boxes of non-professional, unrehearsed, and half-dead white cabbage butterflies, of which only the desperate and fittest managed to fly off into an environment sadly bereft of cabbage leaves, but abundant in marijuana. David made an unexpected appearance – well, in as much as one of the tracks put on while waiting for The Stones to play was 'Space Oddity'.

Another outdoor concert I went to in 1969 was the Isle of Wight Festival. This was only the second year of the festival and The Band was headlining along with Bob Dylan – his first paid gig for three years since his motorbike accident in 1966. I went with The Countess so, naturally, we weren't camping but stayed at a hotel. It was a privilege to see Dylan and I loved The Band, but the highlight of the whole festival for me was thus: it was late evening, the sun was leaving the last of its perfect warm rays. Ahead of us was the stage, and to the left through the dusk was blue sea, upon which small yachts sailed serenely. Above all, there was a dazzling sunset. We had more food than we needed, so I offered some to a couple next to me who were proper hippies: the hair, the beard, the beads etcetera, and they could not have been more appreciative. A little time passed and the dude, having eaten our offering, passed us a joint of the most agreeable weed ever proffered. Then – the deal maker, the Holy Grail, the mind fucker! – Richie Havens, who had been the opening act at Woodstock two weeks' earlier, was there on stage. I'd lived through the Summer of Love, I'd even gone to a few Satsangs with a flatmate of mine who was looking for 'the knowledge' (it's always the knowledge), but on that particular evening, in that particular company, with Richard P. Havens singing 'Strawberry Fields Forever'... I found bliss.

The last concert I saw in 1969 was The Plastic Ono Band, which saw John Lennon and George Harrison on the same stage together for the first time at a scheduled concert since The Beatles' last show in 1966. The event was held

on 15 December and was a benefit concert for the children's charity UNICEF, called Peace for Christmas, held at the Lyceum Ballroom (now a theatre) just off London's Strand. The band were what would have been described then as a Supergroup, comprising Yoko Ono, John Lennon, George Harrison, Eric Clapton, Billy Preston, Klaus Voormann, Delaney & Bonnie, Keith Moon, Alan White, Jim Gordon, Bobby Keys and Jim Price. The band played just two songs, the A and B sides of their current single, 'Cold Turkey' and 'Don't Worry Kyoko'. 'Cold Turkey' lasted around seven minutes, much longer than the vinyl version, while 'Don't Worry Kyoko' lasted nearly 40 minutes! Lennon loved it, but the crowd thought otherwise and got a bit bored. I saw the concert from about 10 metres at the side of the stage, as I was at this point working for Emperor Rosko, the BBC radio DJ who was the compere for the show.

'Maybe I'm Amazed', Paul McCartney, 1970

Emperor Rosko, real name Michael 'Mike' Joseph Pasternak (son of Hollywood producer Joe Pasternak), joined the pirate radio station Radio Caroline as a DJ in 1964. With his slick delivery and American accent, he really stood out from other DJs. He also spoke fluent French and was a presenter for the French-speaking stations Radio Monte Carlo and Radio Luxembourg, which made him a star DJ in France where he was known as 'Le President Rosko'.

I met Rosko in London through his secretary, a French girl called Martine, who was the girlfriend of one of the crowd at Le Bataclan. She'd heard me singing one day (to myself) and told Rosko that I had a great singing voice. I can't remember whether I did some kind of audition or what, as I wasn't that crazed about being a singer. Actually, I wasn't that crazed about being anything. Anyhow, the upshot was that Rosko wanted to record and manage me. In the meantime, and presumably to keep my body and soul intact until ready for stardom, I was hired to be an occasional roadie and driver for him. I ran errands all over London and Paris and sang soulful jingles for his Saturday show like 'Twelve o'clock and time for the Rosko show!' sung to the tune of the intro to Dionne Warwick's 'Do You Know the Way to San Jose', or 'It's a week since he's been here' sung to Lou Johnson's 'Message to Martha'.

Rosko had terrific energy and drive, and the ability to put out the best soul/R&B show on Radio 1 every week, even after having arrived back in London at four that morning from the previous night's gig. While I languished in bed, listening in, Rosko would give me the most public wake-up call in Britain by announcing on his show something like, 'Come on Geoff! Rise and shine! We're in Southampton tonight.' I would drag my weary body out of bed, have a quick wash, go downstairs to the truck – a long-wheelbase transit, adorned in bold orange letters with 'The Rosko International Road Show', parked somewhere on Gloucester Terrace where I'd moved to from Chelsea – peel off the parking ticket from the window, and head to the BBC studios in Langham Place.

The BBC headquarters was the nerve centre of the most powerful and influential radio communications network in the world. From the vast reception area on the ground floor, it was a long, complicated journey through a labyrinth of corridors to Rosko's studio, from where he transmitted his show. Without the assistance of a BBC commissionaire, I was never able to find my way. I would pass various studios with some guy speaking Russian, another speaking Arabic, or someone playing jazz with another playing classical music, until I reached Rosko in full swing, his arms flailing towards heaven, screaming, 'Have mercy baby!' over Wilson Pickett's 'Mustang Sally'.

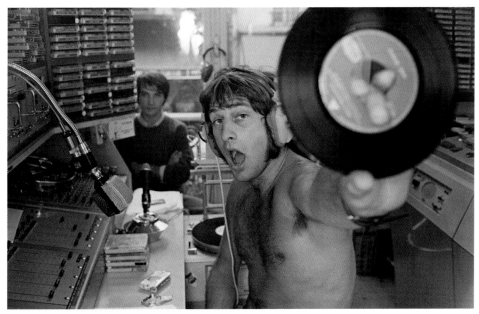

The Emperor Roskso in full voice!

After the show, we would pack up his precious singles and albums – all numbered and catalogued – and wend our way back through the BBC maze against a sonic backdrop of 43 people speaking 43 languages above 43 different types of music; past the commissionaires in their pristine, black uniforms and peaked hats – 'Have a nice weekend!', 'And you sir' – through the main entrance, past Eric Gill's sculpture portraying Prospero sending Ariel out into the world; to Portland Place where Rosko would sign a few autographs; then around the back of All Souls Church, to find the truck still bearing the declaration, 'The Rosko International Road Show'. We'd have a short wait for the two girls who danced for the show – always late – and then it was off down Regent Street to the occasional wave or thumbs-up from the Emperor's loyal fans.

I had some great times working for Rosko, travelling around the UK and Europe. We once did a season at an open-air club on the Spanish island of Majorca, with my then-girlfriend Desna and a girlfriend of Rosko's as the dancers. When we'd finished in Majorca, I had the job of driving Rosko's yellow Mini Moke back from the south of France to Paris, which was a very loud, cold and noisy affair. While working with Rosko, I was fortunate enough to meet several of my heroes – the people who created the soundtrack to my early teenage years: Booker T. Jones of Booker T. & the M.G.'s; bass guitarist and producer Donald 'Duck' Dunn; the drummer and founder member of the M.G.'s, Al Jackson; and a special hero of mine, guitarist Steve Cropper. It was a soul boy's paradise! Not only were they all incredibly sweet and modest, but they had the humility, once introduced, to remember my name.

Rosko flew me to Radio Europe 1 in Paris with a copy of Paul McCartney's first solo album after The Beatles had split up – the simply and directly titled *McCartney* – as the radio station wanted to be the first to play it in Europe. The station committed the album to tape as soon as I arrived, gave me back the precious vinyl, and put it on air as I was leaving. The song 'Maybe I'm Amazed' from that album is, to my ears, one of the greatest tracks ever recorded. Rosko had the most incredible album archive and introduced me to artists I'd never heard of like Johnny Otis and Lord Buckley.

Haddon Hall: The Beginning of Success (1969–1972)

'Madame George', Van Morrison, 1968

'Thanks David for introducing me to the divine album "Astral Weeks".'

In 1969, David had moved to a fantastic Gothic, raised ground-floor flat in Beckenham with his girlfriend and soon-to-be wife, Angie. Haddon Hall was one of many grand Victorian and Edwardian houses built in the suburbs of London for the wealthy who wanted more space as well as easy access to London. I lived in such a place from the age of 12, when my family moved from Bromley to Beckenham, until I left home for West London. My mother's house was at number 1 Blakeney Road, about a quarter of a mile from where David and Angie were going to live.

Haddon Hall was an extremely grand double-fronted abode, and the area David rented had a magnificent hall with stairs that led up to a double-sided gallery from where Joan Crawford would have been entirely happy to have descended. Unfortunately, the gallery didn't actually go anywhere as it was boxed off to create more apartments, but there was enough room to sleep around the balcony, which many people did. Some of the most important balcony guests were three musicians from Hull, Mick Ronson, Woody Woodmansey and Trevor Bolder, later to become the legendary Spiders from Mars.

I remember David introducing me to the wonderful *Astral Weeks* album by Van Morrison around this time, which seemed a perfect backdrop to the interior of Haddon Hall. I would come down from where I had moved to in Bayswater, London, and visit David at the Hall, sometimes in 'The Rosko International Road Show' truck, which always amused him.

David's musical output seemed to be really prolific around 1971 following his 'Space Oddity' hit, which peaked at number 5 in the UK charts at the end of '69. The follow-up single 'Holy, Holy', however, didn't fare so well, and it looked like David might not repeat the success again. But he was writing all kinds of stuff in all kinds of styles; he even wrote a song about his car called 'Rupert the Riley'. It's a wonder that he ever mentioned his Riley (a 1932 Gamecock) since the bloody thing nearly killed him. It happened like this: he was trying to start the beast by cranking it into life the old-fashioned way, with a starting handle at the front of the car; problem was, he'd left the old pig in first gear. As he turned the handle with a mighty effort, the thing lurched forward and pinned him to the vehicle behind, just missing the main artery in his leg. Luckily, he was right outside the police station in Lewisham where the cops who had been laughing at the long-haired idiot trying to get his old wreck going, jumped into action with their first-aid kit. George (Underwood) and I went to visit him in Lewisham Hospital a couple of days later. On seeing his pale, sad little face, we burst into a

David in the garden of Haddon Hall, Beckenham, 1971.

chorus of Clarence Carter's song 'Patches', which goes 'Patches, I'm dependin' on you, son, to pull the family through, my son, it's all left up to you'. I remember he gave us an ironic smile, the kind of smile one might reserve for your oldest friends after you've run yourself over in your own car.

David wrote, or allocated, songs for everyone around him, as if he were on a journey and wanted to take us all along. This was also David's 'Li Li, La La' period. He wrote a song for me ('How Lucky You Are'), which ended with 'Li Li Li Li Li Li Li Li Li Li'. He also wrote a song for George ('Hole in the Ground'), which started with 'Li Li Li Li Li'. Even the song 'Time' ended the same, admittedly two years later. One could argue that the most rewarding moment of this 'Li Li, La La' period was the ending of his 'Starman' appearance on Top of the Pops in July '72, which would launch him as a star.

David wrote a song for Freddie Burretti as part of the Arnold Corns band project, and the song 'Andy Warhol', for the singer Dana Gillespie, with whom David had had a relationship in the late '60s. 'Andy Warhol' was recorded separately by

Gillespie and David in 1971 and appeared on her album *Weren't Born a Man* in 1973, which was produced by David and Mick Ronson, as well as on David's 1971 album, *Hunky Dory*. David also wrote 'All the Young Dudes' for Mott the Hoople.

Of all these songs, which were all recorded with us, 'the artists', mercifully only a few of them are known to the general public. Mott the Hoople's version of 'All the Young Dudes' was released as a single in 1972, making number 3 and number 37 in the UK and US charts respectively. The Arnold Corns' tracks later emerged on Bowie's albums, *Hunky Dory* and *The Rise and Fall of Ziggy Stardust and the Spiders from Mars*.

Part of David and his generosity was wanting to take his friends on the journey with him. He would invite us to a recording of a John Peel Show at the BBC. He took George Underwood and his wife Birgit as guests on a mini-US tour, travelling on the luxurious liner *Queen Elizabeth II*. He asked his friend Freddie Burretti to become his clothes designer. And, sometime later, he asked me to become a member of an extended band.

A QUESTIONABLE DEAL
‘Use Me’, Bill Withers, 1972

The reason David had this new freedom to create music without restriction was due to his new management, who had come recommended to him by his label manager at Philips Records. Litigation clerk Tony Defries and show-business accountant Lawrence Myers had recently formed a business partnership, Gem Music Group. To their credit, they not only saw potential in David, but they offered him what seemed like an attractive deal – one that would supposedly alleviate his day-to-day financial niggles, as well as secure his long-term future. And so, they came to an agreement for Gem Music Group to work with the rising star.

I was never really sure whether David completely understood the arrangement Defries was proffering. I don’t know whether he went along with it out of a desperation to get to the level he desired – deserved even – thinking that he’d deal with it at a later stage when he was established, or whether he signed the deal because he was so eager, after all his previous disappointments. Either way, he took his eye off the ball. The deal he signed was basically as an employee of what would become MainMan, Defries’s new company, not, as he may have thought, as a partner. The vague outline of the details in the contract is something I would only discover around the beginning of 1975 when David and I were hanging out in LA, and he was suddenly broke.

Myers involvement with David would last just a year and a half. Defries wanted to open an office in New York where he planned to build a music empire, adding new artists like Iggy Pop and Dana Gillespie to the roster. Some of the new artists would willingly sign, but others like Lou Reed and Mott the Hoople didn’t. Since David’s ascent was being funded with Myers’ own money to the tune of £75,000 (then an absolute fortune) and he was fed up with all the ‘maybe signed’, ‘could be signed’, slightly deranged-looking ‘artistes’ hanging around his offices, he decided to strike another deal with his partner. This gave Defries the opportunity to start a new company – MainMan – taking Bowie and all the other signed artists for the return of his investment, plus a share of future profits up to the sum of £500,000.

When Defries acquired this sum mysteriously quickly (probably from RCA Records), Myers was happy with his quick return and bowed out. This, in time, would reveal itself to be an expensive arrangement for both Myers, who missed out on taking a percentage of David’s future earnings, and David himself, when years down the line in the late Nineties it was alleged that David had to pay around $25 million to Defries for his original masters.

Tragically, years later, in 2012, Defries was to lose it all and more in a $9.5 million lawsuit with Capitol Records, EMI and others. And, allegedly, he lost a further $22 million in an offshore tax-evasion scheme.

Listening to the new management hold court at Haddon Hall was rather like being at one of those Satsang group events that I’d been to with my friend Chris, but without the smell of incense or the yogic positions. Instead, there was always the pungent smell of a Havana cigar which Tony would always be smoking, used as a kind of Churchillian prop. Deep reverence was paid to his every word as if he were the one with the Knowledge, sagely proffering a new wisdom. David would sit quietly listening, with Angie sat at Tony’s feet, beaming like a dolphin at feeding time. I have to admit, even though we didn’t much care for each other, he was a top-draw spieler and he delivered what he said he would.

ZIGGY STARDUST
'Handbags and Gladrags', Chris Farlowe, 1967

Sometimes my girlfriend, Desna, and I would bring armfuls of clothes from the women's clothing boutique Feathers down to Haddon Hall for Angie and David to try on. The little nylon fake fur-lined jackets that David (and the Spiders) were photographed in many times at the beginning of the '70s, at the start of the Ziggy phenomenon, came from Feathers.

Desna was working as a trainee buyer for Feathers on High Street Kensington, next door to Kensington Market. The store was run and owned by the Burstein brothers, Sydney and Willie, and their wives. Sydney's wife, Joan, later affectionately known in fashion circles as 'Mrs B', was the brains behind Browns of South Molton Street, which she started after Feathers in 1970 and which was known for championing new talent. I would sometimes collect Desna from Feathers and I vividly remember this very pleasant, handsome guy who was always wrapping fabrics around Desna's dainty feet exclaiming, 'I have this wonderful idea'. A few years later, Diana Vreeland, the editor-in-chief of US *Vogue*, saw this guy's portfolio and encouraged him to make things. For Manolo Blahnik the rest, as they say, is fashion history.

When Mrs B left Feathers to open Browns, Desna went along as a trainee buyer. As Browns quickly expanded, they opened a section for men's wear in the basement. I worked there for a short while until they fired me. Actually, they got me to sack myself by asking me to clean the lavatory. Then it was just a matter of waiting, oh, five seconds, for me to tell them to go fuck themselves and, hey presto, I was gone. I then got another unsuitable job at the men's boutique Mr Fish on Clifford Street. Neither of these positions were thought-out career moves, just fill ins.

David or Angie (or both) had been talking about men's dresses and during my short stay at Mr Fish I noticed, tucked away, this small rail of heavily discounted men's gowns. I knew of only one man in London who might be interested in this unrepeatable sale, and he lived at Haddon Hall.

When I called David, he was at Mr Fish's boutique in record time which, strictly speaking, was unnecessary as the garments had been languishing there, unsold, for quite some time. David tried a few of them on and it was as if they'd been made for him. I expected Mr Fish to be at least pleased, but he stood there impassively, almost bored, and not even Angie's squeals of delight made a dent in his demeanour. Perhaps he had realised that the Mr Fish bubble had well and truly burst. However, I'd like to think that somewhere down the line Mr Fish, while browsing through some albums, came across David Bowie reclining on a chaise lounge wearing one of his creations on the album *The Man Who Sold the World* and that a wry smile registered across his handsome face.

David and Angie's son, Duncan Zowie Haywood Jones, was born in May of 1971, a joyful occasion which prompted the writing of the song 'Kooks', which appeared on *Hunky Dory*. The song's debut was heard on the BBC in Concert in June with John Peel. David, who was in great spirits enjoying the birth of a son and a new-found productivity, was in celebratory mode; not 'let's get loads of booze and have a piss up' but 'let's all bowl down to the BBC and celebrate on the air waves'. The show was cobbled together by David at Haddon Hall in a very short time and, as well as the Spiders, friends and neighbours were all invited along to do a bit: Dana Gillespie, George Underwood, Mark Pritchett from across the road from David at Haddon Hall, and me. John Peel announced me as Geoff MacCormack, who lives down the road. The whole affair was to become part of *Bowie at the Beeb*, a compilation album

L–R: Dana Gillepsie, Tony Defries and David do *Pork* at the Roundhouse in London, 1971.

which was released in 2000, nearly 30 years after the sessions. To say it was loose would be an understatement. We sang the Ron Davies' song 'It Ain't Easy' together, with varying degrees of hilarity; David sounds slightly crazy, I sound like my mouth's full of cotton wool, George sounds *completely* crazy.

Another even weirder happening later in the year was the arrival from New York of the stage play *Pork* at the Roundhouse in London. The play was loosely written by Andy Warhol and New York writer/director Tony Ingrassia, with a cast including The Factory personnel Geri Miller, Tony Zanetta, Wayne (Jayne) County and Jaime (de Carlo) Andrews, with photography and stage management by Leee Black Childers. I really don't remember much about *Pork* except that it was rather silly and had lots of nudity. David became friends with some of the cast who would later be

recast by his management at MainMan in various new roles such as 'president', 'vice president', 'tour manager' or 'office managers', as they became part of David's crew and entourage until the mid-Seventies. I must say, I very much liked the cast of *Pork*, especially Cherry Vanilla, who was fabulous fun, and dear Leee Black Childers, who was perhaps the sweetest of them all.

The year 1972 kicked off with David's 25th birthday bash at Haddon Hall. Lionel Bart was one of the guests and it was the first time I'd seen him since the old Mod days in Soho when he used to float about with a posse of good-looking young men in tow; he was very charming and friendly. Lou Reed, who was also in attendance, had met David in New York in September the year before. He and David sat together for most of the evening in an exclusive club of two, while Angie was the perfect hostess flitting from one person

Leee Black Childers and Cherry Vanilla on the British Tour in 1973.

to another making sure everyone was happy. David looked in great shape with a new short haircut and what would become the Ziggy look. I think we all ended up at El Sombrero nightclub in Kensington.

That year would turn out to be the busiest and most gruelling schedule for David so far. He finished recording and released *The Rise and Fall of Ziggy Stardust and the Spiders from Mars*, produced Reed's album *Transformer*, completed a 29-date tour of the USA, mixed Iggy Pop's *Raw Power* album, sailed both ways across the Atlantic, wrote and recorded *Aladdin Sane*, did press and TV appearances for an album and four singles, and collaborated with Lindsay Kemp, putting on two major shows at the Rainbow Theatre in London.

I was living in Notting Hill by 1972, when David's new single 'Changes' popped up on the radio. This was incredibly exciting, not just because it was David but because it was a piece of music that was so different, yet at the same time so accessible. The fact that the album it came from, *Hunky Dory,* (December '71) also had 'Life on Mars' and 'Oh! You Pretty Things' made the album, to my ears, both contemporary and original, while 'Queen Bitch', a harder, rockier

sound influenced by the Velvet Underground, linked beautifully to his next album *The Rise and Fall of Ziggy Stardust and the Spiders from Mars*. A year for great album releases – from Stevie Wonder, War, Neil Young and the brilliant Bill Withers album *Still Bill* – 1972 also saw three albums directly related to David's output: his own, *Ziggy Stardust*, and producing Lou Reed's *Transformer* and Mott the Hoople's *All the Young Dudes*.

Towards the end of 1972, David started to record his follow-up album, *Aladdin Sane*, at Trident Studios in St Anne's Court in Soho. I somehow ended up doing some backing vocals, which I no doubt did for a laugh and probably didn't even bill for them. It was like 'just helping a mate out' kind of thing. Apparently, I also did the percussion for the track 'Panic in Detroit'. My memory isn't clear on any of this, which sounds crazy to most people – I mean, how can you forget working in Trident Studios with David Bowie?! I can only suppose that because I wasn't a session man, it was all a bit, well, casual.

However, knowing the songs and arrangements on *Aladdin Sane* at the recording stage must have put me in good stead later when David wanted to expand his sound for the 1973 tour.

Touring the USA (1973)

'Sea Cruise', Frankie Ford, 1959

'Be my guest you've got nothin' to lose, won't you let me take you on a Sea Cruise?'

'Are you alright mate?'

I was sitting at a desk in an office in North London staring into space, stunned. 'Are you alright mate?' Mike asked again. I replied, 'I've just had a call from David Bowie informing me that I'm now in his band and going on a world tour'.

I had been selling advertising space for a weekly newspaper aimed at the building trade. The publishers of *Construction News* must have been really pushed for staff. I arrived for my interview five minutes late, or so I thought. I later found out I was 24 hours and five minutes late. Perhaps they thought that anyone with the gall to arrive 24 hours and five minutes late and casually apologise would probably stand a better than average chance of selling advertising space to an Irishman with half an acre in Kilburn and three-dozen surplus diggers. Whatever the reason, and quite improbably, I got the job. The atmosphere was pleasantly casual, and the work was more than tolerable for someone who quite enjoys a little chat on the phone. I couldn't have been bad at what I did because after nine months I was offered a position teaching new recruits the 'art' of telesales. Whether I'd have been even better at this I'll never know – though my theory is that bullshit is an art that comes naturally or not at all. Rising through the ranks of *Construction News* or joining David Bowie on a world tour as a backing singer/percussionist wasn't the hardest decision I've ever made. Besides, that morning in the office of *Construction News*, when Gwen the receptionist announced – in very impressed tones – that there was a Mr David Bowie on the line for me, my recollection is that I was 'told' rather than asked my future career plans.

'That's amazing', Mike said. 'My dad's going too. He's Bowie's driver'. This was all too much to take in. 'Jim the Lim, you're kidding! Jim the Lim's your dad?' I'd sat not eight feet away from Mike for months and this had never come up. Like his dad, Mike stood at about six feet two and was built like a shed, but Jim looked a lot more dangerous, and rumour had it that he had underworld connections. Jim was a diamond.

So, I quit my career selling advertising for *Construction News*, packed my bags, kissed my girlfriend goodbye and off I went. I'm not sure whether it was David's fear of flying, or the management's strategy to make David appear even more star-like and special, but we, David and I, were to sail/cruise to New York while the rest of the band flew across later.

David and I boarded the boat *SS Canberra* on 24 January 1973. It was just like in the movies with a brass band playing on the quayside and I remember thinking how enormous the ship

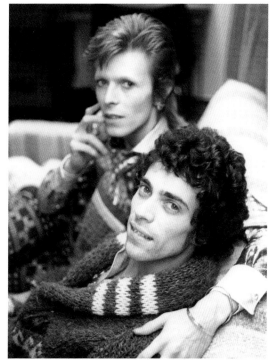

Me and David aboard the *SS Canberra*, 1973.

was which towered above us like some gigantic wedding cake. Photographer Mick Rock had come down to Southampton to take some snaps of David's departure. Mick looked more rock 'n' roll than most bands and was responsible for documenting most of the early '70s images of Bowie. Some think he made his name up, but I'm happy to say, his name really is Mick.

Apart from a couple of journeys by ferry to France or Jersey in the Channel Islands where I'd worked doing a multitude of different jobs for two summer seasons in my late teens, this was my first experience of cruising. Initially I was wary of the courteous manner in which the ship's officers treated us. They looked so smart and precise in their uniforms, quite the opposite of us, that it worried me. I couldn't help thinking that, once we were far out to sea, they might sidle up to us with an evil grin and say 'Right, you two freaks, we're in charge now!'

We were certainly different to the ship's usual clientele who, by and large, were middle to old-

aged, upper-middle class Britons and Americans in semi-retirement. We were shown to our suite, which consisted of two bedrooms and a large lounge, and then went back on deck. The brass band was still playing jolly little tunes while people waved their goodbyes from ship to shore and back again. There was a deep rumbling from the engines and, slowly, we pulled away. People waved ever more furiously, as if they would never see each other again. For my part, I had no idea that my journey would take me away for the best part of three years.

It took a day and a half to realise that near-complete inactivity is par for the course on a cruise ship. By day two, afternoon tea was an exciting event to look forward to. When it came to dinner, we decided to really make an effort and dress up. My fairly conservative clothes and long, dark, curly hair contrasted rather nicely with David's bright-red hair, shaved eyebrows, make-up, and exotic, hand-made Freddie Burretti suits. We took on the roles of a modern-day Oscar Wilde and Bosie. I would turn to David while dining and ask, 'More vegetables my dear

The 'Tango Twosome'.

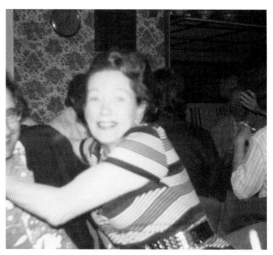

Our friend 'Nutty'.

Oscar?' He would look towards the ornate ceiling with a look of disdain and say, 'I find vegetables so terribly vulgar'. Poor entertainment, perhaps, but marginally more fun than the alternative: watching our travelling companions dance the foxtrot in the ballroom, accompanied by a bored-looking cruise band. Of course, ballroom dancing was a whole different ball game on the high seas, when the irresistible forces of nature would throw the old dears in all directions. Occasionally the band would play something other than a foxtrot. If it was even remotely Latin in nature, a couple we named the 'Tango Twosome' would appear and claim the dance floor as their own, strutting their stuff with nasty little jerky movements. It was clear their skills were beyond those of the fox trotters and for a few minutes they'd have the floor all to themselves, and they clearly loved it.

Despite it all, we managed to make friends. One was an entertaining middle-aged lady who, with her own enthusiastic approval, we named 'Nutty'. We never saw Nutty sober. Always with a drink in her hand and always highly animated, she was capable of the most amazing facial contortions that fluctuated between emotions at an alarming rate. Fully inebriated, she could go from smiling elation to sad desperation in the time it took to light a cigarette. As a finale she would spread her arms wide and collapse into hysterical laughter, all for no

apparent reason. If Nutty really liked you, she would grab you around the neck and shake your head. She shook our heads often, and we liked her too.

Other people we got to know and like immensely included a 60-something-year-old couple from Knightsbridge, London, who lived just around the corner from Harrods. Gordon and his wife were examples of a particular type of upper-middle class English folk with nothing to prove to anyone but a gracious acceptance of others and a positive enjoyment of anyone different. We would dine with Gordon and his wife and sometimes Nutty, if she could find us, though often she couldn't even find the dining lounge. We would catch up with her after dinner, cocktail in hand, reprimanding us for not having been where she was looking for us. Naturally we would apologise profusely and assure her it would not happen again. We'd then buy her a drink, though more for ourselves in an earnest attempt to catch up with her level of intoxication. Unfortunately – or fortunately – she occupied her own boozy plateau and it remained beyond our capabilities to join her there.

After six or seven days we finally arrived in New York on the 30 January. Having said our goodbyes to Gordon, his wife, and dear old Nutty – whose face managed 16 different expressions in 30 seconds, ending in something resembling grief – we made

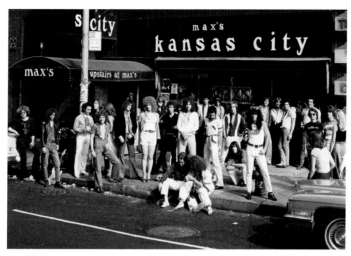

Max's Kansas City in New York.

our way to dry land via a sloping gangplank into a barrage of noise and restless intensity.

To arrive in New York for the first time by air would have been a culture shock. Arriving by sea, senses lulled by the gentle pace of the *SS Canberra*, it was something like a bungee jump on amyl nitrate. Everything seemed bigger and brasher than anything I'd ever seen – cars, trucks, people – it was both exciting and confusing. We were greeted by various RCA and management staff and led to a waiting limousine.

I'd had a lifelong ambition to visit New York and the drive to the hotel was a dream come true. The city was faster and more vibrant than I'd imagined. It was too much to take in. David, who had been to New York City the year before, kept up a running commentary about this street, that street and this famous building, pointing out people and places, his words punctuated by the honking of yellow cabs as we darted in and out of traffic.

We were travelling to the Gramercy Park Hotel at 2 Lexington Avenue. The Gramercy was what you'd call a traditional hotel with a bohemian feel. The warm inviting atmosphere was the perfect antidote to the frenzied drive from the docks. After checking into our rooms overlooking a small park, we went down to the main bar where we sat at a table by a window. With a pianist tinkling away softly in the background, I recall feeling the foggy haze of contentment laced with the anticipation of what was to come; in short, life could not have been sweeter.

DAVID AND THE SPIDERS
'Does This Bus Stop at 82nd Street?',
Bruce Springsteen, 1973

Situated at 213 Park Avenue South, between 17th and 18th Street, just off Union Square, Max's Kansas City was a late Sixties/early Seventies mecca for artists, musicians and freaks. Many of Max's regular patrons were famous, or went on to become so: Willem de Kooning, Julian Schnabel, Larry Rivers, and Andy Warhol were all sometime visitors, as was a host of music superstars and would-be superstars. Max's was run by a man called Mickey Ruskin and, invariably, he'd stand at the door vetting the clientele. Upstairs, a small music room played host to The Velvet Underground, Iggy Pop, and the New York Dolls, to name only a few. The year before, David had met Iggy and Lou Reed, David Johansen, lead singer of the Dolls, and his Marilyn Monroe lookalike girlfriend, Cyrinda Foxe. With his growing reputation and half of his management team being ex-Warhol associates, David had an automatic entrée to the back room of Max's Kansas City.

We hung out at Max's every now and again, usually with David Johansen or the 'Warhol Pork', now 'MainMan', crew. Unfortunately, I didn't witness anything memorable; no Iggy surfing the table tops, just a lot of 'beyond cool' people waiting for something to happen! It did however remind me of Soho, London, in the Sixties, as did walking around the West Village, popping into Bleecker Bob's at two in the morning. But there was one night I do remember at Max's...

In London, David had played me some tracks by someone called Biff Rose. I hate to admit it, but I just didn't get it. Of course, I didn't say so, coward that I am. I was still grateful to David for turning me on to Van Morrison's wonderful 'Astral Weeks' – it was a revelation to me to find a white singer who sang with such soul without mimicking Black singers. So, not wanting to appear ungrateful, I went along with David to Max's for 'An Evening with Biff Rose'. Upstairs, there seemed to be a distinct lack of audience, not counting David and I sitting at a small table right at the front of the small room. The rest of our NY posse seemed to have other things to do that night. At any rate, Biff came on to a rapturous handclap from David and did his Biff stuff. I would have liked to say for David's sake that he was awesome, that I was mesmerised, but it just wasn't my bag. After Biff left the stage, some other guy took his place and played a series of dull, funereal chords from the very same piano Biff had just finished tinkling. This was soon accompanied by a sad and depressive vocal. On and on it droned. I looked around the darkened room at the other five members of the audience for clues. David's delicate features looked somewhat pained, 'Groany moan' went the singer, as we eyed up the exit. But we still had full glasses of beer and felt duty bound to finish them. It was lucky we did too because as we were downing the amber liquid and just about to leave, the singer jumped up, strapped on a Fender Telecaster and was joined by a band. He then launched into one of the most brilliant songs with one of the most

amazing bands and incredible sets I've ever witnessed. The song was called 'Does This Bus Stop at 82nd Street?', the band was The E Street Band, and the singer was Bruce Springsteen. The album, *Greetings from Asbury Park. N.Y.* was on our turntables the next morning.

The tour was to open on 14 February, Valentine's Day, at Radio City Music Hall. David had told me that it was the place where he most wanted to play in the whole city since he'd visited the theatre in 1971. Radio City didn't do rock shows, but the promoter, Ron Delsener, managed to somehow persuade the very conservative Music Hall that it was a great idea. David took me and Hutch (John Hutchinson), who'd arrived from England to join the band, over to the venue for a quick recce and we ended up watching a show that was as camp as the venue itself. When the famous Rockettes dance troupe came on to perform their precision high-kicking dance routine, David was looking around for any props on view that he could utilize for his show. Unwisely, I thought, he came up with the idea to descend as if from heaven from the gods high up above the stage on some gyroscope contraption – this from an acrophobic who didn't fly.

The band's rehearsals took place at RCA Studio A on East 24th Street in a huge recording studio, and we must have been pretty loud because the fella in the studio above came down to ask if we could tone it down a bit. He was very nice and polite, but I suppose that's what you'd expect from Harry Belafonte.

We had enough time to go out in the city a few nights before the first show. One night me, David, Hutch and David's bodyguard, Stuey George, went to see the great Charles Mingus at the Village Gate in Greenwich Village. He was, of course, wonderful. Strangely, at one point a member of his band decided to play a full-size carpenter's saw, using a timpani mallet; the overall effect was

like a theremin. Later that night we went on to Max's Kansas City. This was Hutch's first visit to the joint. The only prior advice he'd been given concerning New York had come from fellow northerner Mick Ronson, which was a cautionary 'watch yourself' upon witnessing the freaks and degenerates therein. As a result, Hutch was more than a little disturbed, especially when the pretty waitress with the nice smile asked him sweetly what drinks he required and then disappeared with his twenty bucks.

On the night of the first show at Radio City Music Hall, David was fantastic. True to his crazy idea, David did it! In a determined effort to maximise his entrance, he descended from heaven. Well, he was lowered down on the gyroscope contraption to (well-earned) gasps from the audience.

The show opened with 'Hang on to Yourself' and the first half of the show was pretty much the *Ziggy* album with a few older tracks like 'Changes' and 'Space Oddity' included. The new and as-yet-unreleased *Aladdin Sane* tracks made up most of the second half, including 'Drive-in Saturday', 'Panic in Detroit', 'Time', and 'The Jean Genie', before returning to *Ziggy* for the last two songs: 'Suffragette City' and ending with 'Rock 'n' Roll Suicide'.

However, right at the end of the show something rather strange happened. As we finished 'Rock 'n' Roll Suicide', a fan managed to get through the security, jump on stage and get within touching distance of David. David seemed to somehow collapse. The fan was ejected, and David carried to his dressing room where he recovered to find a sea of extremely worried faces. I'm still not sure what had befallen him. As for me, the first time I ever performed on a stage is distinguished by the following three facts: it was with David Bowie; it was at New York City's Radio City Music Hall; and Salvador Dali and Truman Capote were in the audience. That was all fairly surreal, even for 1973.

The band I joined at the beginning of 1973 was basically an extension of Bowie's original Spiders. Apart from Mike Garson, who was already installed on piano and Mellotron, I was one of four new recruits: Ken Fordham on saxophone, Brian Wilshaw on saxophone and flute, John Hutchinson on rhythm guitar and backing vocals, and me on percussion and backing vocals. John 'Hutch' Hutchinson (ex-Feathers) and I were to share rooms on the tour, although according to Hutch's book *Bowie & Hutch*, most of the time my bed was empty? The new recruits were positioned to one side of the stage, Mike Garson on the other, with David and The Spiders, quite rightly, centre stage. This arrangement in some of the venues rendered us practically invisible. I have to admit that it was like having a backstage pass but being allowed to join in. However, it was interesting to witness, at such close quarters, how hard His Bowieness worked for his supper. As for myself, being slightly off stage was a great introduction to performing live, the only real setback was that my monitors and Hutch's monitors were never balanced properly, and we could never hear ourselves. We gave up complaining in the end as this situation was never resolved. The problem arose at the pre-show sound check. Someone, say Woody or Mick, would ask for their monitor to be turned up, which would require another band member to ask the same and so it went on. Naturally, being further down the pecking order, we got drowned out which was fair enough as we were less of the total ingredient and our output was less important. Not that I knew it then, but Bowie would require considerably more involvement and effort from me in future shows.

Brian Wilshaw was pretty quiet, but Ken Fordham enjoyed a laugh. He had a typical jobbing muso's philosophy; one day this, the next day that. He'd been playing some kind of ghastly lounge music at London's Heathrow airport before he got the Bowie gig. David and I immediately renamed him Ken 'Funky' Fordham on account of the fact he was spectacularly un-funky and sometimes, when

introducing the band, David would announce him as such. Ken saw the irony and always took a little bow. In fact, everyone got on well, although Mike Garson, and later Mick 'Woody' Woodmansey, could be a bit serious with the whole Scientology thing as Mike was, at the time, a pretty high-up member of The Church of Scientology. As with all these movements/religions (call them what you like) he was duty bound to 'spread the word'. One word that Mike did reveal to Woody which was of definite interest to him was the word 'salary'. The disparity between what Mike (the newcomer) received and the band was astounding. Mike was on $800 a week while the band (who had to work harder) were on less than a tenth of that at $75. Naturally, the band confronted the management who promised a large pay rise and naturally the management reneged on the deal.

TOURING THE USA
'Beale Street Blues', Louis Armstrong, 1954

The tour continued to Philadelphia's Tower Theater, for seven shows in four days, including three matinees. The venue had a seating capacity of around two and a half thousand and all shows were sold out and raucous in their appreciation. Then on to Nashville's War Memorial Auditorium. Nashville was very different. Nashville was America. Nashville was cowboy boots, Stetson hats, open spaces, slow paces and, above all, country music. If you played country music and nothing else in London I'd ask you, probably not so sweetly, to do me a favour and play something else. Not in Nashville. In Nashville it works. You didn't even know you were listening to it half the time. It was the pulse of the city. A few of us went horseback riding as we were leaving and the owner of the stables shouted to us, 'Hey, y'all, come back now, d'ya hear?' That's how Nashville was.

The night after the gig, we went to a night club with a very cool Black guy who worked at our hotel. At first it was a bit edgy because it was a club for Black people and we weren't just white, we were white English fairies with silly haircuts and women's clothes. Luckily, our dude was respected and, better yet, to make the slightly uncomfortable atmosphere work in our favour, Woody got up on stage and joined the house band for a couple of funky upbeat numbers. The boy did good too!

After Nashville, we went to Memphis to do two shows at the Ellis Auditorium. As soon as we had some time off, a group of us went in search of Beale Street, 'Home of the Blues'. To our horror, it wasn't there. That is, Beale Street was there but most of the buildings had been – or were in the process of being – knocked down. Only the Orpheum Theatre seemed to be left standing. We were mortified. We didn't know anybody who didn't love the blues and here was a critical emblem of American culture being systematically destroyed. Thankfully, someone eventually woke up. Beale Street has been rebuilt and is now a big tourist attraction. Quite right too.

One place in Memphis they hadn't pulled down was the delightful Peabody Hotel on Union Avenue. Built in 1869, the hotel has a huge lobby with a marble fountain in the middle. Twice a day, at 11am and 5pm, a red carpet is rolled out, the elevator doors open, and out waddle several ducks, which make their way to the fountain to the music of John Philip Sousa. Incidentally, the hotel was also the venue of Elvis Presley's high-school prom. From Memphis, we travelled over 600 miles to Detroit to do two gigs at the Masonic Temple on 1 and 2 March. Waking on my first morning in Detroit (at the Hilton) I pulled back the curtain of my hotel bedroom to witness the site of an old Black man having a fight with an old white guy several stories below. Being a new visitor to the USA, for some reason this image stayed with me and for a while I pondered the thought of who or what America was. I was to

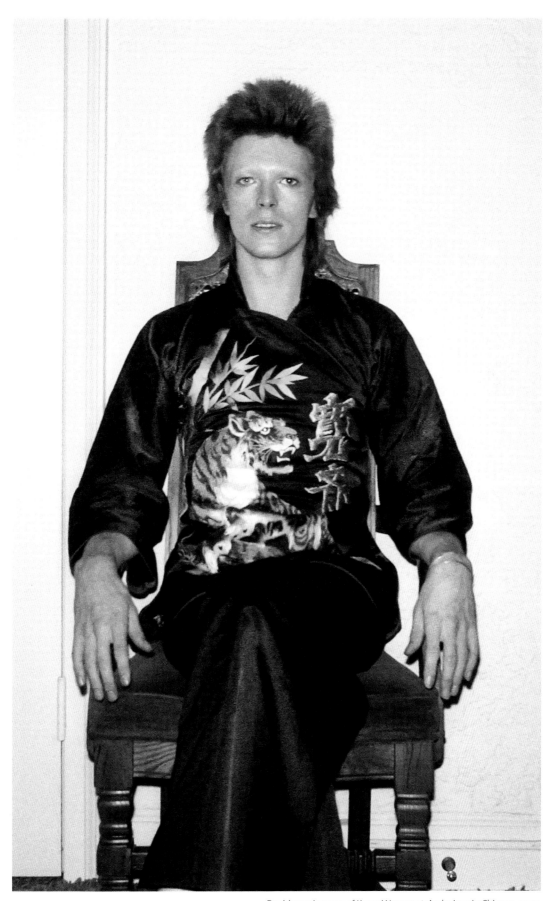

David wearing one of Kansai Yamamoto's designs in Chicago, 1973.

experience the same thought in the presidential election in 2016.

My girlfriend, Desna, arrived in Detroit from London and travelled to Chicago with me, David and Stuey, David's minder, to get the train to Los Angeles. Chicago looked how I'd previously imagined New York would look. Certainly, it seemed cleaner and better organised. We even managed to take in a bit of 'high' culture and visited the wonderful Art Institute of Chicago where we saw on display two icons of American art, Edward Hopper's *Nighthawks* and Grant Wood's *American Gothic*.

TRAIN TO LA
'Night Train', James Brown, 1962

The tour's next stop was Los Angeles to do one show at Long Beach Arena and another at the Hollywood Palladium. To get there, David and I, along with the ever-faithful Stuey, had opted for a trip by train. I was looking forward to the journey by Amtrak. The route between Detroit and Chicago had stopped at places with fantastic names like Kalamazoo, Battle Creek, and Ann Arbor. The trains were incredibly comfortable too, with clean cabins that transformed into bedrooms for long-haul trips. Chicago to LA certainly counts as long haul: it's 2,222 miles. It's a journey right across the USA, from east to west, and you can watch America pass by from specially elevated observation cars. For somebody brought up on celluloid cowboy

heroes, it was pretty strange to see signs reading Fort Madison, Kansas City, Dodge City, Pasadena, San Bernardino and Santa Fe. I'd thought these places only existed in the movies. The service in the trains dining car was almost embarrassingly good. Ancient Black guys – obliging and polite in an 'old world' way, with accents straight from *Gone with the Wind* – called us 'sir' and served a fine selection of food and wine on white tablecloths. Some of these old waiters had been in their jobs for 40-odd years and they seemed proud, not subservient, though I imagine the hip, Black city kids would have considered them 'Uncle Toms'. But then, one night at the Harlem Apollo, I heard some young Black guys ridicule the great BB King with negative terminology.

Los Angeles was like nothing else I'd seen before. It was all palm trees, cloudless blue skies and tanned blondes. At least, that was my first impression as I peered out the window of the limo between the train station and The Beverly Hilton. I didn't stay at the Hilton long. When the rest of the band arrived, I left David there and slummed it at the Hyatt Continental on Sunset Boulevard. The Hyatt used to be the hotel of choice for British rock stars. It has earned the nickname 'The Riot House', largely thanks to Led Zeppelin riding motorbikes through its halls and throwing televisions from the windows. The Hyatt Continental – or the Andaz West Hollywood as it's presently known – is situated on a busy part of Sunset Boulevard halfway between Hollywood and Beverly Hills. It was an unremarkable building then, both inside

David taking a Polaroid of me on the Amtrak train, 1973.

Freddie Burretti, David's friend and clothes designer, LA, 1973.

and out, but well placed for walking up and down the strip. But walking, we soon discovered, was an activity wholly unnatural in LA. Everyone drove everywhere. To be in LA without a car is like being in the old Wild West without a horse. Fortunately for me, I had a girlfriend come and visit from New York. She knew people in LA, so I was able to jump in their cars and see sights other than the inside of my room, the bar, or the ridiculously young-looking groupies that hung around the hotel. On one occasion, my New York friend took me with some people she knew to a riding school near Malibu Beach. Her friends all seemed to know their bits, bridles and forelocks and I didn't want to tell them that my sole experience was a gentle trot in Nashville a week before. After all, I'd seen it done on TV, I wasn't that stupid. I said I'd not ridden for a long time and chose the old nag. Old she might have been, but once she hit that sand, off she went like shit off a shovel. Luckily, I managed to keep the appropriate distance between my skinny arse and the horse's back –

as seen on TV – and galloping by the sea's edge on a beautiful day on Malibu Beach remains my favourite memory of that particular visit to LA.

Freddie (Burretti) came over from London at one point and I went to the airport to collect him. I really liked Freddie and got on well with him. Sometimes I'd hang out with him and, naturally, if you went for a drink or two with Freddie it would be in a gay bar; one moment we'd be having a chat, the next he'd excuse himself because he'd just got 'the look' from somebody standing at the bar. This was always negotiated with great subtlety and to be dumped by Freddie this way was always amusing rather than annoying.

Having completed the 1973 US tour, David and I had the delightful problem of getting ourselves from Los Angeles to Japan, eschewing the sterile environs of an aeroplane. This meant criss-crossing the North Pacific Ocean: from LA to San Francisco, on to Vancouver, then to Hawaii, and on to the Japanese port of Yokohama.

SAILING ON THE *OLD RANCID* TO JAPAN (1973)

'Love Boat Captain', Pearl Jam, 2003

'Yes please!'

Our vessel was another of P&O's finest, the *SS Oronsay*. Not as grand as the *SS Canberra* – smaller, older and shabbier – we immediately re-christened her the 'Old Rancid'.

As any old sea dog will tell you, renaming a ship brings bad luck and we duly got our fair share of lousy karma. Instead of the nice, luxurious suite we were expecting, we were shown to a windowless cupboard near the engine. It was barely big enough to fit David's luggage inside. For one of us to turn around, the other had to leave the cabin. We tried to make the best of it by sticking photos on the walls and substituting the missing bowl of fruit with a bowl of liquorice, but it was beyond the efforts of even the greatest interior designer. With David used to being pampered and fussed over and now stuck in a miserable little box by the engine room, the irony finally caught up with us and we were soon laughing uncontrollably. The kind of 'fall on the floor and hold your guts' laughter that borders on hysteria. It was then that the head steward appeared. Looking at us collapsed on the cabin floor, David with his legs poking out into the corridor, he must have thought that this, indeed, was where we belonged. However, he gave us the sort of smile you might give the Queen had she just told you that you were terminally ill, and informed us that, due to a mix-up, the suite we should have got had been made available. I didn't care who was responsible for screwing up our booking, and I don't think David did either, but for the record he insisted on taking a couple of Polaroid photos. To make the scene as pathetic and as desperate as possible I donned a life jacket. The steward still had the half-arsed smile on his face as he led us back up top to where the nice folk stayed; the kind of folk who didn't roll around on floors and fuck about with life jackets.

Our first port of call was San Francisco. We had a few hours stopover before we had to return to the ship. David had arranged for us to meet up with the lovely Bette Midler who we'd met after her show at the Dorothy Chandler Pavilion in LA (Barry Manilow on keyboards) two days before. As you can imagine, Bette was wonderful company. She suggested we see singer/songwriter Kenny Rankin who was playing at a small venue in town. Not long after we had arrived and ordered a few beers, a comedian came on stage, with the boisterous audience receiving his act routinely rather than enthusiastically. Then Kenny Rankin came on and did a really sweet set. After an encore, he left the stage to the sounds of the boozed-up crowd hollering for more. Instead, back came the comedian and, in an act of near suicide, he launched into the very same routine he'd done an hour and a half earlier. That should have been the cue for us to leave but we were sitting right in front of the stage and it would have looked bad to take a walk right then. With great reluctance, along with our tenacious comic,

As we left the North Pacific for the south, the weather grew steadily warmer and by the time we reached Honolulu it was bright and sunny. Again, the record company had organised a sightseeing trip. We were greeted by a man and two pretty girls who placed garlands of sweet-smelling flowers around our necks.

Me and David onboard the 'Old Rancid' with some of the crew and a passenger we named 'Colonel Sanders'.

Me on the top bunk of our first cabin on the 'Old Rancid', before we moved to better quarters.

we suffered 20 painful, embarrassing minutes during which a bunch of inebriated smart arses in the audience joined in on all the punch lines.

Back on board, next it was Vancouver, Canada, a three-day journey from San Francisco. The record company had arranged for us to be driven around for a few hours on a sightseeing tour. It was the very antithesis of LA. The air was so clean and pure it made you dizzy, the vividness of the open country overwhelming. There were mountains and lakes of such lush greens and blues that no photograph could do them justice.

The last stages of the journey were the longest. From Vancouver it was two weeks to Japan with only one stop, halfway, in Hawaii. Back on board the Old Rancid, life was typically gentle. We would wander the ship, have a beer or two in one bar and wander off again to another, pop into the duty-free shop to browse through knickknacks and over-priced stuff you'd never normally look at, let alone buy, then off again past the hair stylists full of blue rinses and wash-and-blow dries for the thrill of afternoon tea – a feast of tea, coffee, sandwiches, cakes and biscuits – then a stroll around the deck where even shouted conversation was impossible above the wind and spray of the North Pacific. After such a busy day we would return to the

warmth and comfort of our quarters to read or take a nap. And then it was dinner. As we left the North Pacific for the south, the weather grew steadily warmer and by the time we reached Honolulu it was bright and sunny. Again, the record company had organised a sightseeing trip. We were greeted by a man and two pretty girls who placed garlands of sweet-smelling flowers around our necks. This is, apparently, par for the course in the Hawaiian Islands and nothing to get too excited about. Nonetheless, it's a most pleasant way to say 'hello', even if the couple of girls were, possibly, secretaries from RCA Hawaii. We left the port in an American automobile with our American-sounding driver, past American fast-food places and American supermarkets. The whole place seemed like a giant theme park devised by Disney. But once we left the town, the island's own identity revealed itself and it was beautiful. We were taken to a pineapple plantation. Unfortunately, I don't care much for pineapples owing to the fact that my mother used to force tinned chunks of them down my throat, laced with a quite horrible, sweet substance called Carnation Milk, also from a tin. I think she believed this would compensate for any possible fruit deprivation we kids may have suffered in the food rationing following the Second World War. The tour ended with a meal at an attractive restaurant with tables outside,

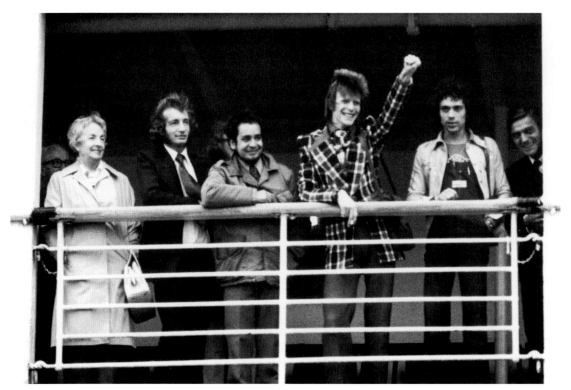

Me and David arriving in Yokohama, Japan, on 5 April 1973.

Walking into a wall of Japanese photographers when we arrived, I fired a shot off back.

A crowd greets David at Yokohama, Japan.

David & The Spiders about to board the bullet train in Japan, 1973.

David and Leee Black Childers (in tour shirt) with fans.

shaded with large umbrellas. The Hawaiian girl serving us was extremely pretty with long black hair and I was being quite cheeky to her and a bit flirty. She obviously had the measure of me and wasn't letting me get away with it, not entirely anyway. David stayed a neutral observer in our little game. And then something happened, so sweet, I'll never forget it. As we got up to leave and say our goodbyes the waitress shook hands with David and then turned towards me, put her hands on my shoulders, leant forward and gently kissed my cheek. It was so unexpected I could have melted. I felt like jumping ship, like Marlon Brando in *Mutiny on the Bounty*. In retrospect it probably wouldn't have worked out. I don't speak American and I'm not crazy about pineapples.

It was then another long haul of five or six days to Japan. Thinking about it now, we must have got on pretty well, the two of us, being that we were banged up for a two-week stretch. We filled our days as before, but from time to time decided to 'slum' it by spending the odd evening with the crew in their basic recreational quarters, which they referred to as 'The Pig', just like Kate Winslet in *Titanic* but without the dancing.

Somehow, we obtained a sound system so we could play the records we had acquired in New York, especially the Latin tunes we had discovered and fallen in love with in some of that city's music venues. It must have been pretty odd for the old dears on deck, performing their daily constitutionals with the sounds of Charlie or Eddie

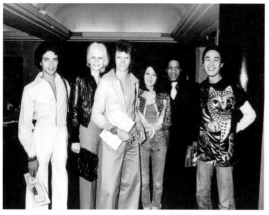

Leaving the Kabuki-za Theatre in Tokyo with Kansai Yamamoto.

Yamamoto's daughter and David's son, Duncan, 1973.

Palmieri, Celia Cruz, Ray Barretto, or the Fania All-Stars booming out from our suite. In quieter moments we tried to learn a few Japanese phrases from a little red book that I still have to this day – complete with David's scribblings in what also appears to be Japanese. The Berlitz World-wide Phrase Book is a must-buy item giving helpful phrases in 16 different languages. It's one of the most useful items I've ever possessed. One day, one of my daughters will borrow this book and lose it in Lithuania or somewhere and, for the first time, I shall cry openly in front of them.

Part of the excitement of going to Japan was, for me, knowing so little about its culture. Not knowing what to expect made the whole trip more magical. By the time we arrived in the port of Yokohama on 5 April, we were bubbling with anticipation.

ANOTHER WORLD
'So Far Away', Hank Jacobs, 1964

The first thing we saw when we started making our way to the harbour was a crowd of about 500 people waving banners. As we drew closer to the quayside, we could clearly see that they read 'Welcome David Bowie', and in the right-hand corner of each we could also clearly read the inevitable letters, 'RCA Records'. After much clanking and winching, it was time to set foot on the most foreign soil we'd ever trodden. I came down the stairs first with David somewhere behind me. When I reached the bottom, I walked into a wall of Japanese photographers. As if in defiance, I raised my puny Instamatic camera and courageously fired a shot off in their direction. And so ended the cruise; and then began Japan.

We were met by an official posse from RCA Japan. This brought an unexpected problem – when to start and stop bowing. My little red book was full of key phrases and sundry pleasantries, but it didn't tell us what to do when confronted by a person bowing profusely. It soon became clear that the team from Japan couldn't be beaten in a bowing contest. I made a mental note to write to the boys at Berlitz on my return. As we were driven to the Imperial Hotel, it was obvious that Tokyo was a very different proposition to LA. Crowds thronged the pavements, buildings threatened to swallow all remaining open spaces, cars crawled bumper to bumper at a snail's pace, posters and blinking neon signs battled for attention on every façade giving the city an incredible vibrancy.

The Imperial was in the heart of the Ginza district, facing Hibiya Park. With over 1,000 rooms – large, luxurious and with wonderful city views – its own shops, restaurants and health club, it was like a small village. The rest of the band joined us there when they flew in the next day.

Everyone was incredibly excited. It didn't feel like we were visiting another city or another country, but rather an entirely different planet. I ventured into the city with Trevor Bolder. I'm not a big lover of crowds and hitting the streets was daunting enough without Trevor's trademark hairstyle – short on top and long at the sides, with long bushy sideburns, all dyed black 'Kabuki' style – attracting the attention as it did. Initially, I felt vaguely panic-stricken amidst the teaming hordes but, after walking a couple of blocks, it felt like I was part of an organised chaos. There was a natural choreography to the moving masses.

One night, Kansai Yamamoto and his wife took David and I to see Kabuki theatre, traditional Japanese plays performed by *onnagata*, male actors who specialise in playing female roles. Visually, it's stunning. The actors wear spectacular costumes and are accompanied by singers and musicians dressed in gold and black, kneeling on tiers of red fabric, playing drums, flutes and plucked three-string instruments. It's a beautiful spectacle. However, after a couple of hours I found myself getting a little fidgety. Despite the eye feast, the music was challenging. The audible aspect is somewhat alien to the Western ear, initially. A flute, however it's played, always has a certain charm as it does in Kabuki, but some of the singing and the percussion... To get some idea of what it sounds like, take off your shoes, purse your lips as if saying 'coool', drop a bowling ball from waist height onto your feet, while erratically tapping a

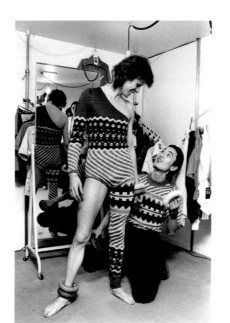

David with Kansai Yamamoto, 1973.

medium-sized saucepan. Add to this, if you can, the sound of someone who is tone deaf hurriedly tuning an old guitar and do all these things as quietly as possible.

It's always a great advantage to know residents of the places one visits, especially when you're experiencing a cultural shock in a place like Tokyo. The good folk at RCA were helpful, as ever, but it was the clothes designer Kansai Yamamoto who really made the city accessible to us. He was gracious enough to entertain us at his home and take us to various places of interest.

David was a big fan of Kansai Yamamoto's work, which he'd first seen in the summer of 1971. Kansai had a heavy influence on the Ziggy look: from the razor-cut hair dyed red to shaving off his eyebrows. David had been wearing Kansai's extraordinary creations on stage during the tour. The photo I'd taken in Chicago of David in the black pyjamas-type outfit has Kansai's name in gold braid on the front. Kansai had knocked up a few more to give him when we arrived in Tokyo and some of these were even more stunning than the original outfit. One featured several vivid colours on a white background, with snap fasteners that allowed the costume to be ripped off, Kabuki-style. Bowie incorporated it into the show by having his two stylists, Susie and Linda, dress top-to-toe in black, come onto the dark stage and rip the costume off a spot-lit Bowie. It was a great effect: Bowie the illusionist, the magician.

The shows in Tokyo went extremely well, despite the famed discipline of Japanese rock 'n' roll audiences. The crowd's appreciation seemed, at first, a little stifled and amounted simply to clapping. But David worked on them and by the end of most of the gigs the fans were, by Japanese standards, positively raucous.

While in Japan, I met a beautiful Chinese girl from Hong Kong. She didn't speak a word of English, but she did speak fluent Japanese. She would take me places that, as a foreigner, I would never have found alone. One feels extremely safe in Japan. Even when being led through Tokyo's back streets and alleys, you feel a calming sense of order and spirituality. In completely alien surroundings, inhaling strange aromas, eating food I'd never heard of let alone tasted, in dark, smoky restaurants with hardly any means of communication and relying solely on my small Chinese companion, I did feel vulnerable but strangely liberated too. As well as Tokyo, we went to Kobe, Osaka, Nagoya, and Hiroshima – the target of the first atomic bomb used in war. Our hotel there was situated next to a skeletal ruin – Genbaku Dome – that marks the epicentre of the explosion. It remains as a monument to those past deeds. The museum shows a man's shadow against a wall, frozen – or rather burnt – in time, and wristwatches fused at 8.15 on the morning of 5 August 1945. The Flame of Peace has burned continuously in the Peace Memorial Park since 1 August 1964, to be extinguished only when the last nuclear weapon on earth is destroyed.

David, the band and I travelled between cities by bullet train allowing us to see, if only in transit, Japan's beautiful countryside, the majestic, snow-capped Mount Fuji, the delicate, ornate details of the buildings and the men and women working in the rice fields. We returned to Tokyo for one last show on 20 April at the Shibuya Kokaido, and then the band flew back to England. David and I stayed on as we were taking a more complicated route home.

While in Tokyo, David also met a beautiful girl who was half Japanese, half French, and who had bright blue eyes. On our last night, David, Blue Eyes, my Chinese girlfriend and I shared a farewell traditional *haute cuisine* at a *kaiseki-ryōri* (multi-course meal) restaurant. We walked through a courtyard past a tree of wonderful, sweet-smelling blossom and were greeted like old friends by a diminutive old lady at the restaurant door. She showed us to our places, and we were served tiny, exquisite portions of food in porcelain and lacquerware bowls. Girls in kimonos glided gracefully here and there bringing more and more delicacies. I looked at David and he was deep in thought. I knew he was trying to think of different angles, some plan, that would allow us to stay in Japan, but there was no way. We had a date with a Russian ship at the port of Yokohama.

> **We returned to Tokyo for one last show on 20 April at the Shibuya Kokaido, and then the band flew back to England. David and I stayed on as we were taking a more complicated route home.**

Bright coloured blossom hanging over
 the sidewalk
Doesn't matter if it's made of paper
All that's important is you still remember
When the blossom has been swept away.

'China Town', lyrics by Geoff MacCormack from the album *Praise*, released by WEA, 1992.

Above and right: Sightseeing in Japan, 1973.

The Spiders on the tour bus, Japan.

Mick 'Woody' Woodmansey asleep on the tour bus, Japan.

Genbaku Dome in Hiroshima Peace Memorial Park.

The Kabuki program from our visit to the theatre.

ALIENS IN THE SOVIET UNION

(1973)

The *Felix Dzerzhinsky*.

Me and David on the *Felix Dzerzhinsky*, signing autographs.

Our travel itinerary from Japan back to London via Russia.

'Many Rivers to Cross', Jimmy Cliff, 1969

'Truly haunting.'

Of course, David and I weren't going home by plane. Instead, we were continuing westward to catch the Trans-Siberian Railway to travel across Asia and back to Europe. That meant getting to Siberia first.

We sailed from Yokohama to a port in Russia called Nakhodka, just up the coast from Vladivostok, which, at that time, was a military port with limited access as it wasn't deemed a suitable sight for foreign eyes. We undertook the two-night journey on a small ship owned by the Soviet Far East Line called the *Felix Dzerzhinsky*. The ship's designers had gone for practicality over luxury. Our accommodation comprised two separate cabins with a bathroom in each and single beds built into the wardrobes. On board

we had our first contact with Russians. The crew were mostly young and friendly, and all were fascinated with David. They must have realised he was a musician because he boarded the ship carrying an acoustic guitar.

As soon as we got on board, we deposited our luggage and headed for the bar, pulled up some stools and ordered some beers. Just as we were taking our first sips, we noticed two men who had already made one attempt to make conversation with us and were going to have another try. David and I were usually uncommonly gregarious folk, but there was something odd about these two. One got used to meeting people on tour and, though they come in all shapes and sizes, you can usually tell if they're fans or simply nice friendly people. These guys weren't the genuine item. In their mid-thirties, they wore short, neat haircuts, Ivy League suits, and button-down shirts. They were also nodding and grinning

66

David's impromptu performance on the *Felix Dzerzhinsky*.

like two long-lost pals. We tried to vibe them off, but it was no use. They barged into our conversation and began what they presumably thought would pass as general chit-chat. To us, it seemed more like an interrogation. They asked us what we were doing in Russia, where we were going and why, who we knew there, and what we thought of the USA? We answered with courteous one-liners while they droned on in American accents, smiling in as friendly a way as they could manage. When they enquired as to our political leanings, we excused ourselves and walked away, utterly convinced we had met our first spies. 'Which side do you think?' David asked. 'KGB,' I said. 'They didn't have a clue who you were.'

After dinner we watched a show of traditional Russian music and dance. It was performed by members of the crew who simply changed out of their smart black sailor's uniforms into more

traditional, colourful garb. The audience was mainly European and Japanese, and David had to sign a few autographs. The crew really got stuck in. They all looked really athletic, kicking out their long boots and shouting 'Hi!' every now and then. The girls twirled like dervishes; various singers took turns doing their thing and balalaikas were strummed. I looked around to find David and he wasn't there. 'That's odd,' I thought. I knew these guys were amateurs, but they weren't all that bad, and I thought we should embrace the spirit of détente and all that ...

Then he reappeared carrying a guitar case and my bongos. If the crew must sing for their supper, then so must we; what a trouper, what communal spirit. It was a great way to enter the USSR, as instant comrades. Our spy buddies had disappeared, but I was sure they were still watching us. I hoped they were making notes regarding our model socialist behaviour. The

KHABAROVSK - TIKHOOKEANSK

crew was obviously delighted that David was going to do a turn and happily turned the stage over to him. He strummed his guitar and I tapped away on my bongos. I felt as redundant as Mickey Finn of T. Rex, if not as good looking. When David strummed the familiar opening chords of 'Space Oddity', I decided to re-join the audience. The song went down a storm with the European and Japanese tourists. Then, presumably to convince the Russians he was a soul mate and to include them in the occasion, he performed 'Amsterdam' – a good old sailor's tune. We spent the rest of the evening drinking with our new Russian friends who wanted to know all they could about music and art in the West. It was the small hours of the morning when I said my good nights. I left David with the prettiest of the Russian girls whom he'd managed to completely captivate. Nice one, Dave.

Many years later, in 2002, David contacted me regarding a book he'd been reading about Stalinist Russia. The book described the gulags in Siberia and the people who had been transported there in their thousands, in the worst conditions imaginable. The book named one of the ships involved: The *Felix Dzerzhinsky*.

TRANS-SIBERIAN EXPRESS
'Station to Station', David Bowie, 1976

We arrived in Nakhodka in the evening. The short walk from the ship to the train was not an occasion that has stuck in my mind. The train, however, was memorable. On first sight it was encouraging. On entering we were dragged back to the time of the czars with dark wood panelling, brass fittings and tasselled décor, which made each car look like the interior of a Parisian brothel (I mean to say, how I imagine a Parisian brothel to look like in 1900). Dinner passed well, except for an odd little incident when David tried to give a book on Japanese Modern art to a fellow traveller. The Russian intellectual looked furtively around him and explained, in a conspiratorial manner, that he couldn't be seen to be accepting any books in case they were banned. An arrangement was made to send the book to him by post anonymously.

Although some of our books were banned, the authorities gave us plenty of their own approved material to read, and quite openly. One, a book titled *Marx, Engels, Lenin: On Scientific Communism*, I have to this day. We also received

Leee Black Childers on the Tran-Siberian Railway, April 1973.

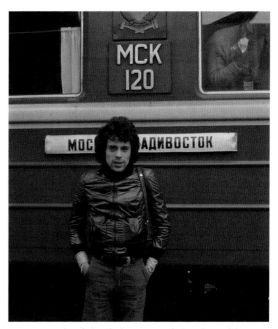

David took this dodgy picture of me in front of the train.

a set of guidelines on what we could and, more specifically, could not photograph, as well as various other propaganda leaflets which I didn't keep, and now wish I had. The one I remember most vividly was a searing condemnation of the cartoon characters Tom and Jerry. The pamphlet quoted a leading American psychiatrist who claimed the duo's act was sick, degrading and a threat to children's moral development. The article went on to explain that Edward Heath, then Prime Minister of the United Kingdom, was a huge admirer of the cartoons and had private showings at Chequers, his weekend home.

It wasn't until we awoke from our first night on the train that we discovered we weren't on the Trans-Siberian Express after all, but on the boat train that travels 564 miles to meet it at the Far Eastern city of Khabarovsk. The Trans-Siberian Railway runs nearly 6,000 miles from Nakhodka on the Pacific coast of Siberia to Moscow, the full journey taking about seven long days.

We were joined throughout the rest of the train journey from Khabarovsk to Moscow by photographer Leee Black Childers and a very amicable middle-aged American gentleman named Bob Musel. Bob was the Moscow correspondent for the United Press International news agency and had been assigned to cover our journey. Naturally he knew Moscow well and offered to show us around when we got there. Bizarrely, Bob had also written the (English) lyrics for a cheesy little song titled 'Poppa Piccolino', which went to number 2 in the UK charts in 1953.

The train's route took in some spectacular scenery – huge lakes, rivers and forests of silver birch. On leaving Khabarovsk, we crossed the Amur River, which runs almost adjacent to the Chinese border; the bridge that crosses it is the longest on the entire Trans-Siberian route – 2,612 metres. David had acquired a Canon Super 8 film camera in Tokyo, while I had purchased a still camera, trade, through photographer Masayoshi Sukita. My camera, a Nikkormat, was recommended, quite correctly, by Sukita as a quality semi-pro starter unit. Apart from a scrappy shot of David's first Russian 'concert' on the ship from Japan, the first picture I remember taking was the black-and-white image of David in front of the train with the Russian emblem above his head; a shot that I have included in my limited-edition David Bowie collection of prints. I either have, or had, a natural

One of my snapshots of a Russian train.

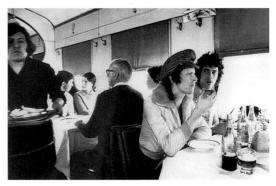
Me and David in the restaurant of the overnight boat-train.

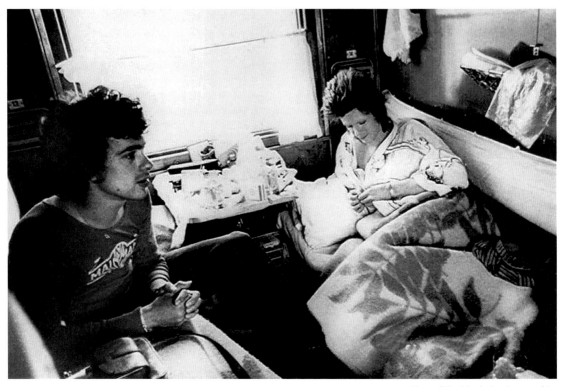
Me and David relaxing in our cabin.

ability at photography or I simply lucked out when I took this shot – to this day, my personal jury is still out! David, by nature of choosing a more complicated piece of equipment, had a somewhat less fortunate result with filming. However, having sat on his footage for a couple of years after he'd sent it to me, I realised that on many occasions we had recorded some of the same events along the journey. For example, when I took a snap of a bunch of kids on a station platform (one of my favourite shots), David had filmed the episode.

When I edited the film and my stills together, the result was complementary to the degree of being almost two halves of a whole. I now show the film, on occasion, when I exhibit my collection.

The actual Trans-Siberian Express train was drab and bland, and it certainly had more than its fair share of Formica. Even though we were in soft class – the Far Eastern version of first class – with our own compartments, washing facilities were thin on the ground. But we were aware that

we were travelling in supreme luxury compared to others; while we had clean bedding, the 'hard class' passengers seemed to sleep on the floor, in corridors, or wherever they could find space. For the first couple of days, the food in the dining car was quite palatable – mainly beefsteak or chicken fried in breadcrumbs. But we soon began to notice that at most of the stops more food was leaving the train than was being loaded on. The stops were fairly remote and isolated regions and the people of these poor towns and villages used the train as a visiting supermarket – a 'meals on wheels', or 'snacks on tracks' – buying up tins of this and that and selling back stuff like eggs and yoghurt. As such, the meals deteriorated as we went along and stock got pretty low – there are, after all, 79 stops between Khabarovsk and Moscow. Trying to buy your own food from outside the train was even riskier than braving the dining car. For the sophisticated palate, choice was limited unless one had a hankering for runny yoghurt. By the time you identified what it was you were buying and paid for it in a currency beyond ones understanding, the train driver could well have decided it was time to move on. Once, caught up in the complications of a transaction, I looked up

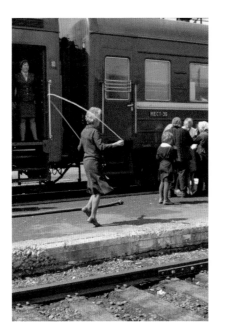

The Skipping Lady!

to see the great train slowly sliding off without me. I threw a handful of roubles to a delighted, and perhaps not-so-stupid Siberian stall holder, and rushed alongside a now quite fast-moving train. I negotiated the door handle and jumped on, still clutching a bottle of rancid Siberian yoghurt bought for David. The very thought of

being stuck with no ID in the wastelands of the USSR in 1973 still fills me with panic, even after all these years.

Upon our departure from Japan, a fan had given David a giant teddy bear. Not wishing to offend either bear or fan, he had brought it along with us. The soft class carriages all had female attendants and one of ours was a rather dour lady named Danya or Donya who could have been anything between 20 and 40 years of age, it was hard to tell. At the end of our carriage was a huge, permanently steaming samovar – an urn used for heating water – from which she would endlessly make glass after glass of tea served in an ornate metal holder. Whenever she placed these glasses in their holders and brought them to us, we would smile and say, 'thank you' in Russian, but we never got much reaction. Then Bowie had the idea of giving her the teddy bear. It was a wonderful pleasure to see how such a simple gift transformed her as she beamed with joy, and it occurred to us that maybe nobody had ever given her a present such as this before. Maybe not even her parents. At any rate, from that moment on she was our mate, as good as gold and always with a nice smile for us. In total contrast to our Russian attendant, was the eccentric 60-year-old English lady a few carriages down. She was very 'home counties', a stiff-upper-lip Brit. At every station we stopped at she would take a rope from her bag, find a clear spot on the platform and, with true die-hard British spirit, start skipping with complete abandonment.

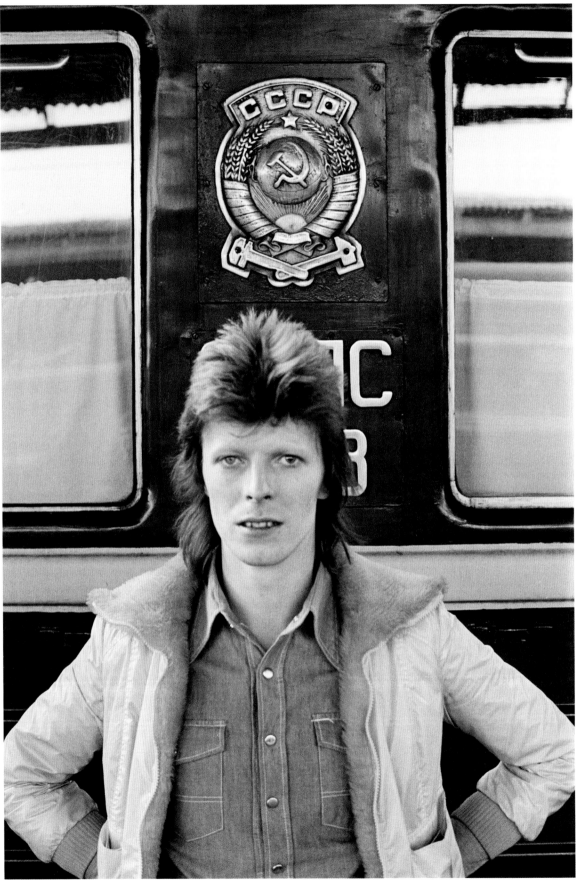

The first picture I remember taking in Russia!

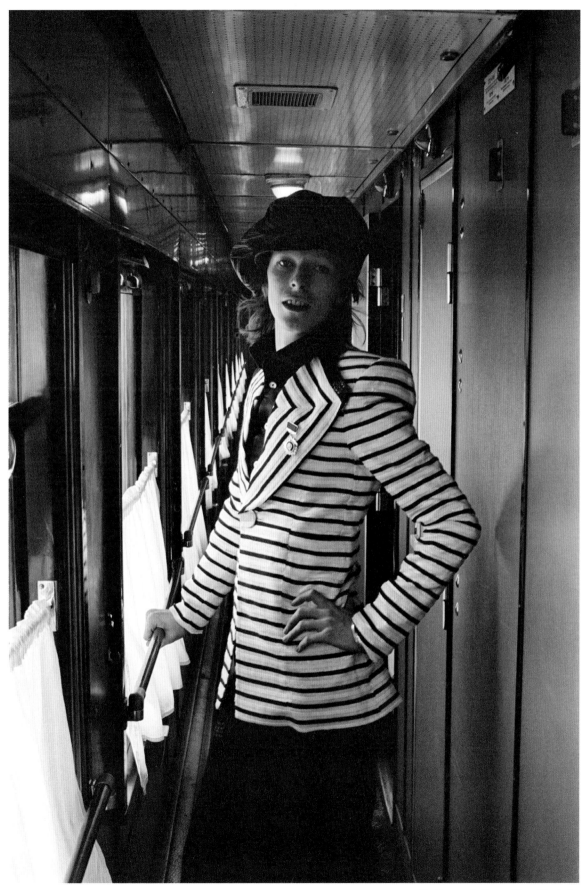

David poses in the corridor of the train.

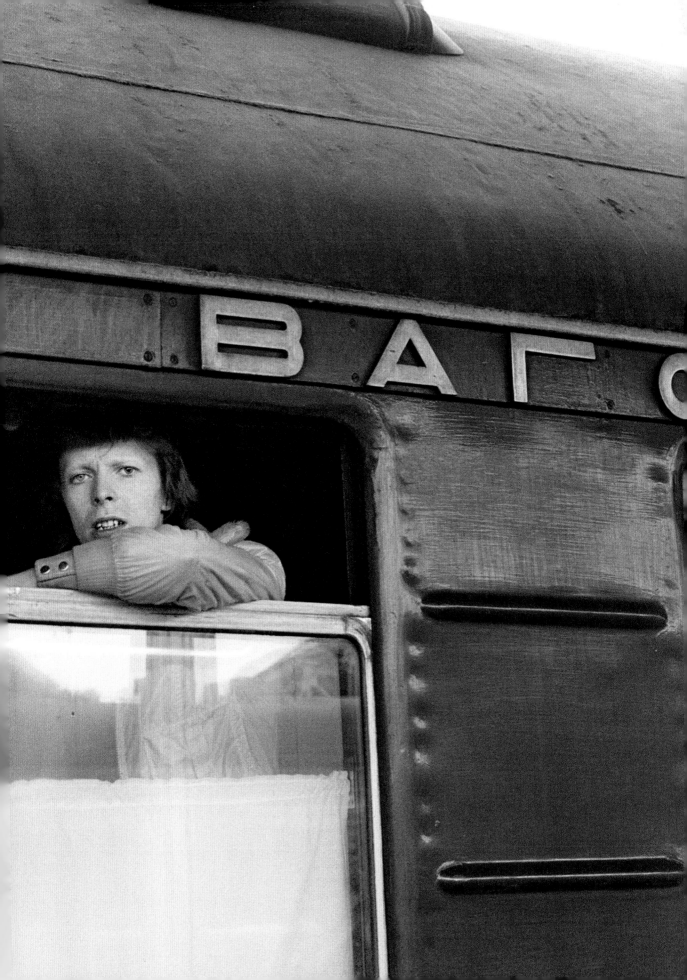

Life going on beside the train track in Russia.

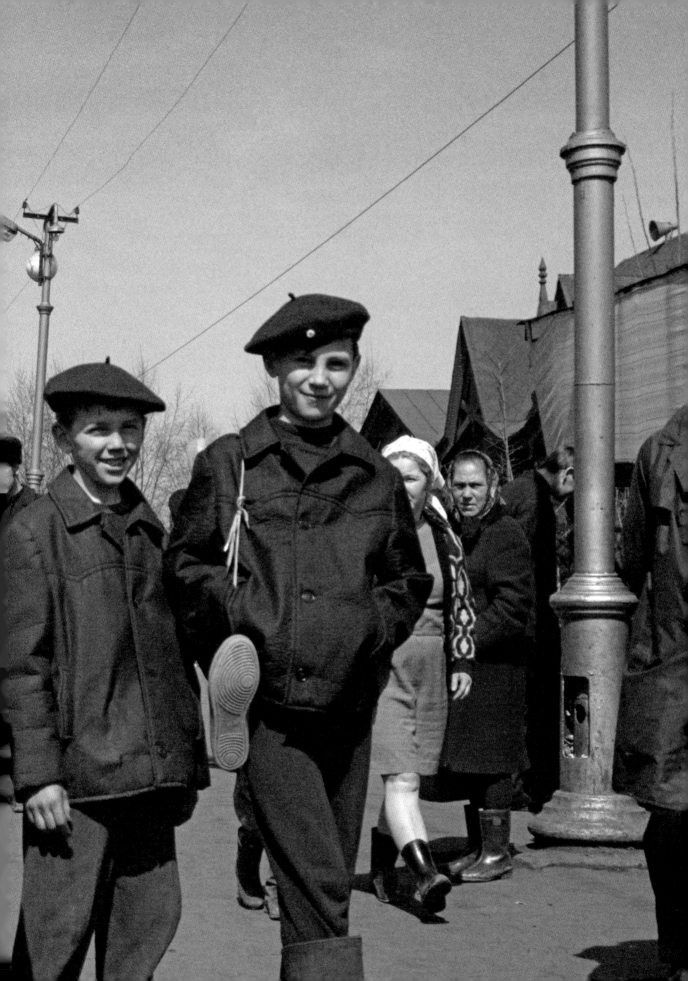

Above and opposite page: Me and David on the Trans-Siberian Express.

We travelled through the perimeters of the Gobi Desert and stopped at a place called Yablonovy There we picked up an extra engine for the steep climb through the Yablonovy Mountains, where the route reaches over 4,000 feet above sea level – or approximately 1,200 metres if there were Europeans back on board. In the mountains the temperature drops dramatically and the stops are at places with equally dramatic names: Mogzon, Petrovsky Zavod and Ulan-Ude. At Ulan-Ude, there's a fork in the line coming from Moscow where the Trans-Manchurian Railway heads south towards China and, ultimately, Beijing. It is also where the train changes from steam to electric traction. Next, we skirted the enormous expanse of water that is Lake Baikal, the world's biggest, deepest lake and the largest volume of fresh water on earth, holding roughly 20 per cent of the world's fresh water. It's 395 miles long, nearly 50 miles wide,

and over a mile deep. It's big. Just a bit bigger than Belgium. After Lake Baikal, we arrived in Irkutsk which was established as a fur-trading post in the 17th century. Due to its isolation, Tsar Nicholas I sent many artists, intellectuals and noblemen into exile there during the early 19th century. It was also the home of the missionary priest Ivan Veniaminov who is better known as St. Innocent. Most importantly, as far as we were concerned, it was also the first stop since Vladivostok where the dining carriage was to be re-stocked.

At one point on our journey the train hosted a crowd of young soldiers and we spent a few evenings drinking with them. The choice of booze was, like the food, limited but we did what we could with beer pee-vuh (as it is pronounced phonetically in Russian), Romanian Riesling and vodka. The soldiers' uniforms were incredibly

shabby and we gathered, through drunken broken English and gesticulation, that they were in construction units. In simple terms they were poorly paid state navvies. They were all between 17 and 25 years old and, even though their clothes were tatty, they looked well fed and in good spirits. The only thing they were starved of was information about England and the West. One night David got the guitar out and sang a few tunes for whoever was around. I think I must have got a little stuck into the vodka as I can't remember what was sung or to whom.

By day six, the scenery had mostly returned to forests of silver birch, which got quite boring to be honest. Although, one bright night we looked out the window to see a very large, very fit-looking Siberian wolf running alongside the train and through the forest. It was an incredibly eerie sight.

Day seven – the penultimate of the journey – took us from Sverdlovsk, through the Urals, to Kirov. The Ural Mountains mark the division point between Europe and Asia, and the Ural area is Russia's industrial heartland and thus the most polluted region in the country. Still, from Kirov, Moscow is a mere one day's travel, 600 miles southwest across north Russia. To celebrate our last night on board, we held an impromptu party in our compartment. Mainly, we were celebrating the fact that we never had to look at a silver birch tree again. As well as the nasty Romanian Riesling and pee-vuh, which we were just about getting used to, we shared a can of French Beaujolais supplied by a couple of Parisian students, François and Olivia. We solemnly sipped the wine, smoked my last Gitanes cigarette between the four us and spoke lovingly of Paris. All of us were looking forward to arriving in Moscow the following day.

View from Hotel Intourist on Tverskaya Street in Moscow.

TACKLING MOSCOW
'Moonage Daydream', David Bowie & The Spiders from Mars, 1971

When we reached the end of the line at Yaroslavsky station in Moscow, we immediately made our way to the rather ugly Hotel Intourist on Tverskaya Street. The train's scant washing facilities had left us in dire need of a good bath, and we decided to follow that with a good shave at the hotel's ground-floor barbershop. The barber, a very large lady, took the notion of a close shave to the very extreme. For her, drawing blood was a handy way of saying that she'd finished with that particular patch and could move on to another. When my whole face was red, she knew the job was done. One might have thought her a sadist, but she seemed to derive no pleasure at all from her torture. The whole grisly act of planing the skin from my face was performed with a deadpan expression. I decided to stick to electric razors from then on and leave cut-throat razors to real men.

After our close shave, we met up with Bob Musel and Leee who, with his dyed blond hair and golden snakeskin boots, gave David a run for his money. We went for a stroll in the city Bob knew well, quickly realising that we were every inch the freakiest show in town. Presumably, in an attempt to tone down the impact of his bright red hair, David wore a blindingly luminous yellow zip-up jacket, a bright yellow scarf, orange trousers, three-inch heels, and a camp, floppy hat. I was his poor understudy in a dark-blue version of his jacket and a mere two-inches of heel, though my boots were bright red. Bob looked like any smart businessman in any big city in the world, which made our trio seem even more surreal. Everywhere we went people stared in amazement, but few had the courage to approach us. Those who did were mainly kids, asking for chewing gum and giving us badges with patriotic Russian designs on them.

The three of us visited the Kremlin and, arriving at an impressively ornate underground station, we caught a train to Red Square and Moscow's premier department store, GUM. I wasn't expecting Harrods or Bloomingdales but, still, GUM was a major let down. It looked a bit like London's famous Crystal Palace, after it had burned down. There was nothing to buy, at least nothing you'd ever want. I ended up purchasing a hand puppet which I still have.

We must have been mad with hunger because, if my memory serves me, we tried eating something from the GUM cafeteria. Presented with their fare, our reaction was on a par with Joan Crawford's when Bette Davis served her a dead rat in *Whatever Happened to Baby Jane?* We decided to make use of Bob's local knowledge and, with a fistful of American dollars, he led

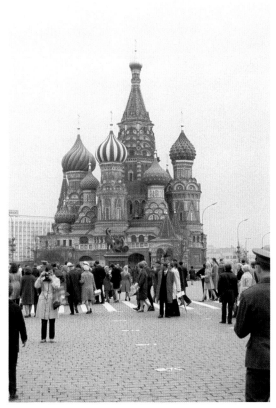

St Basils in Moscow.

us to the National Hotel. The restaurant at the National was exactly what we wanted to see: oak panelling, white tablecloths, waitresses dressed in black with crisp white aprons, and wine waiters looking like wine waiters with serviettes draped over forearms. We could have been in an old London gentleman's club, or a Fleet Street dining room. It was the perfect antidote for our limited diet over the last week. Without hesitation, we ordered caviar followed by fresh fish, while Bob chose some wonderful wines. Everything was set for the meal of a lifetime when, suddenly and without warning, our waitress put her coat on, wrapped a scarf around her neck and rushed out of the restaurant. David and I wondered what we'd done to make her desert us so, until Bob pointed out that caviar was off the menu and she had been sent to find more. Bob said he's never seen two such skinny guys eat so much, so quickly.

We only had two days in Moscow and our second was mostly spent watching the great May Day Parade. Column after column of soldiers marched with robotic precision through Red Square, along with girls in national dress. Red banners waved everywhere you looked, some bearing the hammer and sickle, others with pictures of Lenin, Marx and current Communist Party bigwigs. We watched some of the parade from the vantage point of our hotel. An odd fact about communist-era Russian hotels – at least the Hotel Intourist in 1973, which I assume wasn't unique – was that on each floor, just by the elevators, there was a lady attendant sitting at a desk. I could fathom no earthly reason why one would sit there all day waiting for the elevator door to open so you could watch people walk a few measly paces to their rooms; it must have been one of the most joyless jobs imaginable. And so, I think

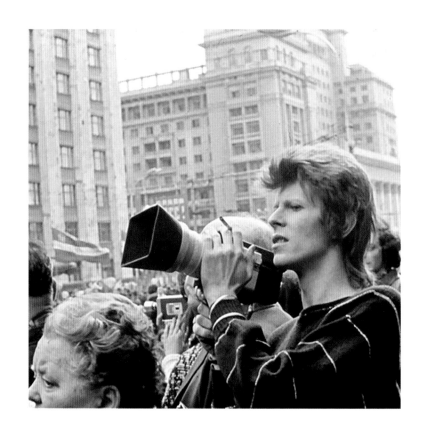

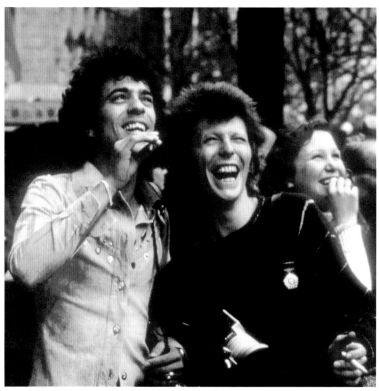

Above and top: At the May Day Parade in Moscow.

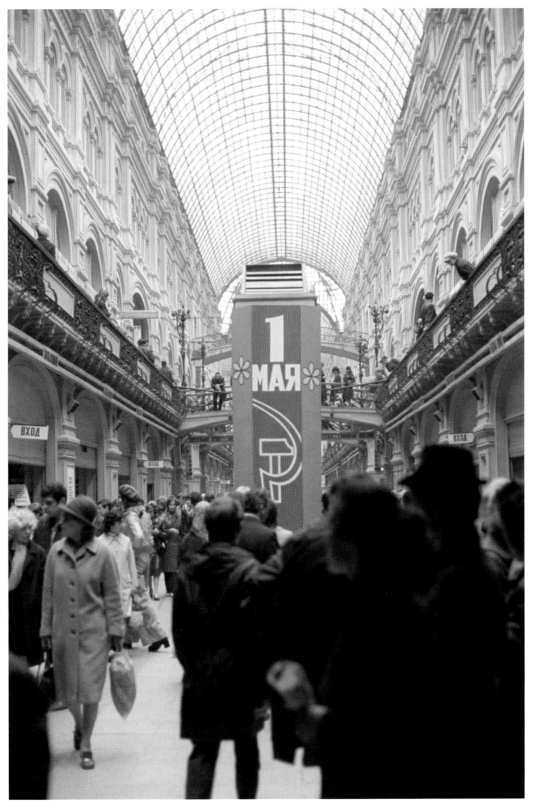

David in yellow attire (bottom left) at GUM department store, Moscow.

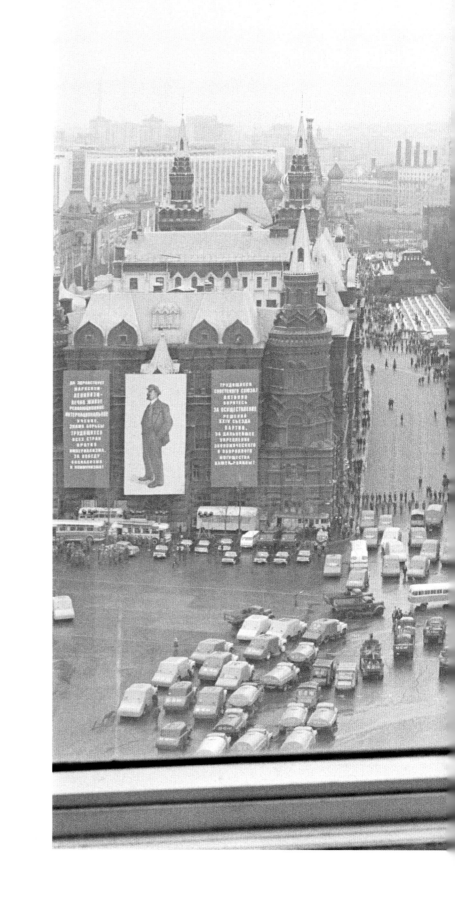

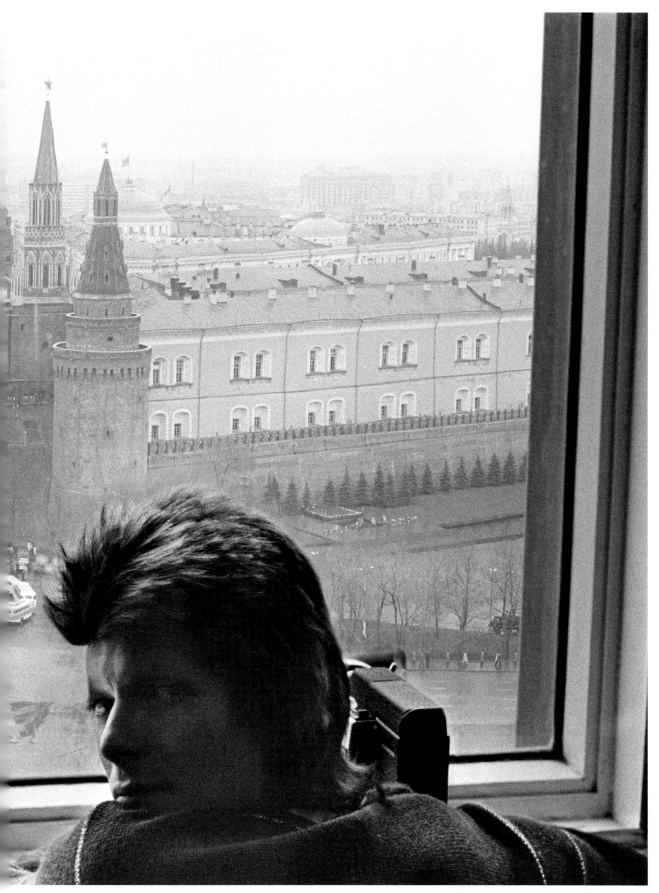

David surreptitiously filming the May Day Parade from Hotel Intourist.

David with Bob Musel in the hotel restaurant.

The dodgy Hotel Intourist
band playing Muzak.

David and Leee Black Childers in the hotel restaurant.

Bowie and I may have provided our particular attendant's career highlight when we decided to film the May Day Parade from the window at the end of our corridor. She watched us like she was privy to the first sighting of aliens from Mars.

The parade had us pretty much trapped at the Intourist all day. The streets were too crowded to move through, and you couldn't cross a road for fear of being trampled underfoot or shot for the capitalist crime of jaywalking, so we decided to have dinner in the hotel restaurant. We dined with Bob Musel and Leee Black Childers, to the accompaniment of a six-piece band. On the Trans-Siberian Express, presumably to reassure travellers that Russians were groovy people too, a tape of pure Muzak of not-so-modern pop classics covered by Russian musos was piped through the train's speakers. Every time the tape looped round to one particular Beatles' tune, David and I would join in, mimicking the Russians by singing: 'Desmond says to Molly, gull I lick ya fass...'. It was bad enough on the Trans-Siberian Express, but the Hotel Intourist had clearly hired the band behind the criminal recording. I've no idea why but I took a photograph of the band and I've no recollection of what we ate that night, only that it came with copious bottles of wine and lethal, throat-burning Russian cigarettes.

We had adopted the latter to replace our usual Gitanes. Only one-third of each contained tobacco which was dry and dark, while the other two-thirds consisted of a hollow cardboard tube. The idea was that you pinched the tube together twice, in opposite directions, to create some kind of filter. Unsurprisingly, this didn't work too efficiently and, along with clouds of hot rancid smoke, one would ingest strands of nicotine-sodden tobacco or, worse, burning hot embers. To smoke this stuff, you really had to want to smoke.

FROM EAST TO WEST
'Riot', Pussy Riot (featuring IXXF), 2020

After two days in the crappy Hotel Intourist, we finally left Moscow from the Belorussky station. A two-day train journey would take us through the rest of Mother Russia, Belarus, Poland, Germany (East and West), Belgium and France to, finally, Paris.

Our compartment was clean, if a little smaller, than that on the Trans-Siberian Express. But facing all the restrictions of train travel yet again rather felt like we'd returned to prison following a weekend's leave for good behaviour. The world as we knew it was now but a couple of days away, and surprisingly there was real food in the dining car.

This time around, our attendant was male, middle-aged and scruffy with rotten teeth. We assumed he was Russian, but we never found out for sure because he never really uttered anything that resembled language. He would simply shuffle around rather unsteadily, grunt a bit, offer us an expression stuck somewhere between a gurn and a grimace, and shuffle off again. Still, we took the gurning to be friendly enough and generally just ignored him. Thus far, the only colour the Russian countryside had offered us was a drab grey, punctuated by the occasional red of a Soviet flag. Ironically, the only brightly coloured signs of life were offered by the graveyards. Each grave would be surrounded by a little picket fence with each picket painted in a different colour: blue, yellow or red. There was a sense of liberation about them. In a macabre sort of way, the graveyard was the best party in town.

Once the train had entered Poland, the landscape changed and we suddenly realised what we'd been missing. Advertising. The view was still one of ploughs and horse-drawn carts, but every now and then you'd see it: a sign bearing the words 'Coca Cola'. I never thought I'd be so glad to see one. It meant we were heading home.

With only hours to go before we were due to arrive in Berlin, something strange was happening to our mutant attendant. Instead of shuffling, he was now lurching around and his general behaviour was becoming unpredictable. With great frequency he would throw back the door of our compartment and shout something that sounded like, 'Pose all John!' At one point he got quite nasty and tried to physically pull us out of our compartment, so we locked ourselves in which really pissed him off. He went completely ballistic and began ramming his body against the door, all the time shouting, 'Pose all John!' Had this been happening in daylight it would have been scary enough, but we happened to be travelling at four miles an hour through East Berlin at the dead of night. We had a lunatic outside the door and the none-too-hospitable backdrop of Soviet-controlled East Germany on the other side of the window. Between these two unappealing prospects were me and a decadent Western 'rock star' with bright orange hair.

The mutant attendant wouldn't give up and as the door of the compartment began to splinter, we were forced to put our own puny body weight behind it in an attempt to keep the maniac at bay. Then, quite suddenly, it stopped. The door ceased caving in, there was no more shouting and all was still. The train had also stopped. Looking out of the window we realised we were at the last checkpoint; I looked at David expecting him to be white and shaken. I was wrong. It might have been the light in the compartment, but he was more of a dull-green colour and shaken and, judging by his reaction, I must have looked the same. If this had happened in London or even New York we would have been able to deal with it better, but we knew we were on the mutant attendant's turf now; this was the maniac's manor and as drunk and crazy as he was, the East Berlin police or whoever he was summoning would be on his side. Eventually there was a sharp, efficient rap on the door. We both knew that this was the time to open the door and face the consequences of whatever the problem was. Upon doing so, it was with some slight relief that we saw a woman. Okay, she was flanked by two mean-looking guys in trench coats and she was certainly no Audrey Hepburn; if she had any hobbies, it probably wasn't flower arranging or dancing but more like hammer throwing or head butting. But a woman it was, and this gave us hope that we might, miraculously, find her soft side.

'Passport', she demanded, and with much nervous fumbling, we delivered. Feeling more

confident, I decided to explain the mutant attendant's behaviour through the medium of mime: raising an imaginary bottle to my lips, I rolled my eyes and swayed in a manner to convey drunkenness while pointing to the still dribbling and snorting attendant who was hovering in the background. The woman's face was as hard and taught as her leather coat and showed nothing but contempt for us. 'VISAS!' she spat. David and I looked at each other; not with a 'have you got the visas or have I' look but a 'Shit! We don't have visas!' look. We stalled for time by pretending to search for them, then went straight to plan 'B' – holding our hand out, palms up, while looking as pathetic as possible. The woman, the trench coats and the mutant fell into deep consultation while David and I wondered what kind of visas the office back in London had missed, and exactly how long said visas might take to acquire? There was also the bigger problem of what would happen to us in the interim. Then one of the trench coats produced a book of papers, stamped them and handed them to us. Clearly pathetic had worked; we felt we could almost read their thoughts: 'Why should East Germany be saddled with these two degenerates? Let the West have them'. Momentarily we were elated, but then they motioned us to gather our belongings and follow them. Our hearts sank again. Were we to be arrested and charged with some heinous crime against the state? Would we be incarcerated with dangerous criminals who would instantly loathe us for our prissy decadent Western ways and who would then act out their loathing in beyond-despicable acts against us before we were shipped off back east to the Siberian wastes from whence we'd come? Thankfully not.

At last, the train rumbled off at a snail's pace through the no-man's land that divided East from West. This was quite the gloomiest site we had ever witnessed.

We were led into the corridor of the train and told to stay there and not move. Then a Second World War movie played out, which was both frightening and farcical, with over-the-top hammy actors. Two East German soldiers boarded the train with peaked caps and jackboots (the director's motivational talk must have been 'play scary SS officers and then some'). They opened the toilet doors by kicking them in with their shiny boots, machine guns pointed at the ready. I mentally thanked the leather-coated woman and her fellow 'secret-service agents' for liberating us from the compartment as heaven knows what these guys would have made of two alien freaks cowering in the corner. One of them came over to us and snatched our passports and papers from our hands, scrutinised them like they were definitely fake, then stared at us intently in a way that said, 'I fucking hate you' and returned them with an extra dose of malice.

At last, the train rumbled off at a snail's pace through the no-man's land that divided East from West. This was quite the gloomiest site we had ever witnessed. Through the darkness we could just pick out the bombed-out ruins of a life before, half-demolished black windowless buildings with the night sky seeping through the cracks and doorframes. The eerie silence made them unlike the ruined houses we'd played in as kids in 1950s' London. As this scene played out before us and the other passengers, everyone was silent. In time, we became aware of city lights growing brighter and brighter from the gloom. Then, suddenly, everything changed. We were pulling into the station at West Berlin, and everything felt normal again, familiar even. David pulled the window down and stuck his head out. I don't know if he wanted to see what was going

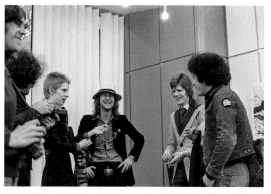

Barrie Wentzell, Roy Hollingworth and Charles Shaar Murray with David at the Gare du Nord, Paris.

The hovercraft we took from Port Boulogne to Dover.

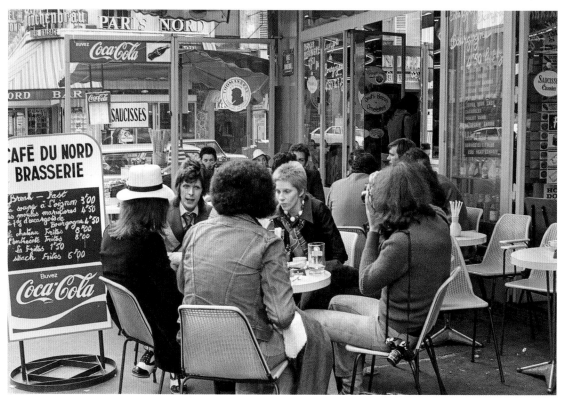

Brasserie outside the station where David bought the journalists a beer.

Fans waiting for David's arrival at Charing Cross Station in London.

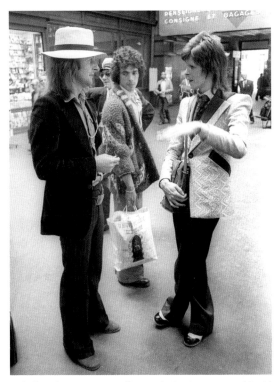

Melody Maker writer Roy Hollingworth chatting to me and David at Gare du Nord in Paris.

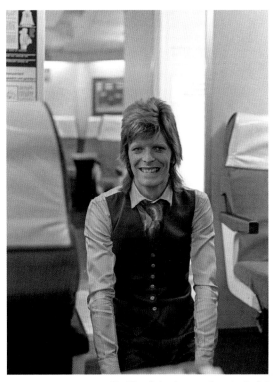

David realising hovercrafts actually fly!

on or if he needed some fresh air to blow away the memory of the stiflingly depressing scenes we'd just travelled through. Almost immediately he turned back to me with a huge grin on his face. 'Have a look at this,' he said. I looked along the platform and there, under the station's bright lights, stood 15 or 20 Ziggy fans, some with painted faces and others with sequins and feather boas. But all expressive, all free. We were almost home.

Whether it was the mental trauma of our journey from East to West, or simply that the journey from Berlin onwards was not particularly eventful, but I've no memory of the rest of the trip, up to checking into a huge suite at the Hotel George V in Paris with Bowie. I remember clearly David and I, for some reason, being unable to sit in the hotel's sumptuous chairs for more than two minutes without getting up and pacing around. And I remember Angie, who'd come to Paris to meet us, barking orders for fine wine, food and fruit in perfect French to a host of waiters,

bellhops and managerial staff. After a diet of cabbage soup and yoghurt, I guess we weren't quite ready for the high life.

After travelling over 7,000 miles, we predictably missed the boat train at Gare du Nord that was to take us to Calais, so another plan was hatched to get us across the channel by hovercraft. *Melody Maker* writer Roy Hollingworth, *New Musical Express* writer Charles Shaar Murray and photographer Barrie Wentzell had joined us for the journey back, so to kill time we all slipped into the nearest Brasserie for a beer.

We took a train from Gare du Nord to Port Boulogne where we boarded the hovercraft back to Dover. When someone pointed out that a hovercraft literally hovers over the surface of the water – that in essence it flies – David became very nervous. On reaching Dover, we faced yet another train journey on to Charing Cross Station in London. And so it was, we were back home and back to work, greeted by a chaos of screaming girls.

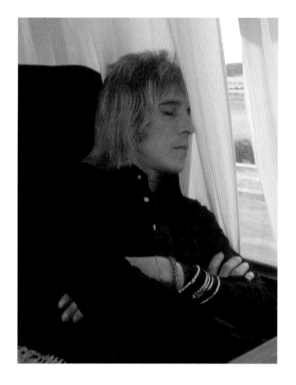

Mick Ronson (left) and Mike Garson asleep on the UK Tour bus.

UK Tour and Pin-ups (1973)

'Que Sera, Sera (Whatever Will Be, Will Be)',
The High Keys, 1964

'Take a twee little song and turn it into a Latin flavoured raucous Gem!'

The British tour of 1973 started badly in May of that year. We began by playing Earl's Court in London, but the sound wasn't up to the size of the venue. It was like playing in an aircraft hangar with bad acoustics. None of us were particularly aware of the problem until we read the bad reviews later. After Earl's Court we went to Scotland, and from then on the tour was great. The gigs were all much smaller, and all sold out – two shows at the Aberdeen Music Hall, one at the Caird Hall in Dundee, two at Green's Playhouse in Glasgow and one more at the Empire Theatre in Edinburgh.

The great thing about touring is that you get to go to places you've never been to before. The lousy thing about touring is that you don't really get any time to see them. Bearing in mind the logistical effort of performing at 40 venues in 50 days, including 16 matinee performances, it's not

The band pose in front of the UK Tour bus. L–R: Mick Ronson, Mike Garson, Funky Fordham, my friend Sharmaine, June and Woody Woodmansey, me, Trevor Boulder and family.

surprising that my memory is somewhat blurry and short on details. I remember that Edinburgh had a nice castle, and that Torquay was very warm and the hotel had a great swimming pool. At the Brighton Dome, Hutch and I went for a pint in the pub next door before the show, dressed in our Ziggy stage gear, and managed to sneak a few fans in through the stage door. Otherwise, my memories of the tour run like a looped tape: get up, get out, sound check, gig, hotel, get up, get out, sound check, gig, hotel, repeat. I didn't even have time to take on board that we'd done two shows at Fairfield Halls in Croydon, the venue where I'd seen The Beatles as a 16-year-old in 1963. Sometimes I travelled with the band on the coach, other times with David, chauffeured by Jim the Lim. Travelling with David meant we left the hotel later than the band, allowing time for a little extra sleep.

For all of us, the real pleasure in touring was found in whatever recreational time we could muster after gigs, or on our days off (though these were few and far between: three in fifty days!). After a gig, we would go back to our hotel, wash and head down to the bar. There would always be a few fans who had managed to get in and that was great. As fans go, David's were the best. He had a lot of time for them and some nights he would put on a second show – a quick song or a couple of jokes – and they always absolutely loved it.

One night, when a group of particularly sweet fans were in the bar, David and I were telling them about one of the cruises we'd been on. We found ourselves putting on an unrehearsed, unscripted and spontaneous sketch for them. David played the uptight gentleman passenger and I played the incompetent waiter. The scene was set on board a heavily rolling ship and basically involved me trying to serve tray after tray of drinks and sending bottles and glasses flying and crashing around the room. Much to the delight of our audience we managed to smash most of the glasses, as well as quite a few of the optics behind the bar.

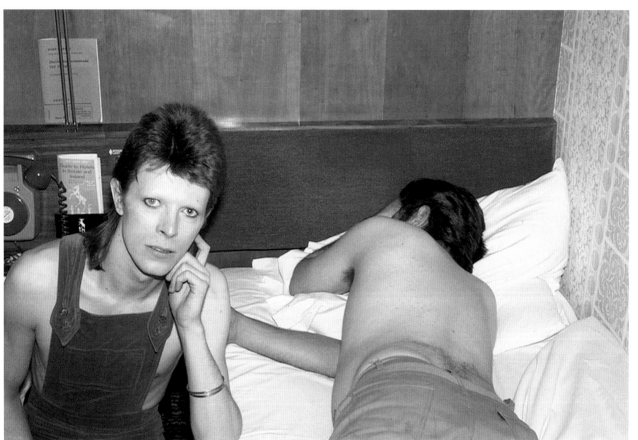

Above and top: David and I look for some (any!) entertainment at 5 o'clock in the morning on the UK Tour, secretly snapping the tour bus drivers.

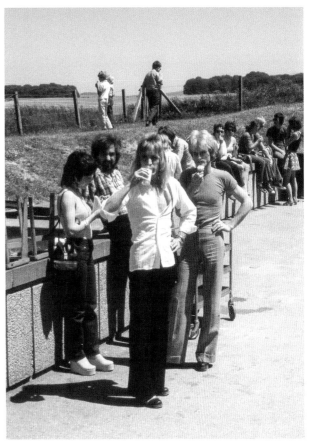

Above and top: David signing autographs in Bournemouth, UK tour 1973.

June Woodmansey, Mike Garson, Mick Ronson and Woody, Stonehenge 1973.

Strangely, the barman seemed to enjoy it too. He must have been working his final evening of employment for, with great gusto, he stepped into the role of prop man, repeatedly replacing our broken glasses with new ones. Or perhaps he was on commission for the night because the bill for this piece of light entertainment came to several hundred pounds. As David was 'director', it was considered 'art' rather than a typical act of rock 'n' roll trashing.

As a rule, the band weren't really into trashing places. It just wasn't our thing. Furthermore, our tour manager was the very competent Eric Barrett. He was a lovely little drinker but could turn, quite magically, from party animal to strict disciplinarian in the wink of an eye. He always made sure the behaviour of the band and the roadies didn't overstep the mark and that everyone made the flights and coaches on time. It wasn't uncommon to hear Eric screaming expletives at any one of us with the temerity to lag behind at check-out time. Naturally the only person exempt from Eric's wrath was David. Early one morning, late into the tour, David and I were still awake and, bored, had been wandering around the hotel when we found the tour drivers slumbering drunkenly in their room with the door open. I fetched my camera and recorded the sad scene while David pulled a few poses. When we got bored of this, we wandered into another room where we found a china tea set. For some reason, David decided to carry out an experiment and find out how long it would take various components of the tea set to travel the seven storeys to the car park below. Six in the morning found us leaning out of the window peering downwards at our handiwork. David had just released the most crucial component in our experiment, the teapot, when we heard a familiar voice, 'If you two stupid bastards don't stop that, I'll come down and sort you out!' When David and I turned to look up to the window two floors above us, we saw Eric Barrett poking out of it. Suddenly, the strangest of looks came across his face. His lips seemed to turn blue and the last words they uttered, before he disappeared back inside, were, 'Oh, sorry David!'

> The last gig on the British tour was a strange night for me because I knew David was about to announce his retirement. The last two shows were at the Hammersmith Odeon on 2 and 3 July. It was the perfect venue for the show and made up for everything the earlier Earl's Court gig had lacked in atmosphere and acoustics.

The last gig on the British tour was a strange night for me because I knew David was about to announce his retirement. The last two shows were at the Hammersmith Odeon on 2 and 3 July. It was the perfect venue for the show and made up for everything the earlier Earl's Court gig had lacked in atmosphere and acoustics. A week or so before, David had told me that he was winding the tour up, but to keep it to myself. Obviously, I would have liked the tour to continue but, with a week's advance notice to come to terms with the situation, I reasoned that I'd had a wonderful experience and, not being the most important cog in the machinery, I'd been blessed to have been involved. The reasons for the decision to cease touring were threefold, mostly business but also partly to deal with 'in house' squabbles about the band's pay. In the management's mind, David was a solo star, although Mick Ronson was

David in the dressing room the night before he retired Ziggy.

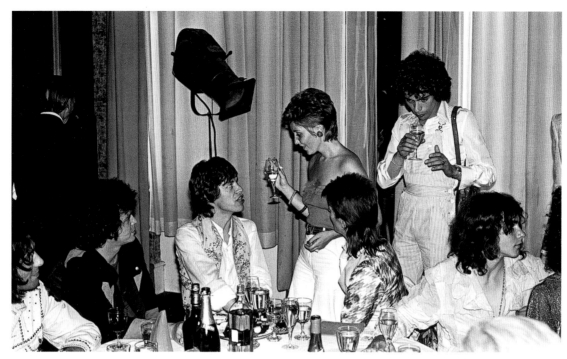

After-tour party at the Café Royal. L–R: Lou Reed, Mick Jagger, Lulu, David, me and Mick Taylor.

also seen as a future solo act who'd be signed to MainMan, thus making Trevor and Woody (and their pay rise) redundant. The management were in disagreement with RCA about venue sizes for the next US tour; the management wanted big venues and RCA wanted smaller. On top of this, the management were trying to retrieve the publishing rights from Chrysalis Publishing. So, 'retiring' David and making a cover album (*Pin Ups*) would solve a lot of problems.

The show at the Hammersmith Odeon turned out to be a great success. The audience was one of the best of the whole tour and one of the show's highlights was Jeff Beck joining us on stage. He was one of Mick Ronson's heroes and this created an awkward moment when Mr. Beck finished a solo and turned to Mick to take over. Mick urged him to carry on but, feeling like he was hogging the limelight, Mr. Beck once again turned to Mick, who it seemed was too awestruck to take over from his hero. This 'after you…no, after you' scenario staggered on for a while. Then the moment came for David to give the pre-arranged signal, indicating

that Hutch should start the intro to the last song 'Rock 'n' Roll Suicide'. But, instead, David hushed the crowd and told them what a great tour it had been and how this show would remain with us the longest because, 'Not only is it the last show on the tour, but it is the last show we'll ever do.'

The band seemed confused rather than disappointed. There was much shrugging of shoulders, frowning and what-was-that-all-abouts, then we were straight into 'Rock 'n' Roll Suicide'. Afterwards, backstage, the mood was pretty grim. Everyone was speculating as to the exact meaning of David's announcement. Was that the end of the concept of Ziggy and the Spiders? Or was it the actual end of the band and therefore their involvement with David? The fact that Mick Ronson had left the building (presumably with Bowie) without the rest of the band didn't help the paranoid atmosphere that, later, turned into anger. As for me, because I had prior knowledge of David's announcement, I carried more than a pang of guilt. I would have felt much worse had I also known that, unlike the rest of the band save

Mike Garson marrying June and Woody, 1973.

Mike Garson, I would be involved in further tours and five more albums with David.

The night after the last gig, there was an extremely glitzy party at the Café Royal in Air Street, London, with a veritable who's who of celebrity aristocracy, including Barbra Streisand, Elliott Gould, Ringo Starr, Keith Moon, Lulu and, sitting either side of David, Lou Reed and Mick Jagger. The whole glamorous affair, I later reflected, felt rather like a modern-day debutante ball, rock 'n' roll style, with David being the deb. I was sitting at the same table as Lulu, who at some point asked me to accompany her to the top table where David, Lou and Mick were seated. The resulting image, taken by Mick Rock, sees me with the look often seen in photos of me; one that suggests I'm not really sure what I'm doing there.

The next time I saw Woody and Trevor was about a week later at Woody's wedding. He got married at the British headquarters of the Church of Scientology in East Grinstead, Sussex, and officiating over the ceremony was Mike Garson – 'Garson the Parson'. I went with my girlfriend, Desna, and, for some reason, I was asked to give the bride away. As I liked Woody and June, there was no dowry involved, and all I had to do was walk, slowly, at a distance of 15 yards with the bride linking my right arm, I agreed. I later found out that I was standing in for Mick Ronson, who'd decided not to attend the ceremony – probably because the management were dangling a glittering career in front of him. To add insult to injury, later in the day the management (showing its true class) telephoned Woody and fired him (yes, on his wedding day!).

PIN UPS AT THE CHÂTEAU
'Papa Was a Rolling Stone',
The Temptations, 1972

Within a week or so of David bowing out as Ziggy, we were off to France to record *Pin Ups*. David invited me along for the craic (fun of it) and to add a few vocals etc. The recording took place at a studio 10 minutes from Pontoise, near Paris. We used a funky 1740s country house called Château d'Hérouville that contained two informal recording studios. It had several bedrooms, a conservatory housing a dining hall and a recreation room with a table-tennis table. The atmosphere was very casual, as, unfortunately, was the cooking. But it was a good place to work quickly. It was suggested that Frédéric Chopin and George Sand had conducted their relationship at the Château, later spending a brief spell at a beautiful monastery in Valldemossa, Mallorca. This means that I've visited two of their love-nests in two countries.

Mick Ronson and the string section, recording *Pin-ups*, 1973.

As the album consisted entirely of covers of songs from the Sixties, the usual pressure of writing original material was replaced with that of creating clever arrangements, which is where Mick Ronson excelled – in particular with string arrangements. Trevor Bolder was retained on bass for the sessions, but Woody was replaced with Aynsley Dunbar. As a backing vocalist, I didn't have much work to do myself, which was handy as, while in France, I met and fell in love with a beautiful French girl called Laurence, or Lolo to her friends. Lolo was exceptionally beautiful, about 5ft 9ins tall, brown eyes, willowy frame, a light tan and copper-coloured hair. We met at the Château when she and a friend came to visit new drummer Aynsley Dunbar, who David and I, with our childish sense of humour, had taken to calling Aimless Drumbeat. Of course, this couldn't have been a less appropriate name since Aynsley was a brilliant drummer.

I didn't think Lolo was that fussed with me the first time we met. A day or two later after our first meeting, I was in a Paris nightclub with an extremely gorgeous model. We couldn't have

been getting along any better and she had agreed to return to the Château and spend the night with me. Just then, Lolo's friend walked in, took me to one side and said, 'Why haven't you called Lolo? She was hoping you would'. Well, this was music to my ears. This was Otis Redding singing 'These Arms of Mine'. I sneaked away from my model friend and phoned Lolo then and there to arrange to meet at noon the next day. Of course, it would have been impolite to tell the gorgeous model, 'Sorry, I've changed my mind, I'm going home alone', so I did the gentlemanly thing and took her home and did what any other red-blooded 26 year old would do . . . I had a game of table tennis with Mick Ronson. When I returned to the bedroom, the model was asleep. In the morning she tried snuggling up to me, but I was so smitten with Lolo, and anxious not to be late for our meeting, I just kind of ignored her. Of course, I was too late to meet Lolo and by the time I arrived she'd gone home, so, from two dates, I'd ended up with nothing at all. There's some kind of lesson to be learnt there – the saying being, 'a bird in the hand is worth two in a bush'. About four years later, David had a little thing going

Mick Ronson.

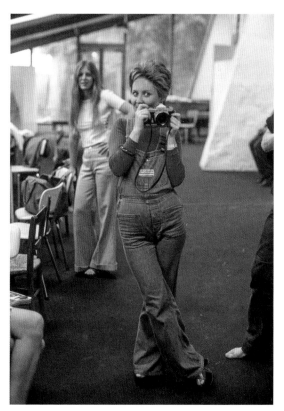

The French 'wolf whistle' outfit that I wore at the Café Royal party!

Lulu, not to be confused with Lolo...

with the same model that I'd ditched. I imagine she asked him, 'Your friend Geoff, is he gay or something?' To which, I can guarantee, David would have replied, 'Geoff? Didn't you know? He's an absolute screamer!' The other lesson I learnt from that day concerned my attire. Having been cocooned in a 'rock 'n' roll' fantasy of somewhat alternative clothing, i.e. poncey, I may have gone a little too far. As I was walking up the road trying to find Lolo, I got a wolf whistle from a scaffolder; not just any scaffolder, but a French one. This made me immediately review my appearance, from top to bottom. I had on (as seen in Mick Rock's Café Royal photo) a cream silk shirt, white dungarees with a ginger stripe, women's lace-up shoes with a highish heel and, just to cap it all off, a rather sweet little shoulder bag. Whoops!

A few faces came through the Château while we were there. Photographer Terry O'Neill dropped by one afternoon to do a shoot with David and Angie; Nico of Velvet Underground fame glided in (all cheekbones and attitude!); and the lovely June Millington from the US band Fanny, who we knew from LA (June's sister, Jean, would later marry Earl Slick). Another guest was Lulu – not to be confused with Lolo – who came to stay at the Château to record 'The Man Who Sold the World'. With Lulu, what you see is what you get. She was very pleasant and natural. We were strolling around the Château one night after dinner and we started singing each other bits of our favourite songs. It was really just a sneaky way of getting her to sing for me – though I've since realised that Lulu doesn't need to be conned into that – she'll sing at the drop of a hat. She was born to sing. A few years back, I was filling my car with petrol in Maida Vale, West London, when I heard this beautiful voice. I turned round and there was Lulu, petrol nozzle in hand, filling up her off-roader while gaily singing away to herself. Back at the Château, we came upon a room housing

Mick Ronson and Suzi Fussey discover each other at the villa in Rome.

David signing autographs on the train in Italy on our end-of-tour holiday.

a giant metal plate. In those days, this was what a studio used to get an effect called reverb. Nowadays, the same effect can be achieved by using a little box about the size of a tin of sardines. When we finally reached the studio, we were greeted with a spontaneous round of applause by all the musicians and technicians, all of whom had been listening to a rendition of Aretha Franklin's 'Do Right Woman, Do Right Man', sung in close harmony by Lulu and yours truly. It had been broadcast into the studio with maximum reverb directly from the room with the giant plate.

When we finished *Pin Ups*, a holiday was organised for about a dozen friends, including David, Angie, Mick Ronson, Suzi Fussey, Stuey George, Freddie Burretti, Anton Jones, Gloria and myself. I invited Desna, as Lolo and I weren't quite an item yet. We went to Rome and stayed in a villa with a decent-sized swimming pool and a driver at our disposal. The villa had about 10 bedrooms and a huge reception room containing a grand piano. Food was prepared by a chef, the aforementioned

Unfortunately, David didn't find it so magical. Too hot and a little bored, he travelled back to London with Angie after just a few days. The rest of us stayed on and spent the rest of the holiday hanging around the swimming pool, eating and relaxing. Others were more industrious.

Anton who was an awesome-looking bloke standing at about 6ft 2ins, sporting a giant afro haircut, with eyes that said, 'Trust me, I'm mad.' Gloria, who worked at the London office of David's management company, could not have been more different. She was petite and polite in an English home-counties way, yet, by some freak of nature, this most unlikely couple contrived to fall in love and later marry. There must have been something in that villa's water supply because the same thing happened with Mick Ronson and Suzi Fussey.

Unfortunately, David didn't find it so magical. Too hot and a little bored, he travelled back to London with Angie after just a few days. The rest of us stayed on and spent the rest of the holiday hanging around the swimming pool, eating and relaxing. Others were more industrious: Mick used his guitars and the grand piano to work out ideas for his debut solo album, *Slaughter on Tenth Avenue*, while Freddie was busy every night working out some of his own ideas with Rome's vast gay scene.

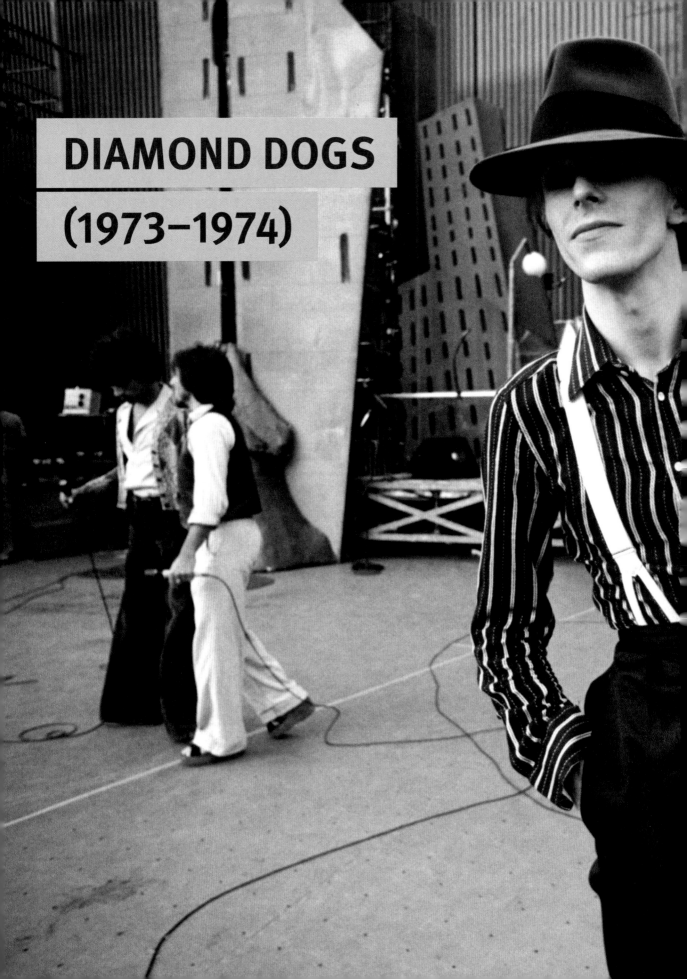

DIAMOND DOGS

(1973–1974)

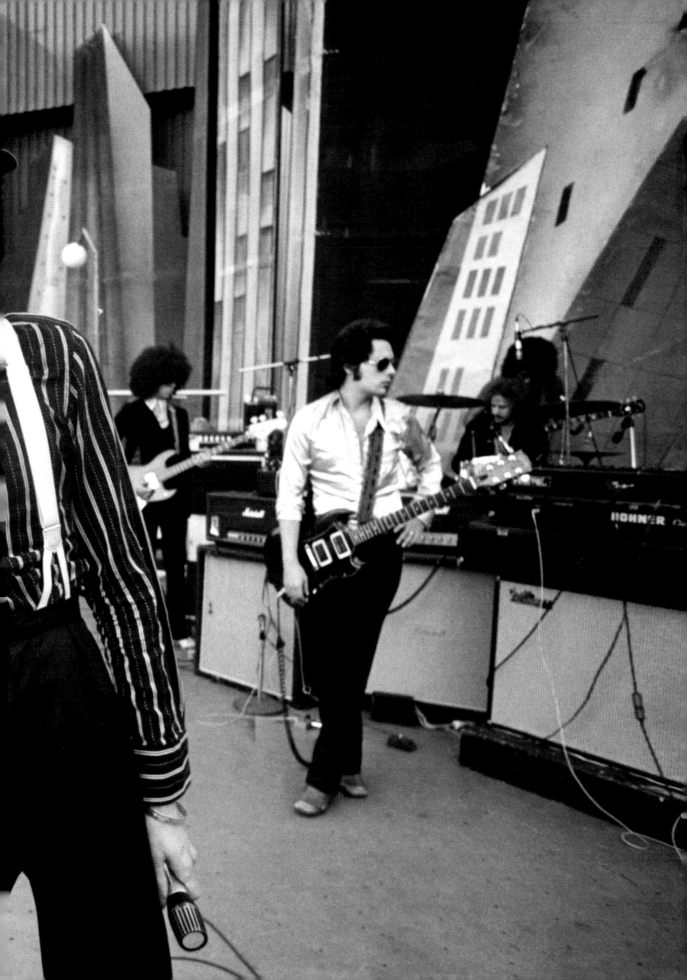

'Rock 'n' Roll With Me', David Bowie, 1974

'Live at Radio City Music Hall.'

At the end of 1973, David moved to Chelsea near my old stomping ground on Oakley Street, between Kings Road and the River Thames. It was a terraced house of five storeys with a basement apartment with its own separate entrance. Freddie Burretti was installed in the basement and used the front room as a design studio-come-production facility. There he would design and make his own unique and exotic creations for David, who would only need to walk downstairs for a fitting.

The ground floor housed a large kitchen, the first floor a double lounge area with a grand piano at one end and a television at the other; the other floors above contained various bedrooms, an office, and a music room with an upright piano. It was on the upright piano that I accidentally wrote a song with David.

One evening I had nothing to do and nobody to play with, so I thought I'd go and annoy David. When I got to Oakley Street, he was enjoying a short break from writing. He was stuck on a song idea, so we made some coffee and chewed the fat. After a while, just for something to do, I decided to tinkle the upright's ivories, playing this half-arsed melody I'd devised. David came over and asked me to play it again and, although I was fully aware that it was no masterpiece, I duly obliged. 'Let's have a go,' he said. We swapped places and he began to learn and play my little tune. After a couple of run

throughs, and to my amazement, he ran through my bit, added some more, and went straight into a killer chorus singing, 'When you rock 'n' roll with me, there's no one else I'd rather be'.

David had the idea to put a trio together called The Astronettes, which was a project to promote Ava Cherry, a girlfriend of David's. The trio consisted of Ava, me and a male model named Jason Guess. We played around at Olympic Studios with some ideas as demos then, mercifully, the project was put on hold. Sometime in the 1990s, David's ex-management thought it would be a good idea to release (without permission) the unfinished mess.

The Astronettes did have one professional outing as David's backing vocalists on a show shot at the Marquee Club on Wardour Street, London, on 18–20 October. David called the show 'The 1980 Floor Show' and it was being filmed for the US television show *The Midnight Special*, hosted by the fabulously named Wolfman Jack. The show had guest appearances from The Troggs, Marianne Faithfull and Amanda Lear. In addition to the two remaining Spiders, Ainsley Dunbar replaced Woody on drums and Mark Pritchett played rhythm guitar. The show, played before an audience of David's fan club, could not have been more camp!

It was about this time that I changed my name to Warren Peace, partly because I thought it a good name for an imposter, and partly because it felt like I was the last person in London or New York without an alias. That's how my name appears

> **The record featured familiar musicians like the brilliant pianist Mike Garson, the drummer Aynsley Dunbar, bassist Herbie Flowers and guitarist Alan Parker. Another drummer, Tony Newman, played on a few of the later sessions too.**

Herbie Flowers, bassist for the Diamond Dogs.

on some credits. 'Rock 'n' Roll With Me' was one of the tracks we recorded at Olympic Studios in Barnes, London, for *Diamond Dogs*. There was a very relaxed atmosphere in the studio, probably because it was a little out of town. A few famous faces dropped in on some of the sessions. Jagger turned up at the studio a few times, and on one occasion the American writer William Burroughs – author of *Naked Lunch* – visited. Boy, was old Bill pasty or what! He made David look like a beach bum. He wore a grey suit and a trilby hat, and he had strange little eyes; the kind of eyes that looked like they'd seen stuff you wouldn't want to see yourself.

We finished recording around the start of 1974. All the tracks had a very strong, coherent theme and David put much more time and effort into his playing and production than I'd ever seen before. The record featured familiar musicians like the brilliant pianist Mike Garson, the drummer Aynsley Dunbar, bassist Herbie Flowers and guitarist Alan Parker. Another drummer, Tony Newman, played on a few of the later sessions too. Tony Newman and Herbie Flowers were, first and foremost, great musicians but, running a close second, they were also a comedy duo. I had the pleasure of getting to know them on the *Diamond Dogs* Tour of 1974. They took the job of making music seriously, but not the music industry itself, which was very refreshing. This attitude also disguised the fact that the two were pretty canny when it came to getting paid for their efforts!

THE DIAMOND DOGS GO CRUISING
'Ne me quitte pas', Jacques Brel, 1959

Sometime around late March, early April 1974, David needed to head back to New York to begin rehearsing the forthcoming *Diamond Dogs* Tour. I was fortunate enough to be included in the new band, once again as a backing vocalist. I would also be required to perform a bit of mime, a bit of dance, and various other staged choreography. Anyway, David was still not flying, so arrangements were again made to travel by boat.

The only ship available for the dates was, happily, the *SS France*, which was sailing from Cannes in the South of France on 3 April. We would have to spend two nights at the sumptuous Hôtel Raphael in Paris, and three more nights at the even more sumptuous Carlton Hotel in Cannes. This was obviously a real treat, made even better for me in that it provided the perfect opportunity to see my French girlfriend, Lolo.

On Friday 29 March, we travelled from London's Victoria Station to Gare du Nord in Paris, crossing the channel, in those pre-tunnel days, by ferry: a seven-hour trip in total. We checked into a suite with adjoining rooms at the Raphael and my Lolo turned up soon after looking more beautiful than ever. Ronnie Wood also turned up, looking as Ronnie Wood as ever. Ronnie suggested we go to Le Crazy Horse Saloon, a revue bar/restaurant like the Moulin Rouge but with a more modern twist. Instead of dancers performing the can-can in traditional costumes, the girls at the Horse wore modern costumes and danced modern routines, making use of the many chromium poles placed strategically around the stage. Basically, it was a classy strip club.

The girls seemed to be all the same height and shape – small and perfect. After watching for a little while, it was clear that even if the show's overall concept was fairly weak, David was showing a lot of appreciation for the artistry of one particular dancer. By the middle of the show, which was intensely erotic, his appreciation had grown from infatuation to obsession. In short, he simply had to have her. Of course, it was strictly against the house rules for the performers to fraternise with the customers, even rock star customers, so it was with great delicacy, diplomacy, and the subtle enquiries of my French-speaking girlfriend, that we finally managed to arm David with the girl's name. As I was infatuated with my own girl, Lolo, I don't exactly recall the sequence of events that followed. I do remember that some flowers were sent to the girl, along with a note, and that the flowers were the exotic birds of paradise – good choice Dave. I also remember that we didn't leave Paris until we really, really, really had to – that is, the day we were due to board the *SS France* in Cannes. By that point, David's management were decidedly edgy – we simply had to be on that ship. Lots of people and a complex series of future arrangements were dependent on us arriving in New York on time.

With that in mind, I made sure that on the day of departure I was, with the help of a pre-arranged wake-up call, up at the sound of the first sparrow's fart. The plan was that I would

Ambassador TRAVEL SERVICE
PROPRIETORS: BUTLIN'S TRAVEL SERVICE LTD.

Telephone: 01-499 1313
Telegrams: AMBTRAVER.
LONDON, W.1
Overseas Cables: AMBTRAVER
LONDON, W.1

P.O. BOX I B H
441 OXFORD STREET,
LONDON, W.1

ITINERARY

DAVID BOWIE AND GEOFFERY McCORMACK.

Friday March 29 London to Paris By Train.
Deapart; Victoria Station. 1530 hrs
Arrive; Paris-Gare du Nord 2227 hrs
Two seats reserved on train Victoria to Folkestone.
On the French train seats are not reservable.

For the nights of March 29 & 30. We have reserved one twin bedded suite
and one adjoining twin bedded room at the Hotel Raphael. Enclosed is a
hotel voucher. Please present this at the hotel reception and they will
invoice us for the stay.

Sunday March 31 Paris to Cannes By Train.
Depart; Paris-Gare de Lyon. Train 11 (Le Mistral) 1320 hrs
Arrive; Cannes Station 2158 hrs

You will be met on arrival by a chauffeur driven limousine to transfer
you to the Carlton Hotel.

For three nights, March 31 to Apr 3. We have reserved one twin bedded suite
and one adjoining twin bedded room at the Carlton Hotel, Cannes. Enclosed is
our hotel voucher. Please present this at the hotel reception and they will
invoice us for the stay.

On the night of XX April 3 at 2130 hours a chauffeur driven limousine will call
at the Carlton to take you to the Gare Maritime for embarkation on the France.

Enclosed with your tickets are two vouchers drawn on Avis Rent A Car. These
should be handed up to the chauffeurs and Avis will invoice back to us the cost
of these.

On arrival on the France you will be met by a senior member of the crew who will
escort you to your suite, the Ile de France suite which is booked for the duration
of the voyage. The ship will sail sometime during the early hours of April 4 to
New York. There will be one stop en-route at Funchal (Madeira) on April 6. Shore
excursions will be organised for this stop.

On April 11 the France is due to arrive at New York at Pier 84, 0800 hours.

From thereon you are in the hands of Mainman, New York.

PLEASE HAVE A PLEASANT VOYAGE.

Butlin's Travel Service Limited.
Directors: Lt-Col. A. Basil Brown T.D., N. F. Butlin, R. F. Butlin, N. R. Maclaren, O. S. Ogg, T. H. North, J. W. Gundry M.T.A.I., A. L. Miller F.C.A.
Registered Office: 441 Oxford Street, London. Registered Number 513244 England.

Our itinerary from England to New York, via France, 1974.

wake David, order some juice and coffee, pack and go. My Lolo could sleep in and leave later. I crept out of bed, so as not to wake her, wrapped a bath towel around myself and went to wake David. As I walked into the lounge separating my room from David's I came face to face with a girl I recognised as another of the stars of Le Crazy Horse Saloon. She was very well-built and sexy in an overt manner. We looked at each other, each with a look of 'What the hell are you doing here?' written all over our faces. Then she suggested that the two of us join David and her friend who, I guessed, were already enjoying each other's company in the privacy of David's bedroom. When I declined, she must have mistaken my decision for coyness for she then suggested we get down to it right there and then. I hated to let her down, with her being a big star at the Crazy Horse, I really did, so I explained to her that my girlfriend was in the other room and took the opportunity to head back to my bedroom and reassess the situation. Lolo was still fast asleep with the covers pulled right up to her face. I turned from this image of tranquility to find the girl from the Horse standing behind me, hands on hips. She took a pace forward, pulled back the covers and spat – quite incorrectly – 'Sheez not so pretty!' Without even opening her eyes, Lolo responded in that special way only French girls can by making a noise like clearing phlegm

David (left) and me on our stopover in Madeira.

from the throat. She then replaced the covers and went back to sleep. Aah Lolo! What class!

Predictably, we only just made it to the Gare de Lyon in time to board Le Mistral train for Cannes. 'On time' actually being three days late, of course. The two girls from the Horse came along to wave us off, which I thought was a jolly sporting thing to do on the part of the one that I had rejected. Perhaps she figured, quite rightly, that if I could have, I would have. It was very nice, and not a little romantic, to be sent off from the 'City of Love' in such style.

We arrived at Cannes station late in the evening with a limousine waiting to take us to the incredibly swish Carlton Hotel. Bearing in mind that we were supposed to board the *SS France* at 10pm, we only had time to visit the suite – which had been waiting for us for three days – have a quick wash and shave, grab a banana from the fruit bowl and split. To this day, using the glorious Carlton Hotel like a common washroom remains one of my most decadent acts.

We were sound asleep when the ship pulled out of Cannes and far out to sea on our way to Madeira, which was two days sailing away; New York a further five after that. After a late breakfast, we explored the ship and were pleasantly surprised. The *SS France* was enormous, beautifully appointed and, as ships go, tastefully fitted-out and decorated. There were umpteen bars, lounges, restaurants and even a cinema. Our own suite, the Ile de France Suite, was extremely large and comfortable. But the best thing of all was the food. The first-class restaurant was very grand and I would have been happy enough just eating the midday lunch menu, but in the evening it was like visiting a top French restaurant. I revealed my complete lack of class by ordering caviar off the menu every night. David showed off his knowledge of wine by ordering something different to suit every course. There were many courses and, inevitably, we ended up the worse for wear each night. After dinner we would lurch off to find a bit of non-existent action. When on a ship rolling in the high seas, the apparently simple act of walking can prove tricky. With the added handicap of alcohol, it's pretty much a pot-luck affair. In hindsight, it was lucky we were only on board for seven days. Any longer and the risks of us dying from obesity, alcohol poisoning, or simply falling over, would have become very high indeed.

We stopped at the Portuguese island of Madeira, which is essentially a beautiful and lush volcano

The kids in Madeira tapping us for money.

poking out of the Atlantic Ocean. With no sign of an RCA Records Madeira executive on the quayside, we hired a taxi to drive us around for a couple of hours. It was a pretty island but we really didn't have time to do a full recce, so I just took a few snaps with my little Instamatic. None of them were very interesting, except a couple I took of three kids who asked us for money. We gave them a little cash and I just had to take a photo because they were quintessential street urchins; their clothes were ragged and stained, with holes in and the smallest kid had a bandage on his head. They tried tapping us for more cash, but our taxi driver told them to piss off.

With Madeira done and dealt with, we were back on our wine and caviar binge with five days to go until we reached New York. Eventually we managed to find some female company on board. David hooked up with a dark-skinned beauty, who was a passenger, as I remember; I found someone blond and blue-eyed who worked on the ship – as what, I don't remember! I lost interest very suddenly one afternoon when, as we lay on the top bunk bed in her tiny cabin, she clamped a hand over my mouth and whispered, not so seductively, that I should be very quiet because the frantic knocking on her door was her boyfriend, the fitness instructor. On the cruise

ships we travelled on, at times there seemed to be a form of madness in the air; whether it was due to the feeling of imprisonment or the drink, I don't know. On one occasion, while walking down a corridor on our way to one of the many bars, we encountered a married couple we'd met previously, who'd seemed nice and friendly. However, on this occasion, perhaps a little worse for ware, the wife lunged towards David, grabbing him by the arm (and anything else she could get hold of) and declaring undying love, passion, and a desire to be taken somewhere (I can't remember where), while her poor husband tried, both verbally and physically, to restrain her. All the while, David bore the look of someone who'd just discovered the downside of stardom.

We were definitely getting the hang of the cruising lark though. We felt like two Victorian gentlemen; respectable first-classers by day and slumming it by night. One evening we did encounter some culture when we attended a recital by the late, great Larry Adler. Good old Larry, working his passage! He was fantastic, of course, but we didn't go back a second night. Harmonica performances, like prostate inspections, are things one only hopes to experience occasionally. It has been written that David did a concert for the crew on the

SS France. While I remember hanging out with the crew on at least one occasion in 'The Pig' (crew's quarters), I don't remember David playing anything that could be described as a performance.

With New York still a day or two away, we had become certified winos. Each morning we could only remember snippets of the previous evening's activities – like the vague recollection I had of lying on what seemed to be an operating table in the ship's hospital, while David and one of the ship's nurses dressed me in her uniform. I don't remember much else about my brief change of gender other than the look of absolute horror on the faces of two gentlemen who were enjoying a pee in one of the gentlemen's urinals until I stumbled in and hoisted up my dress for the purpose of relieving myself.

We arrived in New York on 11 April. Here we would meet a whole new gang of highly creative people for David to collaborate with and, in some cases, for me to become life-long friends with.

BECOMING A DIAMOND DOG
'I Wanna Be Your Dog', The Stooges, 1969

The first thing we did on arrival in New York was to go to a pre-arranged recording session. David had decided that the American release of 'Rebel Rebel', the lead song on *Diamond Dogs*, would benefit from me adding a conga rhythm throughout, with some other percussion. It wasn't the hardest thing to pull off, even for a fake like me, and it was done in two or three takes.

We also added new and hearty 'Li Li Li'-type backing vocals. Afterwards, we visited David's management at their new suite of offices on Park Avenue, where we were reunited with a whole posse of presidents, vice-presidents, executive-vice-presidents, corporate heads, secretaries and assistants, AKA the cast of Andy Warhol's *Pork*. The staff was a mixture of queens and princesses, though one girl stood out: Raquel. Raquel was a very soulful Puerto Rican beauty, who would later introduce us to the Latin music venue, Corso. Later on that evening, we checked into the Sherry Netherland Hotel on the south-east corner of Central Park, just opposite the Plaza.

> I hadn't been around when the Ziggy show was conceptualised, so it was fascinating – not to mention a privilege – to be a fly on the wall and watch some of the planning of the *Diamond Dogs'* shows unfold.

I hadn't been around when the Ziggy show was conceptualised, so it was fascinating – not to mention a privilege – to be a fly on the wall and watch some of the planning of the *Diamond Dogs'* shows unfold. David was at his happiest when devising something or other. He doesn't indulge in this morose artist, behind locked doors, 'leave me alone' stuff. Of course, one wouldn't be stupid enough to bother him if it's obvious he's working, but he doesn't have a problem with people being in the same room at the same time. Sometimes he would discuss with me what he was doing or play a song he was working on. Occasionally, when engrossed in something, he might unexpectedly give me an exaggerated wink and a twist of the head and ask, 'You alright?' It always amused me because you knew that really he was miles away, locked into the idea. The trick was to give him a quick thumbs-up and let him get on with it. I don't know the ratio between luck and judgement, but throughout the whole process of *Diamond*

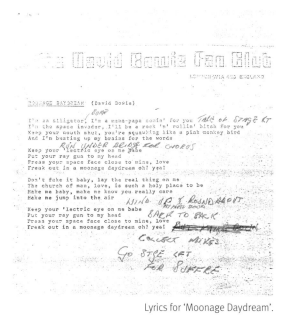

Lyrics for 'Moonage Daydream'.

Geoff's scribbled movement/choreography instructions for the *Diamond Dogs* show.

Dogs, from the design and choreography through to the choice of musicians and crew, everything seemed to click into place. Of course, it took a tremendous amount of hard work. It seemed to me that central to every plan was the core of the original idea, which David held very clearly in his head.

One of the first people he spoke to about the *Diamond Dogs*' project was Broadway lighting designer Jules Fisher, who he'd recently met in London. In turn, Fisher brought in stage-designer Mark Ravitz. Various ideas were discussed and drawings made of the ideas David had put before him, until they had developed a scaled-down model of a complete stage set. This involved a moving bridge, a remote-controlled module made of mirrors that opened to reveal David behind neon stripped doors, and a (cherry picker) crane that lowered David, strapped to a chair, over the first few rows of an astonished audience. The backdrop was to constitute 30ft-high models of skyscrapers positioned at disturbing angles, one with blood seeping down the side and others with billboards that could be ripped down during performances. David and the Diamond Dogs only tore down the billboards for the first two or three shows of the tour as, thereafter, it began to get prohibitively expensive to replace them. This wasn't the stage-set for a rock concert, rather a fully fledged piece of theatre. It would have been a brave proposition for a Broadway show, but certainly nothing like this had ever been attempted for a touring rock band before.

View from the Sherry Netherlands hotel in New York, where David designed the Diamond Dogs show.

The Universal Amphitheatre, Los Angeles, California, September 1974.

While the set was being constructed, David formed a new band of top-class musicians with backgrounds ranging from rock and jazz to classical. Instrumental in organising this outfit was Michael Kamen, a classically trained New York composer who played piano and oboe.

Michael had just written a ballet, choreographed by Margo Sappington, based on the work of the sculptor Auguste Rodin. It premiered in New York while we were there and so David and I attended. Both music and movement were sensational. Michael went on to work with people as diverse as Pink Floyd, Eric Clapton and Metallica, and wrote scores for movies including *Die Hard*, *Lethal Weapon* and *Robin Hood*, winning more than a few Grammys and Baftas. Years after that premiere I would nag Michael to play me a bit of Rodin or other

examples of music from the period when he was working with Margo. Michael and I remained close friends until his tragic early death in 2003, aged just 55.

During the intermission at the ballet, we made our way to the theatre bar. On seeing David, various theatregoers subtly closed in on him. This was par for the course and not unusual – people just wanted to get a glimpse. Sometimes, the pushier ones would barge in and say something like, 'Hi, you don't know me, but I'm a friend of Henry Scrotum'. Usually, though, and especially in genteel surroundings like the ballet, people kept their distance. What was odd this time around was that we noticed a similar situation playing itself out at the other end of the bar. It was like a magnet with opposite polar energy fields. The other 'pull' was the ballet star

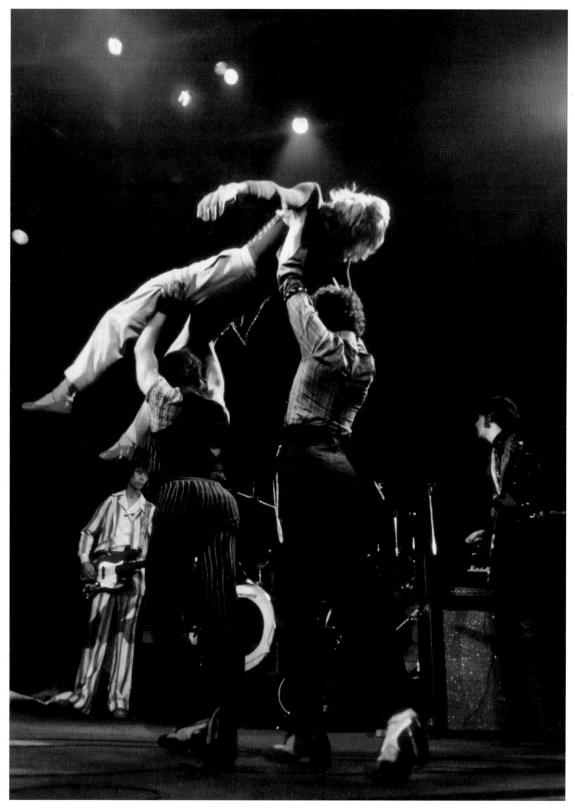

We had to stage a mock fight, beat David up and carry him off stage!

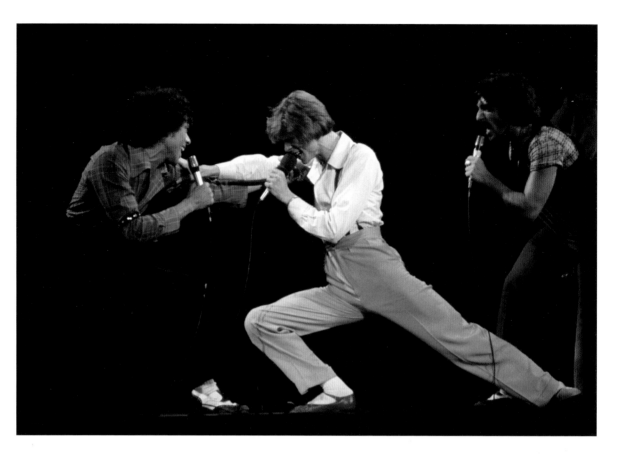

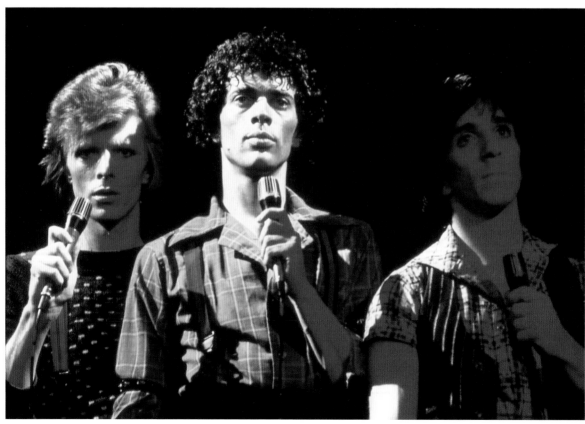

Above and top: Me, David and Gui on stage.

Rudolph Nureyev. Rudolph and David had never met before, but they had a lot in common, not least that they both wore eyeliner, both were perfectionists at the top of their professions and, alone on stage, both could captivate an entire audience. As the bell rang to end the intermission, Mr Nureyev glided gracefully past us. Without stopping or breaking his stride, he tilted his handsome head towards David, lowering it almost imperceptibly in recognition, then he glided out. I caught David returning the gesture in kind and I remember thinking that the whole exchange was positively regal.

We already had the bassist Herbie Flowers, drummer Tony Newman, and Mike Garson on board. Michael, as musical director, brought in others who he'd worked with previously, including lead guitarist Earl Slick, Dave Sanborn on alto sax, Richard Grando on baritone sax and flute, brilliant percussionist Pablo Rosario, and Michael himself on additional keyboards and oboe.

I remember the day David auditioned Earl Slick. We were in a recording studio with an amp set up and David was in the control room. In walks this young guy who looked about 17. I think he had a bottle of some kind of dark-coloured brandy, which he sipped nervously. When he'd got through that bottle he looked up and said to anyone in the control room, 'Got any wine man?' He played some great stuff and got the gig, he also got a new nickname from me: 'Wine Man'.

Thankfully for me, the other addition that Michael introduced to the production was the singer, dancer and choreographer, Gui Andrisano. The husband of Margo Sappington, Kamen's ballet collaborator Gui became, almost instantly, one of my best friends. In the show, Gui and I were using dance and mime, singing backing vocals and performing set theatrical pieces – we were a bit like a two-man Broadway chorus line. To help choreograph all this movement, David brought in Toni Basil, who was an incredible visionary. She worked with a dance troupe called The Lockers, who were a bunch of Black guys of all shapes and sizes with names like Mr Penguin and Mr Robot, all with their own individual moves. The beauty of it was that it didn't look choreographed – it looked like spontaneous street dancing, years before hip-hop popularised breakdancing. With Toni, the whole team was in place, and rehearsals began in upstate New York. Occasionally, David, Gui and I would have separate rehearsals under Toni's instruction at a New York dance studio. It fast became evident that my casual involvement days were over. Now I was going to have to work – and work hard – for my keep. The movements and routines were physically very demanding. There were very precise fight scenes and props involved. Bowie, Gui and I would be using the whole stage with most of the band performing behind the set. Rehearsals went on for over a month. I even had to wear proper dance shoes and trousers, acquired from a reputable New York supplier. These were replaced, eventually, with Freddie Burretti-designed stage clothes; checked shirts, baggy trousers that narrowed towards the ankles and which were held up with braces, and spats

There were very precise fight scenes and props involved. Bowie, Gui and I would be using the whole stage with most of the band performing behind the set. Rehearsals went on for over a month. I even had to wear proper dance shoes and trousers, acquired from a reputable New York supplier.

Our tour bus.

Herbie Flowers and Tony Newman on the tour bus.

on our feet. One of the last things we learnt, from David's hairdresser/wardrobe man, Jack Colello, was how to apply stage make-up.

Gui and I were now The Diamond Dogs.

NORTH AMERICAN TOUR
'A Case of You', Joni Mitchell, 1971

The *Diamond Dogs* Tour opened at Montreal Forum in Canada on 14 June 1974. There was a lot of adrenaline pumping around backstage, not simply through nerves – although we were nervous – but because we were excited to be involved in something we knew was extremely special.

The audience, not knowing what to expect, were left absolutely stunned when David took to the stage. Many of them had turned up in full Ziggy attire or Aladdin Sane make-up, only to see their hero on stage dressed in street clothes with a smart parting in his hair. But after the first number, '1984', they went wild and stayed that way for the whole of the show.

After two more dates in Canada, at Ottawa Civic Centre and the O'Keefe Centre in Toronto, it was on to the USA for a month. Starting on 17 June at the War Memorial Auditorium in Rochester, New York, the venues started to get dramatically larger, turning from auditoriums into arenas. We played Cleveland Public Auditorium, Toledo Sports Arena, Detroit Cobo

Arena, Dayton Hara Arena, then headed on to Pittsburgh, Charleston, Nashville, Memphis, Atlanta and Tampa. The show in Tampa had to be somewhat improvised when one of the truck drivers hauling the scenery and props got stung by a bee, swerved, and ditched half the stage set into a swamp! There was talk of cancelling the show but the challenge seemed too good to pass over. It turned out to be one of the best and most enjoyable dates of the whole tour. High on fear and adrenalin, we performed a straight in-your-face rock show.

Actually, in light of that little hiccup, I should mention that the stage crew were really the unsung heroes of the tour. They worked through the night, every night, to get the complicated set built and operational. From Tampa we progressed via Charlotte, Orlando, Greensboro and Norfolk to Philadelphia.

In Philadelphia, we had a rather large hiccup. Arriving for the sound check at the Tower Theater, we found the whole stage covered in extra microphones. It seemed we were to record a live album; unfortunately, no one had taken the trouble to tell the band. With only an hour and a half until show time, Herbie Flowers and Tony Newman went into shop-steward mode. A meeting was held in the dressing room where Herbie, quite rightly, made the point that it was not in our contracts to do anything other than rehearse and perform. In recording a live set, we would be generating monies of which we would see no

Richard Grando.

Earl Slick.

benefits. There were talks with the management which were predictably inconclusive. When, just 10 minutes before curtain-up, Herbie was still threatening not to play, David had to give the performers his personal guarantee that they would get paid. Personally, the situation was a pill I was prepared to swallow. I felt supremely lucky just to be there and for the chance to travel the world by land and sea. But the band were right and the management wrong, and David should never have been put in that situation. Naturally the management buried David's promise, so the band later had to hire a lawyer at considerable expense and everybody got paid eventually. The management was notoriously mean when it came to paying musicians and it had become a standing joke with Herbie and Tony who would mimic an imagined scenario of the management having to pay up, arms outstretched, screaming, 'What! How much?', which became the mantra for the band at the beginning of every performance thereafter. What you hear at the beginning of the 1974 album *David Live*, just before Michael Kamen's oboe solo, is the sound of the whole band arriving on stage (minus David) squawking 'What! What!'.

After Philly, we went to New Haven and Boston, finishing the *Diamond Dogs* Tour at New York's Madison Square Garden over two nights, 19 and 20 July, somewhat exhausted but thrilled to have been part of one of the most important and innovative rock shows in history.

Dogs to Soul Tour (1974)

'Love Don't Love Nobody',
The (US) Spinners, 1974

'Fabulous vocals from Philippé Wynne.'

Between July and September, we had a six-week break. Never one to take proper time off, David took the opportunity to record at the famed Sigma Sound Studios in Philadelphia, which was something of a shrine. For me, this was extremely cool. Sigma was the place out of which the producers Gamble and Huff worked and it was where groups like The O'Jays, The Spinners and The Stylistics recorded their hits. Fortunately, David recruited the services of guitarist Carlos Alomar; a further piece of fortune was that Carlos brought along his wife, singer Robin Clark, and their friend Luther Vandross who, with David, helped arrange and sing on tracks like, 'Young Americans', 'Right', 'Somebody Up There Likes Me', 'Who Can I Be Now?', 'Come Back My Baby' (which was later re-titled 'It's Gonna Be Me'), 'Can You Hear Me?', 'After Today' and a funky new version of 'John, I'm only Dancing'. Of course, with backing vocalists like Robin Clark and Luther Vandross, they weren't exactly desperate for my input, which was minimal. But I didn't care – it was just fun to be around such great vocal arrangers as Luther and David. Luther and Robin met when they were 16 and later joined a group called Listen my Brother, which was managed by the owners of the Apollo Theatre in Harlem. It was there that she met fellow group member and future husband, guitarist Carlos Alomar. Later in 1969, the

three friends joined the cast of a new experimental children's educational TV program called Sesame Street. It was on that show, plus writing and singing jingles for a living (something I would later be involved in), that they learned their craft.

Years later, for my 40th birthday, David gave me *The Philadelphia Story: 1971–1986, 15 years of Philly Classics*, a fantastic box set of 14 albums in one. My daughter, Iraina, sometimes uses them to DJ! The beat goes on.

My first memory of meeting Tony Mascia – Carlos, Robin and David's driver – was when he drove me, David and Ava to the Apollo Theatre in Harlem to see Richard Prior and The Main Ingredient. I think B.B. King was on the bill too, although that might have been another night. The drive itself was pretty scary. For a couple of South London boys, emerging from the bright lights and elegant streets of Manhattan into the drabness of Harlem in the early Seventies was a bit of a shock. Travelling by limousine only enhanced our paranoia for, on every dimly lit street corner, groups of bored, forlorn-looking dudes seemed to stare at us with malicious intent. Although, in retrospect, we were probably being wimps and they couldn't have given a shit about us or our show of limo ostentation.

Arriving at the Apollo on 125th Street, between Seventh and Eighth Avenue, was a special occasion for me. Not only was this the venue where jazz greats like Duke Ellington, Count Basie, Louis Armstrong

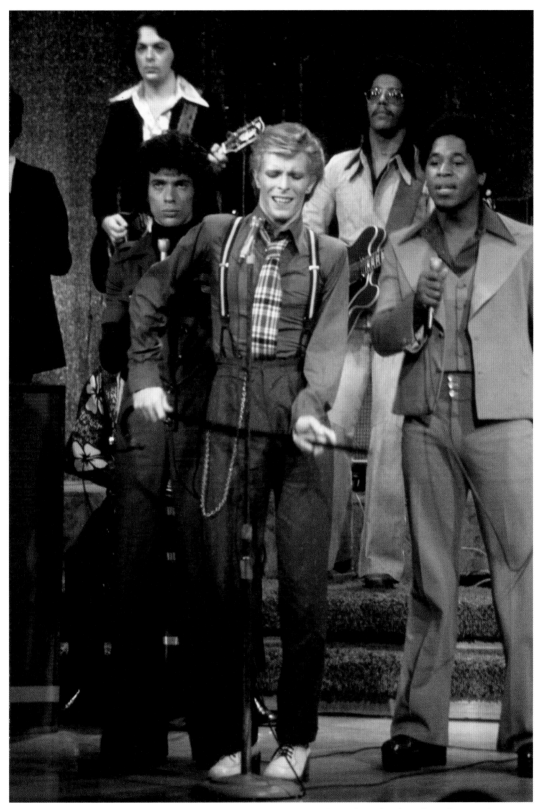

The Soul Tour band on 'The Dick Cavett Show', 1974.

and Billie Holiday had performed, this was where the 'Hardest Working Man in Show Business' – AKA James Brown – had recorded his live album in 1962. After the show, David and I, together with Ava Cherry, Carlos Alomar and Robin Clark, went backstage. Carlos introduced us to some of the members of The Main Ingredient and we chatted with some of them and other musos for about an hour, then realised that they'd locked the front of house. This meant that we would have to leave via the rear exit on 126th Street. We would only have to walk one block back to the limo but seeing how uncomfortable Ava was with this prospect didn't instill much confidence in David and me, especially as David was the whitest person this side of Reykjavík. Happily, there was no one about on Eighth Avenue but, as we turned the corner onto 125th Street, there was quite a big crowd still hanging about the front of the theatre. This made us a little nervous. What if Tony had assumed we'd left, or he had gone to look for us? Just then we saw, amid the crowd and right outside the main entrance, the 6ft-tall, 6ft-wide frame of Tony Mascia, leaning against the limo smoking a cigar as if he was hanging out in Little Italy. Shortly after that David hired Tony as his permanent driver.

Tony Mascia, David's chauffeur.

We would return to Sigma in November to continue recording the album *Young Americans*. One night Bruce Springsteen turned up. I think he was in a Volkswagen camper van and looked like an Australian tourist. He hung around for a while, chewed the fat with David, then got back on the road. Had I known he was going to write the intensely moving and beautifully sculptured 'Racing in the Street' on his 1978 album *Darkness on the Edge of Town*, I'd have thanked him and bought him a hundred drinks.

After our 'break', the *Diamond Dogs* Tour resumed at the beginning of September at the Universal Amphitheatre in Los Angeles. The tour was no longer strictly the *Diamond Dogs* Tour. As the elaborate $400,000 stage set (much to the management's annoyance) would gradually be done away with, but for the Universal gigs it was still in place, although later shows would transform into what became known as the Soul Tour. David and I travelled to the West Coast by train, taking the Amtrak from Philly to LA.

The train stopped at St. Louis for a few hours, so we went into town for a meal. The restaurant we found was on the top floor of a building offering panoramic views of the whole town. We finished our meal with a few hours still to kill so we decided to order a couple of tequilas. Gui Andrisano had introduced me to the drink. He would keep a bottle of white tequila in his freezer and we would do the shots with beer chasers, first licking salt from our hands and then sucking on a wedge of lime, so I thought I was a connoisseur. In St. Louis, David and I necked gold tequila, one shot after another, for two hours. I awoke the next morning fully clothed. At least I'd made it to the train, though I'd no idea how. David took great delight in explaining how he'd practically carried me from the restaurant to the train and put me to bed!

The material we had just recorded at Sigma Sound Studios in Philadelphia was ever present in David's mind while touring. For the Universal Amphitheatre gigs in LA in September '74, he wanted to incorporate some of the new songs into the live set, but to do that he had to change the format of the show. As such, the band line-

up also changed. Bassist Herbie Flowers and drummer Tony Newman had already been replaced with Doug Rauch on bass and Greg Errico on drums, and more backing vocalists from the Sigma recordings were to be added.

We, the band, stayed at the Sunset Marquis on Alta Loma Road, West Hollywood. This wasn't a hotel as such, but serviced apartments of around 600 sq ft each, which meant one could entertain a guest or two. The place was built around a swimming pool with ground, first and second floors overlooking. It had a pleasant atmosphere, much calmer than the dreaded 'Riot House' up on Sunset (as the Hyatt was known). We got to know the Average White Band, who were either staying or hanging out there in September '74, and David and I caught their set at the Troubadour on Santa Monica Boulevard one night – they were brilliant. The band were the hottest act from the UK at the time; their track 'Pick up the Pieces' would reach No. 1 in the US charts the following February in '75, which made what happened next even more tragic. The band were invited to a party up in the hills and, while there, a glass vial was passed around. Assuming it was the usual, coke, a couple of the band sampled it, only to become instantly unwell. The drummer, Robbie McIntosh, collapsed while Cher Bono and her friend, who were at the party, kept bass player Alan Gorrie conscious by walking him around non-stop until the drug wore off. Unfortunately, McIntosh didn't survive and died the next day from the effects of the powder, which turned out to be a mixture of heroin and morphine. This, unfortunately, was always an accident waiting to happen in LA in the '70s; trusting people who you may never have met before when they offered to 'turn you on'. We saw the band sometime later in Santa Fe, still sounding great, with new drummer Steve Ferrone, who later joined Tom Petty and the Heartbreakers.

The shows at the Universal Amphitheatre in Los Angeles were the most enjoyable of the tour. Mostly that was down to the venue itself: the shows started while it was still light and it was so much more comfortable working in the open in a cool evening breeze. During the week we spent there, it was not uncommon to see a major star or a member of the Hollywood elite in the audience: Diana Ross, Raquel Welch and The Jackson Five were among those who turned up. One night the British singer Donovan showed up with his wife and son. I knew he'd just released 'Rock 'n' Roll With Me' as a single, so it was pretty cool to be able to introduce myself as the song's co-writer. After LA, we played in San Diego, Phoenix, Tucson, and Anaheim where Elton John and Elizabeth Taylor attended. Towards the end of the tour, before I went on stage, I foolishly smoked half a joint offered to me by one of the band members. Bad mistake. It wiped me out and, given the complexity of some of the dance and mime routines, this wasn't a good thing. One part of the show required Gui and I to beat David up until he collapsed. We would then pick him up and carry him over our heads with extended arms – quite a dangerous thing to get wrong. Thankfully, although I was stoned, I managed not to do anything stupid. In fact, I managed to do nothing at all. As Gui single-handedly gave David a going over, I stood and watched in a daze as he independently finished the routine and carried the whole weight of David off stage, while I absent-mindedly strolled after them.

On another occasion, again towards the end of the tour, we were singing 'Changes' for the purposes of a sound-check. When we reached the chorus David stopped the band, walked over to Gui and me, and asked us to sing our part. When we duly obliged, David doubled up with laughter. For two-and-a-half months we had been singing, 'Turn and face the strain', instead of 'Turn and face the strange'. From then on, every time we performed that song David would stick his posterior out towards us and make like he was straining, which would make us both laugh and fluff the line even more.

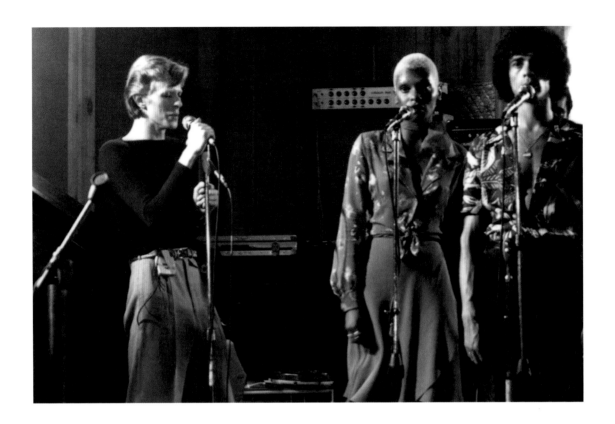

FROM REHEARSALS TO MEATBALLS
'Moody's Mood for Love', King Pleasure, 1952

After the Universal shows, a two-week period of rehearsals was arranged in LA, which I approached with a deep sense of trepidation. David had decided that each backing singer should sing a couple of numbers in a warm-up/ support band, preceding his show. The other singers were Diane Sumler, Robin Clark, Anthony Hinton, Luther Vandross and Ava Cherry, all of whom sang like angels. I began to panic and, not thinking straight, I decided to try and blind them with science. I chose to sing one of my favourite Georgie Fame covers, 'Moody's Mood for Love', a song he used to sing sometimes at The Flamingo on Wardour street, London, back in my old Mod days. This is a song with 56,000 words – or so it seems when singing it – and is based on the melody of a saxophone solo played to the tune of 'I'm in the Mood for Love' by jazz legend James Moody. With new lyrics delivered

in a fast, scat-like way called 'vocalese' – as performed by singers such as Eddie Jefferson and Jon Hendricks – it's not a song that should be attempted by the fainthearted.

Later, I reflected that there was a degree of karma about my choice. As a 16-year-old, my sister Rosie had taken me to see the great Dizzy Gillespie Band in concert. I was an R&B and soul freak and backstage, after the show, I asked this American dude if he knew when James Brown might be coming to London. This guy looked at me as if I'd called his wife a whore and walked away muttering to himself. That dude, I later found out, was James Moody. As I finished my attempt to cram in all 56,000 words into his tune, live onstage, before rushing off to retrieve my tongue from my throat, I could almost hear the great man saying, 'R&B is R&B, but jazz is jazz'.

The rehearsals took place in a dark and funky rehearsal studio, which was less than glamorous,

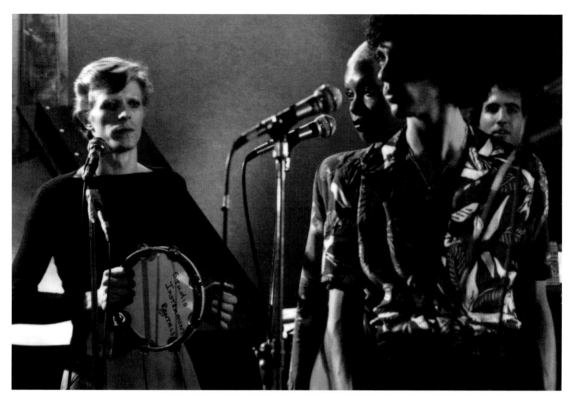

Above and opposite page: Me and Ava rehearsing with David.

so it was some surprise when one day Elizabeth Taylor turned up, sat down and listened to us rehearse. She just strolled in off the street with this bloke who I'd heard was a car salesman. All I can remember thinking was how only Liz Taylor could slum it wearing a diamond as big as a boxer's bollock. As I was leaving the studio, I told Ms Taylor, proudly, that my birthday was on the same day as hers (27 February) she looked at me with something resembling pity, so I grinned a bit and backed away. It's possible I may have genuflected in retreat.

After the rehearsals, the tour continued at the beginning of October, now fully as the Soul Tour. Happily, Gui Andrisano's services had been retained as a choreographer and master of ceremonies, and this saved the touring experience for me. The changing line-up had made the band less cohesive, more fragmentary, but Gui, Slickie and I remained a permanent team, always trying to make people laugh. Though we now travelled with Carlos and Robin – two of the nicest people on the whole tour – I missed the London humour of Herbie Flowers, Tony Newman and Michael Kamen. Perhaps it was the change in line-up, but the new shows lacked some of the precision of earlier dates, and performances got a bit ragged at times. I'm not sure, for instance, if the audience in Boston appreciated Ava Cherry's loud, clear voice saying, 'Good evening, Buffalo!' (or a similar *faux pas*). The tour wound up in Atlanta on 1 December and an end-of-tour party was arranged at the Hyatt Regency Atlanta hotel. It's one of the few hotels I remember well and was quite new at the time, with a large atrium and glass elevators – no place for somebody with vertigo.

The farewell gathering, held in one of the hotel's suites, was for band and crew only, but throughout the day Gui and I had noticed a couple of strange guys hanging about. They looked awkward, had particularly bad taste in

clothes and suspiciously short haircuts. When they clumsily asked Gui and me if we knew where they could score, they confirmed our suspicion that they were undercover cops. Naturally, we told them we had no idea where to buy coke because we didn't do the stuff. Then we alerted anybody in our group who might possibly fall prey to this trap. This amounted to pretty much everybody except Mike Garson and Luther Vandross; Mike did Scientology and Luther did Kentucky Fried Chicken. Anyway, it was no surprise when, later that night, as the door of the suite where our end-of-tour party took place began to cave in and the partygoers threw their personal stashes out of windows and through the toilet door, that it was our two undercover friends who led the charge with the cry of 'POLICE! Everyone stay where

you are!' It was a bit of a close shave for me. I had some (livening-up) stuff inside my cigarette packet. The instant I had dug the packet from my pocket, opened it, found the incriminating content and thrown it, my skinny wrist was being held in a vice-like grip. Still holding my cigarettes, I turned around and there he was, the badly dressed cop who had asked me and Gui where he could score. With a triumphant look on his face – a look that said, 'I've scored now buddy!' – he opened my packet of cigarettes to see nine or ten Gitanes staring back at him. He fumbled around inside, spilt the contents on the floor and finally just stood staring at the empty packet. He seemed perplexed. Then again, he may just have been impressed. After all, the delightful artwork of Max Ponty on a packet of Gitanes, featuring swirling

smoke and the silhouette of a gypsy dancer, is pretty slick. The police broke up the party and arrested the member of the management who'd been responsible for booking the hotel suite. Presumably they wanted to discuss the nine phials of Columbian marching powder, ten lumps of hashish, five bags of homegrown, and three smouldering roaches that had appeared on the bathroom floor.

At the end of the US tour, in December 1974, most of the band, including David and myself, headed back to New York and its many suburbs. David checked in to The Pierre and I stayed at my favourite place: Gui and Margo Andrisano's apartment, close to Washington Square Park, near Greenwich Village. Gui and Margo's friends were all actors or dancers, all on the fringes of greatness. Margo, I think, was born in the Midwest, Gui in East Harlem, New York, when it was still an Italian neighbourhood. Gui's family were affluent enough to have a cine camera, and the footage of Italian Harlem from the late Forties and early Fifties was pure Scorsese. Gui invited me for an Italian meal at his mother's house, which was the second invitation to a home-cooked Italian meal I'd had. The first invite was to the home of Tony Visconti's mother in Brooklyn, New York, which I went to with David in '73. Naturally, the food was great and the company pleasant.

When Gui first took me to lunch at his mother's, he warned me of two things: first, that I would be force-fed amazing Italian food; second, that his aunt (his mother's sister) would be present and that she and his mother would almost certainly argue, and it would *not* be pleasant. Gui was right on both counts. I immediately fell in love with his mother, Helen, who was very small but very fiery, and who shared the same birthday as me (and Elizabeth Taylor) – 27 February. She liked me too because I was English and polite.

At first, lunch passed quite amicably. Helen fed me lasagna, meatballs, and other stuff until it started to seep through my nostrils. And the conversation was pleasant enough until Gui's aunt began telling us of the grief her children gave her. 'You shouldn't have kids, they're too much trouble,' she told Gui. I looked at Gui, who gulped like he'd swallowed a baby seal, and he began kicking me under the table in a manner that said, 'Oops! Here we go!'

Gui's mother spoke in a slow, low voice, sounding a bit like Regan in *The Exorcist* when she was very, very ill. 'You sit there,' she said, 'You sit there and tell my son that he shouldn't have children.' Her small frame began to rise slowly from her chair. 'You sit there and tell me I shouldn't be a grandmother to my son's children.' Gui's mother now stood at her full 5ft of glory, leaning menacingly across the table with her arms supporting her weight and glaring at her sister. Gui, realising the heavy stuff was on its way, kicked me hard on the shin and cocked his head towards the door. With the speed and intensity of a mousetrap, Gui's mother struck the table and sent three different types of pasta, a dish of meatballs and four half-empty glasses of Italian red wine flying six inches into the air. But this was nothing. The ferocity with which she made her next pronouncement was frightening: 'Cancer of the throat you should get!' As Gui and I quickly exited the room, his mother, now bent double over the table, pointed at her sister, and like some wild banshee screamed the immortal line, 'You see your two eyes? TEN I'LL MAKE OF THEM!'

> **Still holding my cigarettes, I turned around and there he was, the badly dressed cop who had asked me and Gui where he could score.**

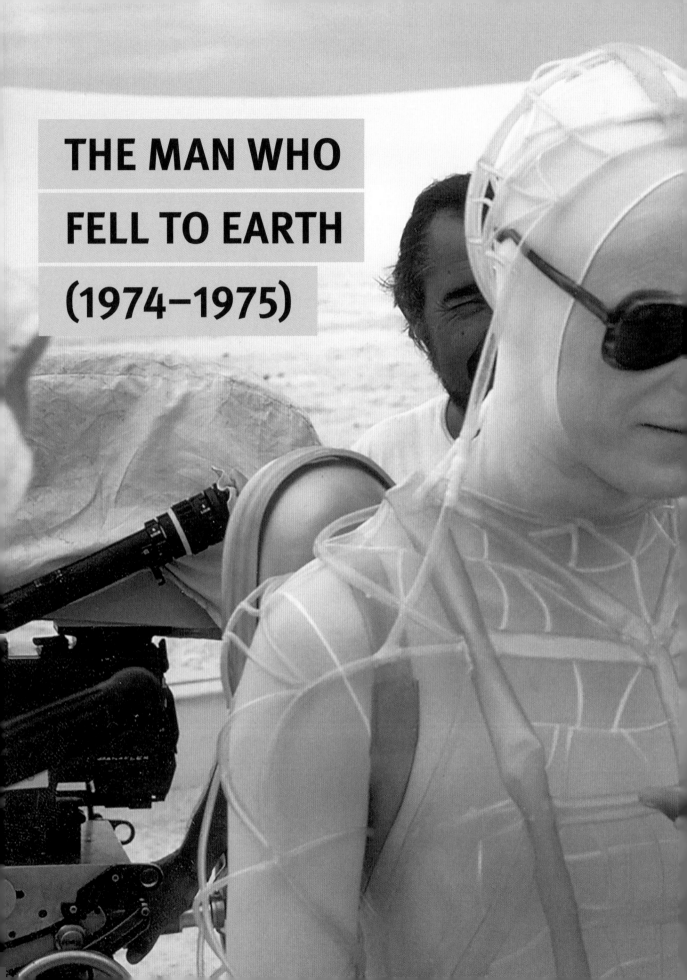

THE MAN WHO
FELL TO EARTH
(1974–1975)

'Sonero', by Johnny Pacheco, featuring Pete 'El Conde' Rodrigues, 1970

One of the venues Raquel from the MainMan office introduced us to in New York was Tony Raimone's Corso, a Latin club located on East 86th Street. It had a huge rectangular hall resembling a ballroom, with tables around three sides and a bandstand at one end. The clientele ranged in age from six to sixty, all of whom would participate in the dance competitions held there. The only Latin dancing I'd seen before was on the British television ballroom-dancing show called *Come Dancing*, in which the band always played some cheesy cha-cha-cha and the dancers moved with horrible exaggeration through thoroughly unsexy, jerky routines. Latin dancing New York style, however, was a completely different kettle of salsa.

The guys at the Latin club took on the part of a pivot, leading the girls with small, subtle movements. The girls took the starring roles, gracefully twirling around their partners this way and that, backwards and forwards, young and old as one, like a field of exotic flowers in a summer breeze. *Come Dancing*, indeed! If I knew little about Latin dancing before I went to New York, I knew even less about Latin music. In my late teens, however, the only deviation from my staple diet of R&B, soul and Blue Beat 45s had been a quirky, Cuban-style instrumental called 'El Watusi' by Ray Barretto. What foresight for a soul boy that turned out to be. Lest I upset another jazz legend, I resisted the temptation of telling Señor Barretto about my early acquisition of his work and, instead, David

and I merely exchanged pleasantries when introduced to him one evening at the Corso by Jerry Masucci, head of Fania Records. On other evenings at the club, we had the privilege of hearing Tito Puente, Celia Cruz, Johnny Pacheco, Larry Harlow, and the Fania All-Stars. Raquel, the Puerto Rican beauty who worked for David's management company, took me to another smaller Latin club called Casablanca. It was a strange experience because everyone there spoke Spanish, except me. Worse, I couldn't quite master the dancing, probably as a result of being exposed throughout my childhood to all that third-rate ballroom shite on British television. The problem was, I looked Puerto Rican. And Puerto Ricans can dance as well as they speak their mother tongue. So, there I was, mute and motionless. But hearing and seeing this wonderful music played live, with its incredible rhythms and hypnotic chants, made me realise why, all those years ago, Ray Barretto's simple little tune – with its string riff, percussive rhythm and flute line – had appealed to me so much. After a while, Raquel got fed up with standing still and turned to me, saying, 'Dju no hi got to dance'. After several invitations, she hit the dance floor, leaving me to wonder how I'd reached my mid-twenties ignorant of these wonderful sounds – the offbeat bass lines and the subtle rhythms, which soothed you one moment then, with a lightning crack of a timbale, altered course and pace into a carnival of musical excitement and joy. *Gracias por la música maravillosa, Señor Barretto*.

At the end of 1974, I headed back to England to spend Christmas with my family, then on again to *la belle* France to visit my Lolo. Sometime in

February of 1975, I headed back to New York. Why, I don't remember. There was no recording to be done, no shows and no tours. The only reason I can think of now is that I was invited to give moral support to David, who was then going through an acrimonious – not to mention complicated – split with his management. It was a subject I studiously avoided discussing with David, not because I didn't have opinions on the issue, but because I felt it unwise to get involved in someone else's messy divorce.

I loved New York in the Seventies. I love New York now. I've always loved what New Yorkers love: the Village and its restaurants; Central Park, all dried out in the summer heat; listening to fantastic a cappella groups in Washington Park; eating at people's apartments; the delis, the weird clubs and hang outs; and the taxi drivers. I was in a taxi one evening with Gui's wife Margo, en route to see a Broadway show. The cab was a little shabby and the Black driver sat low in his seat. Margo and I were chatting away about this and that when suddenly, through the hatch in the grill dividing front and back, the driver's hand appeared holding a spliff of very fine-smelling stuff. I took hold of the offering, had a couple of draws, then handed it to Margo, who did likewise. When we had finished, Margo

reached into her bag and brought out some equally fine shit. She skinned up an impeccably tailored joint and we both took a few puffs before handing it over to our friend at the wheel. During all this time, not a word passed between the driver and us. When we reached our destination, we disembarked and paid. Just before he drove off, I said, 'Thanks for turning us on, but how did you know we were cool?' His face slowly turned into a huge grin and he said, 'You know, man. You just know'. That's New York City.

Wisely, David had moved out of the money-draining Pierre hotel and into a brownstone townhouse on West 20th Street in Chelsea. The house was similar to his old Oakley Street home in London's Chelsea, except the bedrooms were on the first floor with the lounge on the second, and there was an attic space where David slept. Around this time David had an interest in filming and directing. He even had some tuition from filmmaker John Dove in using the video camera and lighting equipment he'd acquired. At one point David suggested we film ourselves acting out part of a play. I suggested part of Harold Pinter's *The Caretaker*; I can't remember which brother he played but, as I remember, I played the homeless man, Davies. Somewhere in a box,

in a trunk, there lies a long-forgotten old video tape of our efforts from that day in 1975 at West 20th Street.*

John Lennon and Yoko Ono were regular visitors to David's house on 20th Street. John and David had recently written *Fame* together with Carlos Alomar. I had only seen Lennon twice before, once with The Beatles in 1963 at Fairfield Hall in Croydon in the flush of their first success, then again at the beginning of the Seventies when I saw The Plastic Ono Band at London's Lyceum Theatre. So, it was a great thrill, years later, to meet him in person. John was unassuming but magnetic. I found him extremely warm and gracious. In fact, graciousness is a quality many true stars possess. David had it and so did Paul McCartney. One time, when leaving a *Diamond Dogs'* show early to avoid the crowds, McCartney spotted Gui and me standing at the back of the stage waiting for our next cue. He put his hands above his head, clapped, and mouthed, 'thank you' as he and his wife, Linda, walked past. Major class, Paul.

I am sorry to say, however, that Aretha Franklin was not quite so generous. In March 1975, David presented her with a Grammy at the Uris Theatre in New York. David looked *très suave* in a fine-cut suit and said all sorts of sweet things about Miss A. Franklin, who sashayed on stage, grabbed the Grammy from David's hot little hands and proclaimed, 'Oooh, I fill so good I could even kiss David Boowie!'

I have two other distinct memories of that night at the Grammys. First, I was sitting about four or five rows from the front, waiting with the rest of a packed and influential house for the show to begin. As we were waiting, one of the organisers – a trim and efficient-looking woman in her late twenties – marched back and forth across the stage, clearly enjoying her moment of glory, when suddenly, mid-march and mid-stage, she fell flat on her face. No stutter or stumble, just a cool,

trim, efficient thwack. She seemed to stay there, motionless and clutching her sad clipboard, for an eternity. Everyone in the audience was frozen in sympathetic disbelief and were geographically redundant, as far as our ability to help her in any way. Eventually other clipboards appeared and carried the woman somewhere which, I'm sure, was not nearly far enough away for her.

The second memory is of sitting at a table at the after-show party with singers David Essex and Andy Williams (which left me feeling quite tall). This is fairly surreal in itself, but then David strolled up with the wonderful Ann-Margret. She'd performed an incredible dance routine at the show. After David introduced us, I told her, without hesitation and absolutely genuinely, that I thought her to be extremely sexy. You can call me a liar, but I swear the girl blushed.

When writing this chapter in 2001, my memory became hazy around a party that we went to. So, I emailed David:

> Dear Old Sock,
> We went, with John Lennon, to a party at a huge New York apartment, (hotel?) it had lots of rooms and a grand piano, John had agreed to do an interview with a small New York radio station. We broke off from the party and found a bedroom where John made his call to the station. The guy at the other end of the line was naturally ecstatic at having achieved this, scoop of a lifetime, live on air. The upshot of this, is that the bedroom was actually full of major music stars, and after a while John said, 'I've got someone I'd like you to speak to' and handed the phone to you, this was like winning two lotteries in a row, the guy was totally destroyed, thus it went on, with the phone being passed from one Muso legend to another, until the poor chap was just a blithering wreck.

* Footage from that day in 1975 found its way into Brett Morgen's film *Moonage Daydream* (2022).

Nancy and Michael Lipman.

Question: Who were the line up? I've got, in the remnant of my brain, some misty images of which I will [annoyingly] share with you. Obviously, John Lennon, Yoko Ono, Paul Simon? Art Garfunkel? Bette Midler? Billy Preston? Ronnie Wood? - - - -Can you demist my poor old brain?
Love Best G

Bowie's reply:

Trouble is... these all sound very likely.

The mystery was finally resolved 36 years later in an interview with Art Garfunkel in 2011. As Art tells it, apparently after the Grammy ceremony, John Lennon had invited a few people back to his apartment at The Dakota building on West 72nd Street. This meant that it was his grand piano I had played (badly) and it was his bedroom where we had all retired to when he (and others) conducted the interview. Garfunkel also recalls John Lennon asking him when he was getting back with Paul (Simon); to which Art replied (naturally), 'When are you getting back with your Paul?'

JUST HANGING IN LA
'Lovin' You', Minnie Riperton, 1974

In mid-March, I went back to Beckenham to see my mother and sister and to check on my apartment on Blackheath. After a few days in South London, I went over to Paris (or Lyon?) to meet up with Lolo, and the two of us travelled back to the USA to stay with Michael and Nancy Lippman in Los Angeles. I had met Michael in 1974 when he was at CMA entertainment agency in LA. Michael was now dealing with the fallout between David and MainMan as a lawyer and stand-in manager. He and his wife had a warm and friendly bungalow-style house halfway up North Kings Road, off Sunset Strip, that was guarded by a big, fluffy sheepdog called Marvin. Michael and Nancy were real people living in an unreal world. They had a great stabilising effect on me during the many months I spent in Los Angeles, and they showed me great kindness and friendship. The night Lolo and I arrived at the Lippmans' they were hosting a party for Minnie Riperton. She was celebrating a massive hit with her song 'Lovin' You', from her 1974 album *Perfect Angel*. The song has since

become a classic, and quite rightly so. With its simple arrangement and her phenomenal vocal delivery, it's unique. Sadly, Minnie died from breast cancer in 1979 at the age of just 31. She was as sweet as she sounded and I'm grateful I had the chance to meet her and her lovely family.

Minnie was managed by a friend of the Lippmans called Jack Kelman. Jack was a lovely guy. I remember he taught me, patiently, how to throw an American football on Malibu Beach. He kept telling me about his girlfriend, saying stuff like, 'You wait till you see my girlfriend' and 'You're gonna love my girlfriend'. This went on for a while until, finally one evening, she arrived at the Lippmans' house. As I walked into the lounge to meet her, I just knew I'd be really disappointed. However, it turned out Jack was spot on, I really did love his girlfriend! She had olive skin and large green eyes framed in a beautiful face. The problem was that she instantly took a fancy to me too, and we spent the rest of the evening, which happened to be at the Troubadour, flirting outrageously with each other. The fact that she was Jack's girl, who was good friends with Michael and Nancy, ruled out any idea of taking it any further, although we did hang out a bit with Nancy, who policed us like some suspicious Victorian chaperone, keeping us respectfully (mostly) at arm's length. Her name was Jolie and one day she said she'd like me to meet her dad. When we got to her father's house and introductions were made, I found myself shaking hands with the legendary Quincy Jones. Mr Jones was a gentleman with great charisma. I knew some of his important collaborations with the giants of music from my brother's record collection – Dizzy Gillespie, Count Basie, Frank Sinatra and the queen herself, Ella Fitzgerald – so, for me, it was a huge pleasure to meet him. A few years after meeting Mr Jones he would produce Michael Jackson's hugely successful *Off the Wall*, *Thriller* and *Bad* albums.

David had been signed up to star in a film, *The Man Who Fell to Earth*, by the brilliant director Nick Roeg. Nick had made, among other films, *Don't Look Now* (1973), starring Donald Sutherland and Julie Christie. This encouraged David to move from the house on West 20th Street in New York to Los Angeles to be ready for filming. Unfortunately, the film company (British Lion Films) hadn't managed to get the finance they thought they had. This meant David would be hanging around LA for three months with nothing to do except hang out.

The Los Angeles I encountered later in my life, at the end of the Eighties and Nineties when I went there to score films or do advertising spots, was very different to the Los Angeles of the Seventies. The cult of clean living and personal trainers, with smokers treated like lepers, was a world away from the city I remembered. A common form of greeting in 1975 was for someone simply to say, 'Hi', and stick a silver spoon under your nose. A little bottle of white powder with a tiny spoon attached by a chain to the lid was *de rigueur*. It was a must-have fashion accessory. Cocaine was the Nike of the Seventies; somebody even

> **The Los Angeles I encountered later in my life, at the end of the Eighties and Nineties when I went there to score films or do advertising spots, was very different to the Los Angeles of the Seventies. The cult of clean living and personal trainers, with smokers treated like lepers, was a world away from the city I remembered.**

Cinematographer Tony Richmond, focus puller Bob Rickerd and director Nick Roeg.

presented me with a book extolling its historic beneficial applications. Luckily, I met a girl who was allergic to the stuff so my consumption was considerably less than it might have been. I met this girl the same night I accidently wrote a song with Iggy Pop.

David and I would bump into Iggy in LA, here and there, usually literally, as he was always in a bit of a mess. David had played me the marvellous 'I Wanna Be Your Dog' from The Stooges' 1969 self-titled debut album and told me how he'd met Iggy at Max's Kansas City back in '71. So I was, let's say, informed. I must say I really liked Iggy, mostly because everything he did, he did with the most stupendous ironic smile. Anyway, on this particular day we bumped into Iggy, and the three of us went to a small studio somewhere in North Hollywood. I had no idea why we were there at the time, although it was probably because David wanted to drum up some musical ideas for Iggy. As soon as we got there, I headed for the grand piano and started playing a sequence of a few chords. I'm not the greatest pianist but I can spoof it. I was playing this series of chords which had a gospel-type feel and the next thing I know Iggy's standing beside me, giving it large, extemporising vocal lines. Then David comes over, all excited, telling us to keep going. He jumps into the control room and starts running the tape. Having got, I presume, what he thought he wanted, he came back out and said something like, 'Excellent!' Knowing I was only good for one idea, I thought I'd take my leave. And that was when I met this girl. She was sitting in the reception area of the studio, and I just stopped in front of her and said, 'Hello'. She was very good-looking, slim, of average height with long thick dark hair. Her name was Loree, and her mannerisms were poised and soulful. The attraction between us seemed both natural and instant. I asked her why she was there, and she said she'd come to see Iggy. I figured Iggy would be far too busy working on the song idea

I had just instigated to be messing around with beautiful girls, and to interrupt him would be thoroughly inappropriate. So, to help out, she and I left together. As it turned out it was the right thing to do. The chord sequence I'd put onto tape became 'Turn Blue' on Iggy's 1977 album, *Lust for Life*.

Five minutes after having met, Loree was driving me back to the Lippmans' house. She had a white sports car and I remember looking at her driving me up Sunset Strip and thinking, 'This isn't too horrible'.

When we got to the house, we sat on my bed and played backgammon. She had planned to go to Chicago the next day – her hometown – and we decided that, if I won, she would stay; if she won, she would go. I took it as a great compliment that she lost to the world's worst backgammon player. She said she had a boyfriend in Chicago. I said I had a girlfriend in France. But we liked each other a lot and it kept us both out of trouble for a few months. In fact, she had quite a few boyfriends – and why not? She would say, 'I can't see you later, I have a friend coming in from London [or New York]' which, of course – being male – wound me up a bit, even though I had a wonderful girlfriend in France (and a couple of others in LA). We weren't girlfriend and boyfriend (officially), but we stumbled along like this up until I went off to be an incongruous stand-in for David in *The Man Who Fell to Earth*. A little while after me, she had a relationship with Glenn Frey of the Eagles who, accurately, wrote the line 'She got a lot of pretty, pretty boys that she calls friends' ('Hotel California', 1976). At some point later, Loree utilised her appreciation of pretty boys and made a living as an agent/manager to the likes of Brad Pitt and Robert Downey Jr, among others. Later still, she would become a jewellery designer to the stars and beyond. In fact, Michelle Obama wore some of her pieces for President Obama's inaugural ball in 2009.

KILLING TIME ON DOHENY DRIVE
'I'll Take Care of You', Bobby 'Blue' Bland, 1959

The Troubadour on Santa Monica Boulevard was a favoured venue for labels to headline new acts. Leo Sayer performed his first gigs there, as did Average White Band (AWB) and Elton John. One night, I was sitting at a table just in front of the stage with David and singer Claudia Lennear. We were there to see the old soul/blues man Bobby 'Blue' Bland. Towards the end of Bobby's set, as he was getting down all hot and sexy with a slow number, in walks this guy called Freddie – a middle-aged, straight-looking dude who was a cocaine connoisseur. His thing was knowing all the big bands and turning them on to his guaranteed goodies. He never needed anything as mundane as a backstage pass; his bags of fun made him the ultimate queue jumper. Heaven knows what Freddie passed me under the table that night. As I dipped the little silver spoon into the bottle, a delicate cloud of lighter-than-air crystals hovered in front of me, glinting under the coloured stage lights like a miniature indoor version of the Aurora Borealis. After a generous toot, we were all completely at one with Mister Bland. In fact, so good were Freddie's crystals, we were one step ahead of Bobby. Quite spontaneously, I hit on a backing vocal line and sang it into David's ear who, not being shy, immediately countered with a lovely harmony. By the time Claudia came in with a top line we were sounding like a little band of angels. The next thing we knew, one of Bobby's band members, prompted by the great man himself, swung a microphone on a long stand in front of us and off we went, into soul boy heaven, carried in the generous arms of a soul legend. Perfect.

David eventually got some finances (probably from RCA) to rent a place in Los Angeles on Doheny Drive. David and I had stayed with the Lippmans periodically, when we were both 'sofa surfing' with no fixed abode in LA. Nancy would lend me, and sometimes David, her bright-yellow Volkswagen Beetle convertible. Nancy was a teacher at a local school, and I would drive her there in the morning and collect her late in the afternoon. David and I loved that little car; driving around town with the top down in the LA sunshine was magic. If I wasn't at the Lippmans, I would quite often stay with my Chicago girl who would occasionally lend me her sports car. A car in LA is essential. Nobody walks. To walk would be considered eccentric, to say the least. Some nights, Michael and Nancy would treat me to a meal at Mr Chow or the legendary Dan Tana's on Santa Monica Boulevard. Michael was well known and liked around town and would always get a table. Sometimes the Lippmans and I would eat with Michael and Tina Chow, and other times I would go and hang out with David at his rented bungalow on Doheny. I was there one evening when Dennis Hopper and Dean Stockwell turned up; to me, they were two of the coolest dudes ever seen on screen. However, on this particular night, they were a little too cool. The two of them were beyond wired and David, if not far behind, was possibly ahead. Mere conversation, as such, wasn't hip enough to communicate; instead, they just stared at each other nodding or saying stuff like 'It's...it's like...you know what I mean...like...heavy man', to which the other would respond with a short whistle, followed by 'Yeah... it's like...far out'. This cosmic bollocks went on for an excruciating amount of time so, not being on their plateau, I excused myself and left.

Another night, at the house on Doheny, we were sitting on the floor of this long, oblong room. David had all his paraphernalia around him – books, papers, photographs and sketches, including his hand-written diagram of something called the 'Isolaric Alphabeth' (I have no idea what this is!) – and we were listening to the radio. The DJ kept telling us it was William Shakespeare's birthday, so I guess it must have been 23 April, St. George's Day in England. The DJ's name was, I think, The Shadow, and to celebrate the great

bard's birth, he kept playing English comedy records – snippets of *Monty Python*, *The Goon Show* and other more obscure material (obscure for the local Los Angeles populace anyway).

At some point in the middle of the night, when we were both pretty well in another dimension, David suggested we conduct an extra-sensory perception test, using me as the medium. He asked me to think of an object that was – though not to our knowledge – in the room, and I was then to write down a description of it. I concentrated as hard as a truly wired person can and wrote down four words: pyramid, windows, children, tree. We then searched the room for any item that might bear any correlation to one or more of my thoughts. We searched for quite a time, on tabletops, bookcases and in cupboards, but we couldn't find anything. All the while The Shadow was reminding us it was Shakespeare's birthday and playing more British comedy sketches, as well as a very tasteful selection of contemporary music. As we were about to give up the search, David, without much hope, pulled out a drawer that we had already looked in and found to be empty. This time, however, he saw something wedged in the back. Pulling it out, David looked at it open-mouthed and wide-eyed, as if he'd forgotten how to blink. 'Shit,' he said, and handed it to me. It was a Christmas card, about 8-by-8 inches. On the front was a picture of a Christmas tree in the shape of a pyramid. The tree was adorned with little windows that, when flipped open, revealed the happy, smiling faces of children.

Meanwhile, as the DJ kept reminding us, it was Bill Shakespeare's birthday. We decided that, since we were English, we would go and see The Shadow and take him a present. By now it was daylight but still very early – maybe five in the morning. With no stores open, we thought we'd make him something ourselves. We took a random book from the shelf, re-covered it and titled it *The Complete Works of William Shakespeare*. We found out where the radio station was, climbed into David's hired Mercedes and drove off. There was nobody on the roads at that hour, except for Mexican gardeners, so we were at the studio in no time. As we pulled up, coincidentally and for the first time in his show, The Shadow played his first Bowie track. As we entered the reception there was a guy descending a set of stairs to our left. He looked at David, did a visible double take, turned about face and rushed back up the stairs, two at a time, looking like a cross between Groucho Marx and Basil Fawlty. However, he quickly composed himself and was soon back down leading us upstairs to The Shadow. We entered the studio with Bowie's 'Young Americans' still playing on the air waves. 'I do not believe this!', said The Shadow. We gave him his book, signed from the two of us, which he was extremely delighted with, had a quick chat and left.

As we were driving back down Sunset Strip towards Doheny Drive, The Shadow came back on air saying, 'You are not going to believe this. David Bowie just walked into my studio with his friend Geoff, and they gave me a book on William Shakespeare that isn't really a book on William Shakespeare – it's really a book about quantum mechanics – but he was really just here in my studio talking to me with his friend Geoff... and they only left about five minutes ago... and...'

As we listened to him stumble chaotically through his tale, it occurred to us that nobody would believe him. After all, who would believe a man so ardently celebrating William Shakespeare's birthday in the middle of the night and who could apparently summon up the presence of David Bowie at 5.30 in the morning, just by playing one of his tracks?

> *'Is the sun dimm'd, that gnats do fly in it?*
> *The eagle suffers little birds to sing,*
> *And is not careful what they mean thereby,*
> *Knowing that with the shadow of his wings,*
> *He can at pleasure stint their melody.'*
> William Shakespeare, *Titus Andronicus*.

The Isolaric Alphebeth.

David's hand-written diagram of his mysterious 'Isolaric Alphabeth'.

The Winnebago that I drove from LA to New Mexico.

THE MAN WHO FELL TO EARTH
Forest Flower, Charles Lloyd, 1966

After three or so months hanging out in LA, sofa/bed surfing and doing very little in a constructive way, it was now the beginning of June and filming for *The Man Who Fell to Earth* was about to start. David and I would be living a healthy lifestyle for the next three months. David knew this was a new and important gig and would need his full concentration and discipline. This would see David at the fittest and happiest I'd ever seen him, and the photos I shot of him in this period bear this out. It occurred to me later how important it was for him to have the unit around him at this time, which included me, Corrine (who I'd re-christened Coco) and even driver Tony Mascia, all of us having been close to David for a long time.

My first job on *The Man Who Fell to Earth* was to deliver David's make-up and wardrobe trailer from LA to the set in New Mexico. When you're in your twenties and somebody asks, 'Can you drive a Winnebago?', you're nodding your stupid head and saying, 'Sure' before the 'bago' bit has left their mouths. Actually, I found it wasn't such a big deal, even though they're the size of London buses and not nearly as streamlined. A Winnebago, despite sounding quite exotic to a young South Londoner's ear, is in fact a giant shoebox on wheels. The one I had to drive did have automatic gears and power steering, though, and, as motor homes go, it was pretty spacious and comfortable – about the same size as a Tokyo apartment. In real-estate speak it 'boasted' a bedroom with en-suite shower, kitchen/lounge, colour television, sound system and air conditioning. This luxury box was to be David's refuge while on location in and around New Mexico.

Having driven the Winnebago the few miles from the hire depot, I got a touch overconfident, and not a little ambitious, and decided to undertake the drive from LA to Albuquerque in one go (nearly 800 miles, or 1,300 kilometres). It was late in the evening when I filled up the 'bago with gas on Sunset Strip. It was going to be a long night. However, I had a secret weapon: a local dealer had given me this ingenious fountain pen that was supposed to deliver a perfect hit of powdered pick-me-up every time the top was depressed. I was able to hold out for two hours before I needed the first pop of the pen, then took it from my pocket and had a couple of toots. Boy! Did that thing deliver! I was ready to drive all the way to New York. A few

Me in the Winnebago.

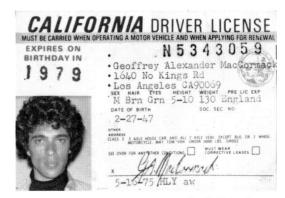

My US driving licence.

toots later, as I wondered why the dealer had never provided anything quite as potent as this before, the pen ran out, which was inconvenient because I'd only got as far as Flagstaff, Arizona, with 200 miles still to go. I quickly realised the pen had been delivering about a third of a gram with each hit; no wonder it delivered.

The Man Who Fell to Earth is about an alien who comes to our planet to gather water that can save his own. Needing money and resources to rebuild his spacecraft before he can return, he uses his superior scientific knowledge to build a business empire. Then, naturally, some greedy bastard spoils it and it all goes bandy.

I stayed at the Hilton hotel in Albuquerque while the film crew was assembled. The crew was predominantly English. In fact, it consisted mainly of Londoners. Some were on their first trip to the USA and were clearly very excited about it. All of them – electricians, lighting specialists, carpenters, wardrobe and prop technicians – had worked together before and the banter between them reminded me of what I missed most about London. The repartee went through the whole crew, up to and including the director, Nicolas Roeg, and cinematographer Anthony Richmond. As a director of photography,

Roeg had worked with François Truffaut, Roger Corman and Richard Lester, and he had co-directed *Performance* (1970) starring Mick Jagger. But it was his directing of *Walkabout* (1971) starring Jenny Agutter and his own son, Luc, and *Don't Look Now* with Donald Sutherland and Julie Christie, which really excited David. Both films are, arguably, the best of their genre and simplified David's decision to work with Roeg on *The Man Who Fell to Earth*.

Looking back, it was pretty courageous of David to take on such a big role. But he did it with his usual aplomb. Michael Lippman and David had contrived to get me involved with the production in any way they could. As such, my jobs included driving – the Winnebago, mostly – boosting morale, and being a stand-in for David when required by Mr. Roeg. The first of these activities I was okay at; the second I was pretty good at I think; the third was more difficult. Bear in mind that I have olive skin, green eyes (with evenly sized pupils) and dark brown hair, and you'll realise I'm not exactly David's doppelganger. We are more or less the same size, but despite some bright spark in the wardrobe department finding me a red wig to wear, as the shoot went on, I was mercifully used less and less as a stand-in.

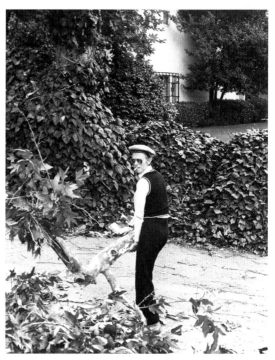

Tony Mascia at the ranch in Albuquerque.

I have no recollection of taking this snap of David dragging a branch!

After some time staying at the Hilton, David rented a ranch-style bungalow near Santa Fe, and Coco and I moved in with him. To reach it, you had to drive down a long, unmade, dusty track which led to a forecourt, lush with green trees and well-kept flowerbeds. The house was a large wooden building with three bedrooms, a lounge, a large kitchen, and a conservatory that led to a beautiful garden with pristine lawns and an outdoor swimming pool, in which I gave a couple of swimming lessons to David's son, Duncan, when he visited. David used the bright conservatory to start painting again. I even took up the brushes myself. It was very tranquil on a summer's day, with the sound of birds singing, the faint trickle of water in the pool and the occasional scraping of pallet knives mixing paints. In fact, those were some of the most calming moments of my stay in America.

Less calming was the plague of moths New Mexico experienced that summer. The first I knew of it was one morning when I started up the Winnebago. As the big old engine growled into life, from every nook and cranny, from behind every curtain, in fact from every orifice – perhaps including my own – flew hundreds of large moths. Now, one-to-one I'm not particularly fazed by a moth. I can even tolerate the odd tickling sensation when, with cupped hands, I occasionally deposit one out of a window. But this? This was Hitchcock's 1963 film, *The Birds*, and I was Tippi Hedren. I freaked out, just a little bit.

Freakier still was the sight we encountered at Carlsbad Caverns National Park a few weeks' later. David, Coco, Sabrina Guinness (who was working on the film) and I borrowed a car from the film crew and drove from Artesia to see these great caves. They were pretty spectacular, with massive underground chambers and countless rock formations; the deepest cave descending 1,600 feet. The caves are also the summer home of the Mexican free-tailed bat, which gives birth between June and July before migrating south in October to spend winter in Mexico. Every evening, the bats leave the caves

David doing his stork impression.

David buys a model aeroplane for…err…Duncan?

Lolo, Mary Samuel and Sabrina Guinness in Santa Fe.

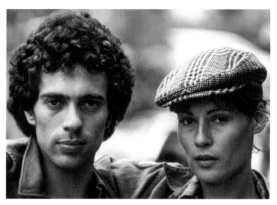

Me and my girlfriend, Lolo, snapped by David.

to feed. Thousands of them perform this mass exodus, swirling through the mouths of the caves like a scene from a vampire movie. It's unforgettable, and not a little eerie. On the way back from Carlsbad, we stopped at an antiques fair. David bought me an old railroad pocket watch that he'd seen me admiring, which I still have. Then, feeling a bit peckish, we found a fast-food diner full of local folk and fat, red-faced tourists. A few of the locals seemed to recognise David and were giving him funny looks that said, 'Look, it's that English weirdo rock star...' David picked up on it and decided to adopt his meanest look, lest any fool try to mess with him. I thought, at first, that he carried it off quite well. He leant against a wall, arms folded, in his brown leather bomber jacket, with a sneer on his face suggesting a very bad smell was in the air. When I looked back at the rest of the room, however, it was apparent that David's act wasn't working. In fact, no one seemed to be looking at David's face at all; rather, they were looking at his legs. Turning back to David, I understood why. Although the top half said, 'hard man', the bottom part had adopted some bizarre yoga position, with one foot hitched up to rest on the other knee, stork-like. We left shortly afterwards.

Back at the ranch, Lolo came to visit. Tony Mascia collected her from the airport in secret, then David and Coco hid her in the house to surprise me. I cottoned on that something was

up, though, when I smelt her distinctive (and apt) perfume, *Je Reviens* (I Return). She stayed a while, came on set a few times, and was lucky to visit some great locations like Santa Fe, which really is quite beautiful. One of the cameramen fell in love with her and would stare at her with the expression of a faithful dog. I think Nic Roeg approved too because, when he first saw her, he walked directly up to her, studied her face intently and, without averting his gaze, simply muttered, 'Yes'.

White Sands is a somewhat inhospitable place. It's 275 square miles of desert near the Mexican border, close to Alamogordo and El Paso. Wildlife, plant or animal, is at a minimum due to the fine, white, gypsum sand that continually moves and shifts with the wind, creating lovely patterns but burying all vegetation. It is, however, a great place for blowing things up, which is why NASA and the US military used it as a missile testing site. Its spooky landscape also made it a great double for an alien planet, and it was here that Nic filmed the scenes of Bowie and his alien family before he falls to Earth. It is also where we met a real-life astronaut – Jim Lovell – who had been booked for a cameo appearance in the film, playing himself. Jim was a quiet, unassuming man with a ready smile and gentlemanly nature that belied the fact that he'd been involved in the most harrowing experience in space travel. Not that I expected Jim to be able to levitate or anything,

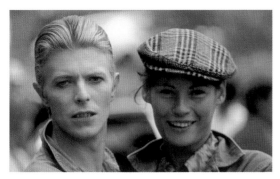
David and Lolo, snapped by me.

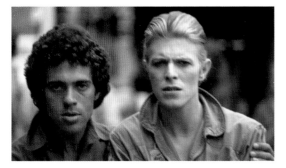
Me and David being (Monty Python) Gumbys.

A genuine space boy!

but seeing him standing at a hotel bar swigging a few beers and chewing the fat, just seemed incongruous somehow. Far too normal for such a remarkable man.

Less amiable than Jim was the singer/pianist Fats Domino, who David and I saw play at the Hilton in Albuquerque. When he was nine-years-old, David's dad had bought him the Fats Domino record 'Blueberry Hill', which we loved, so we were really looking forward to seeing the man himself perform it live. The big man took to the stage with rings on every finger and his hair greased back. Our excitement, and a good few beers, had us shimmying and swaying through a nostalgic set and afterwards we stumbled backstage with all the confidence and swagger you'd expect of two guys who'd just polished off 28 bottles of Budweiser. We knocked on the big man's door and, from inside, there came a booming voice.

'Who is it?'
'David Bowie,' said David Bowie.

'Who?' replied the voice.
'David Bowie, from London.'
'David who?'

By now, rat-arsed drunk that we were, the whole situation seemed incredibly funny. A big posse of attractive Black girls arrived, knocked on the door and gained immediate access from a very large bodyguard. David tried once again and, at last, got a response. The door opened and there, looking down on us, was the same huge bodyguard. He informed us that Mr Domino was busy right now, then closed the door in our faces. David didn't take any offence from this episode. On the contrary, it was all just too amusing.

Towards the end of the shoot, the crew started to come to its senses and the American girlfriends, whom they had been planning to leave home for just a month earlier, were off-loaded in haste. I was sad to have to leave the ranch house. Of all the places that David had rented, we'd been the happiest there.

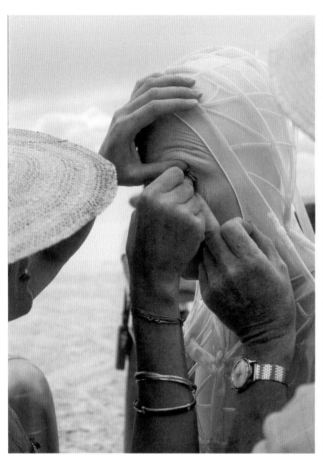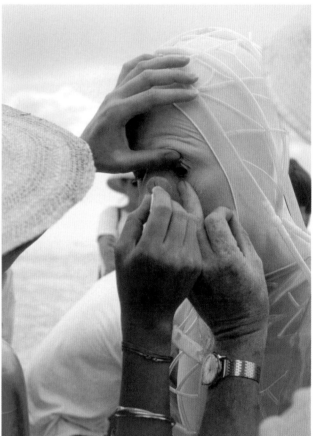

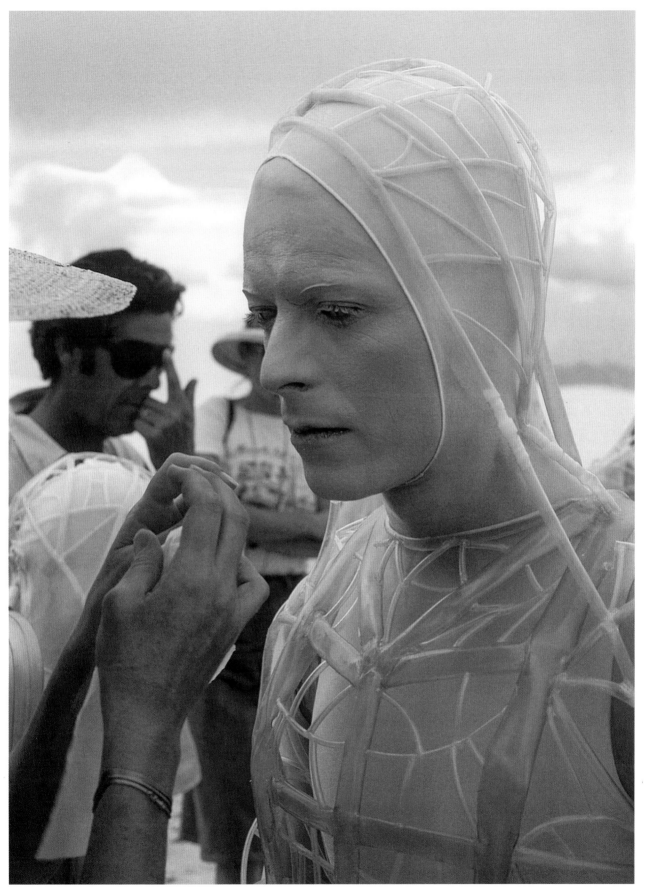

Above and opposite: David getting into costume for *The Man Who Fell to Earth*.

Filming *The Man Who Fell to Earth*.

David with his co-star, Candy Clark.

Above and right: Me shooting David in the mirror of his dressing room.

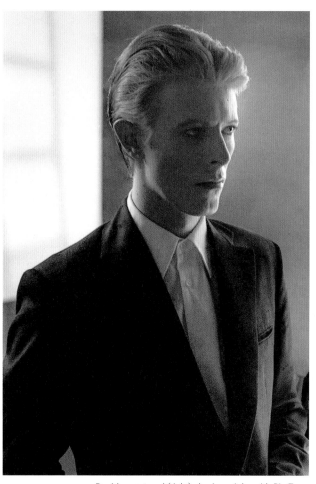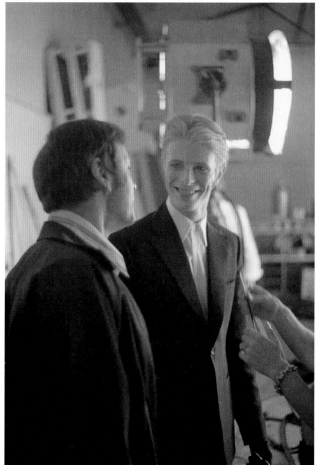

David on set and (right) sharing a joke with Rip Torn.

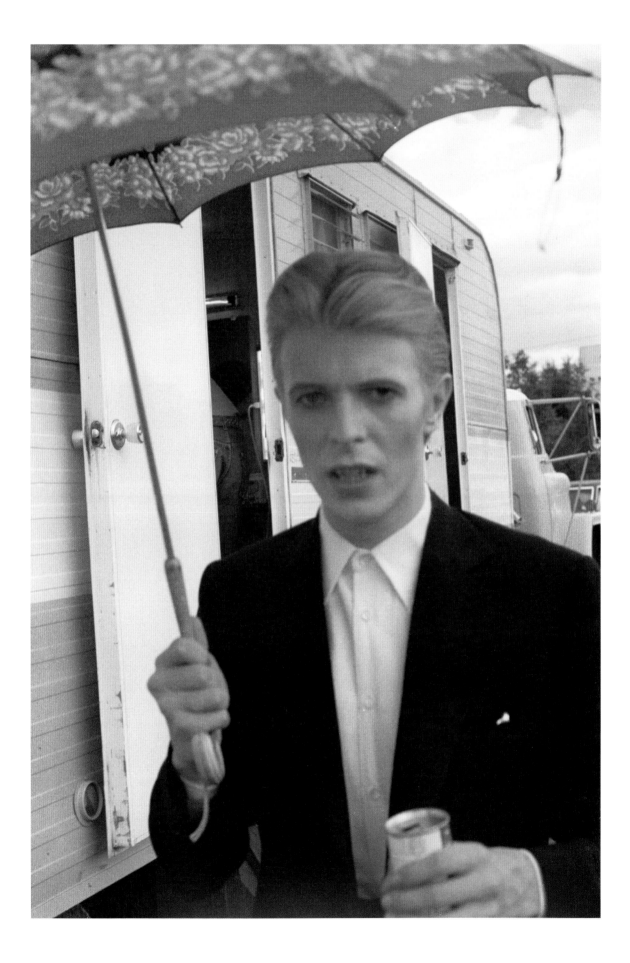

Geoff is one-up in the cup shooting contest!

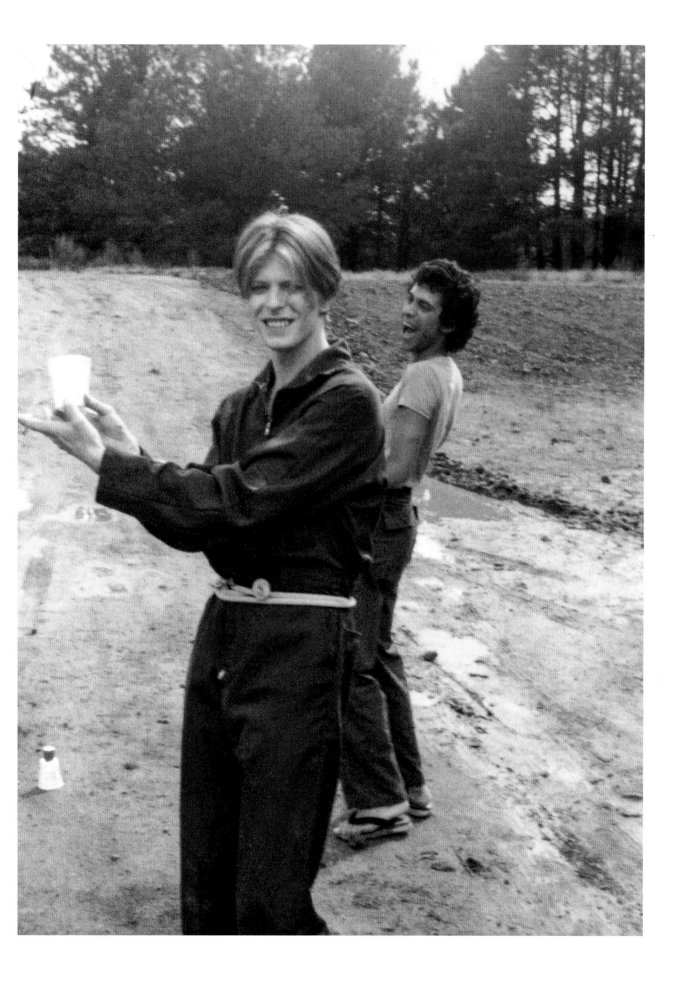

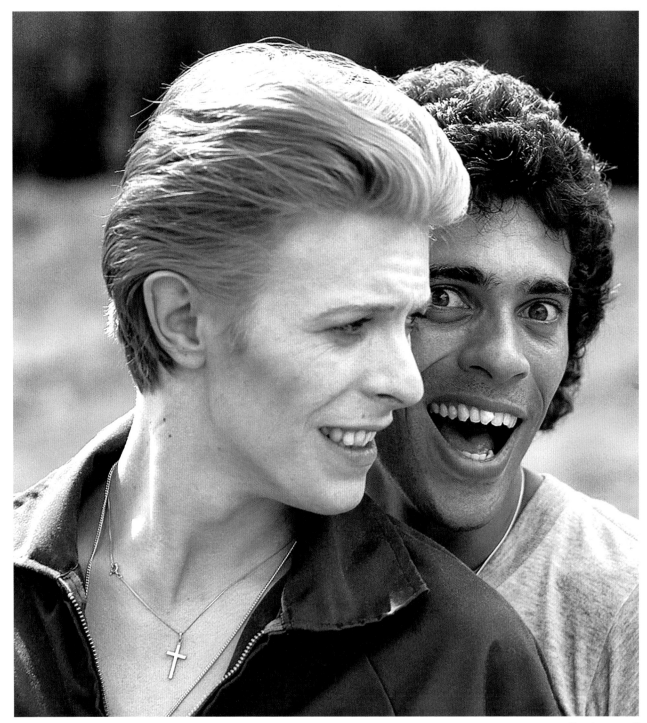

Messing around!

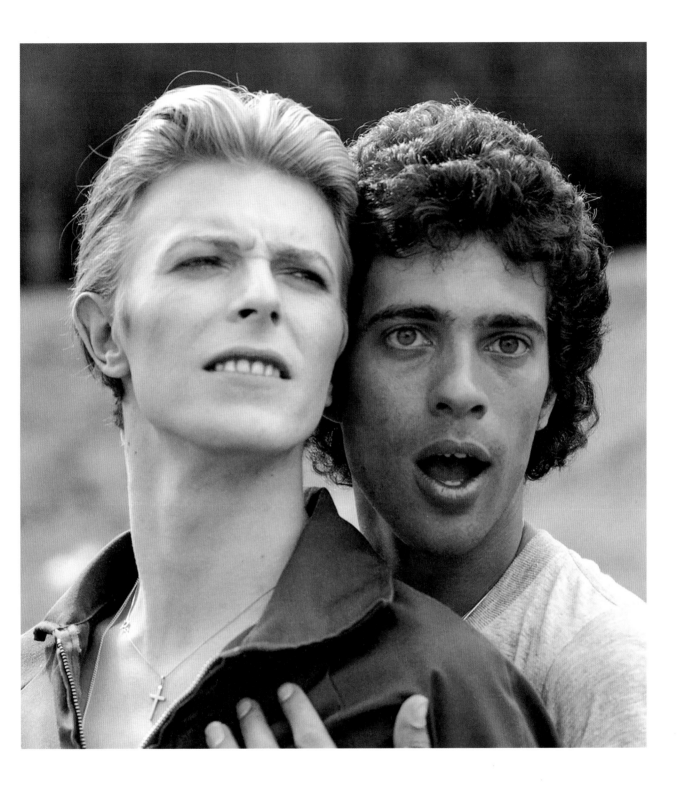

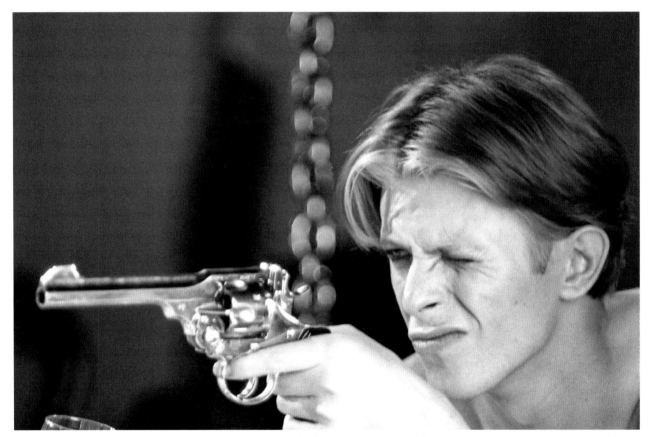

Above and right: I only discovered I had these images in 2020! They are now in my collection.

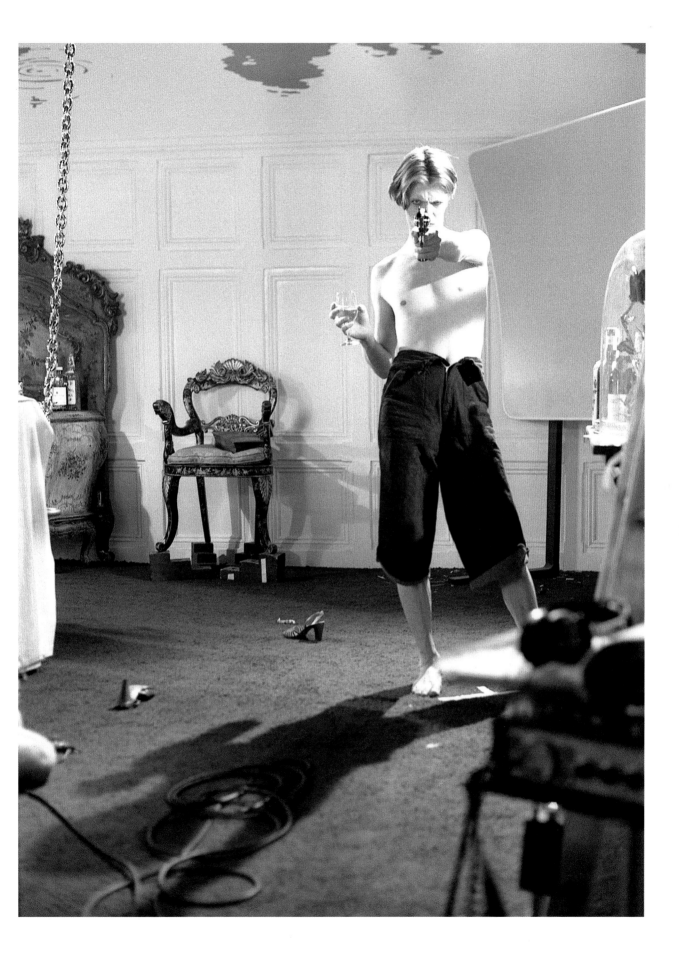

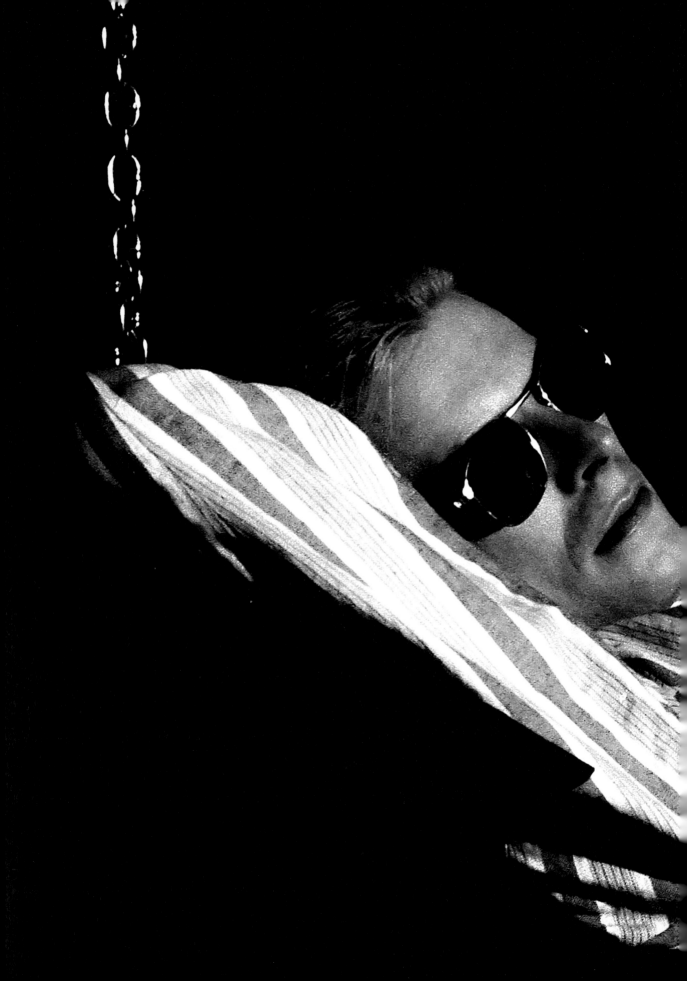

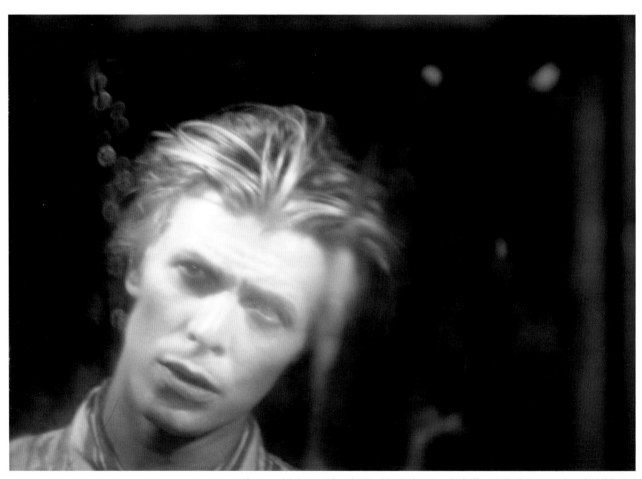

Above and right: David perfecting his Marlon Brando (left) and Charlotte Rampling (right) looks!

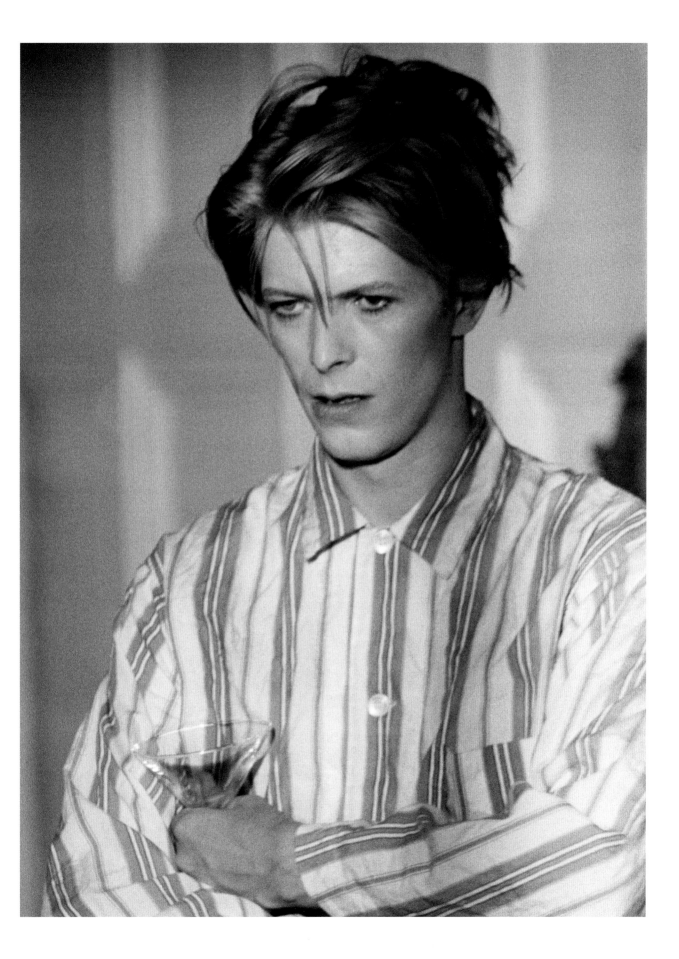

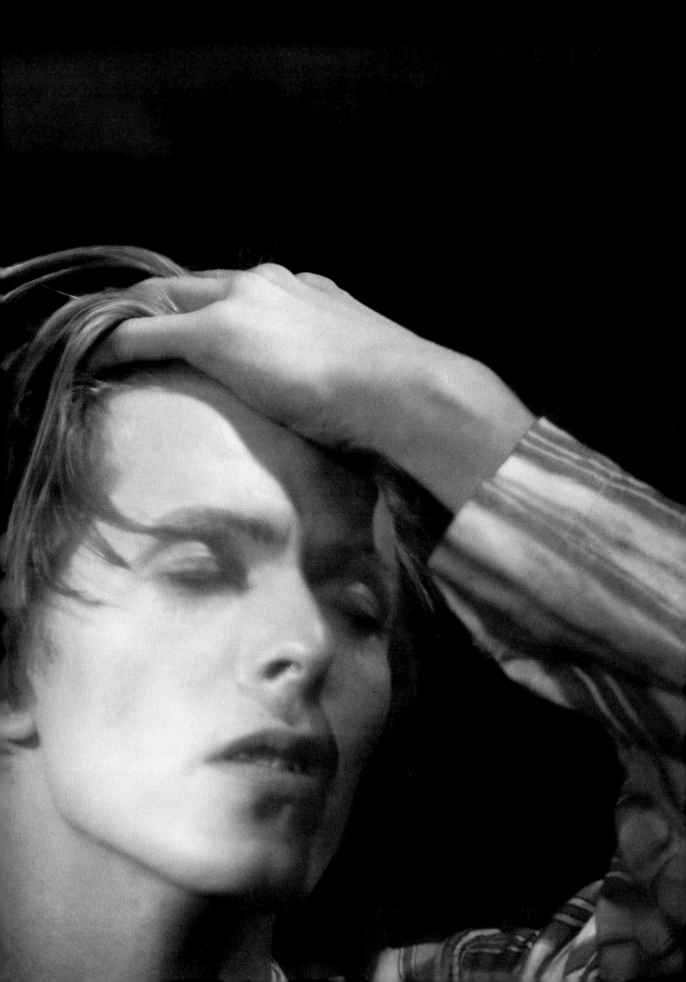

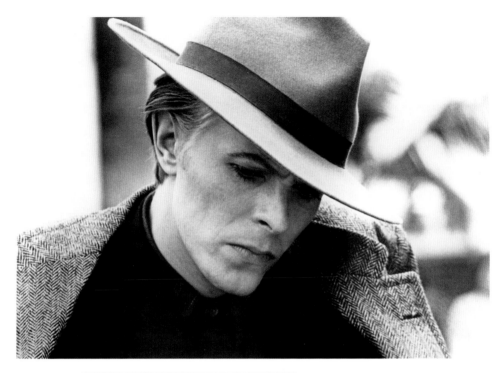

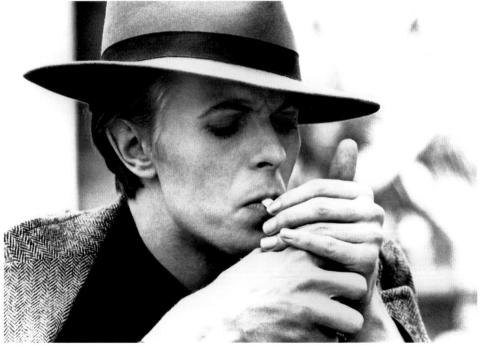

These pictures were taken towards the end of filming *The Man Who Fell to Earth*.

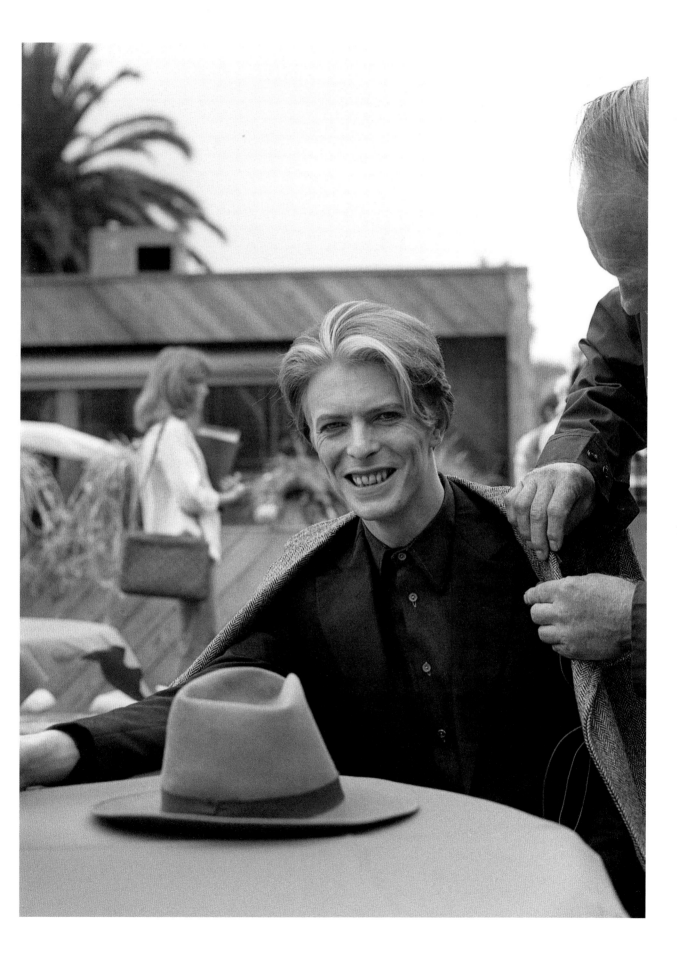

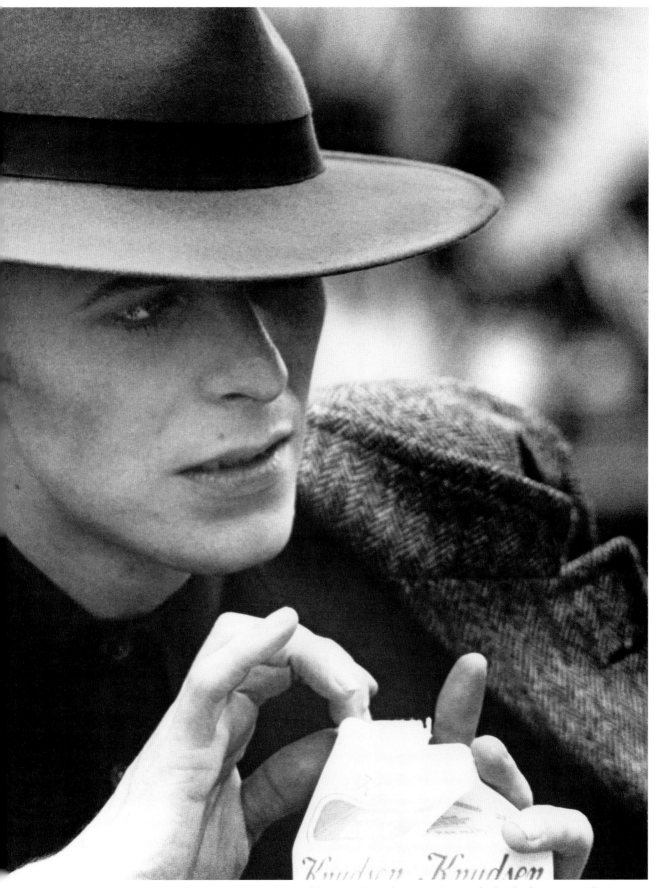

This shot was chosen for one of the series of 'David as an actor' images for the Isle of Man stamp collection 2022.

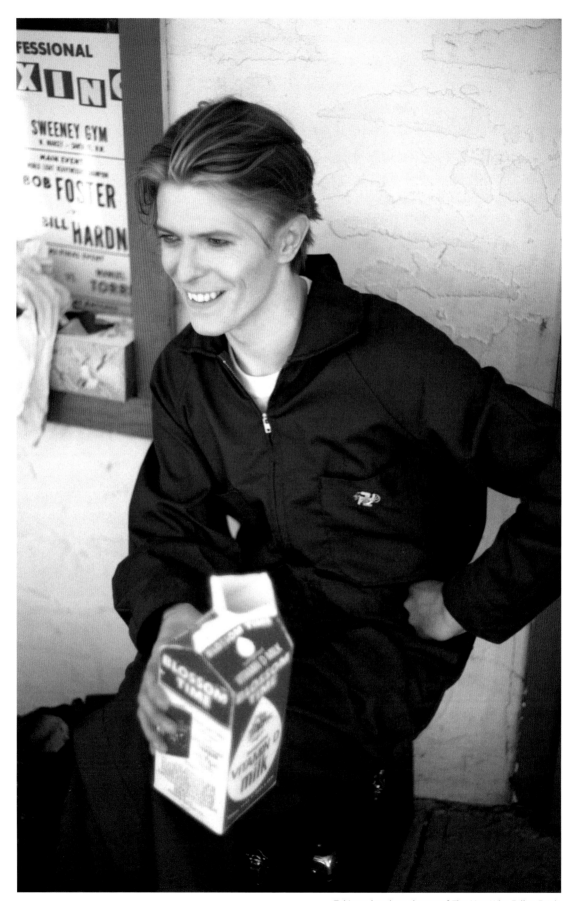

Taking a break on the set of *The Man Who Fell to Earth*.

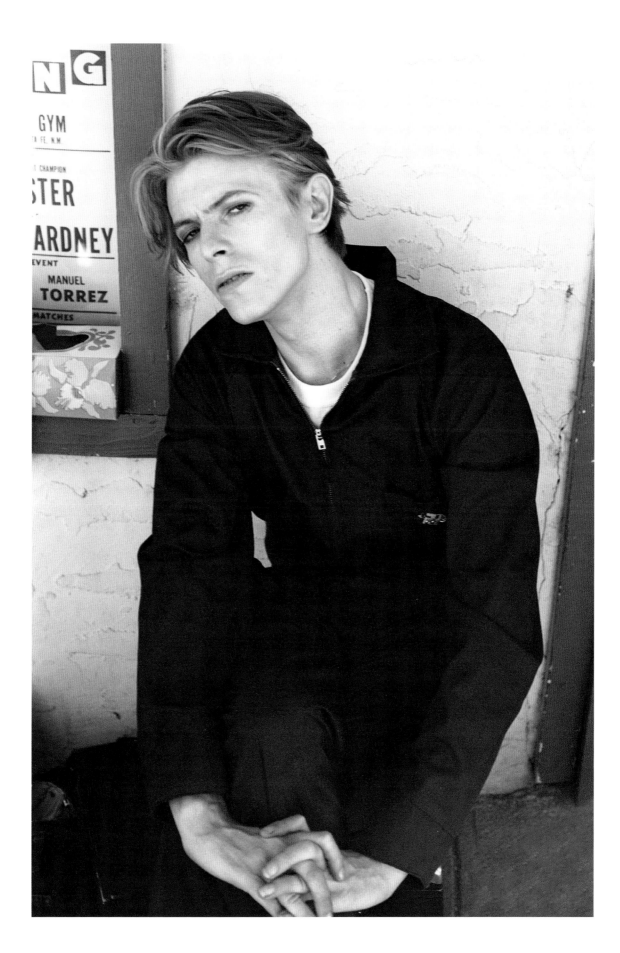

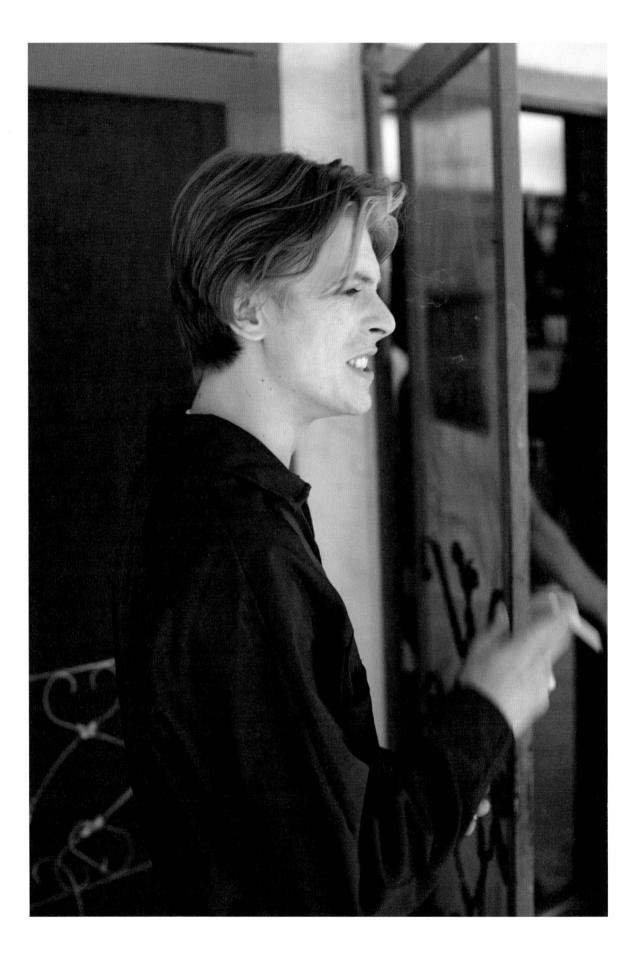

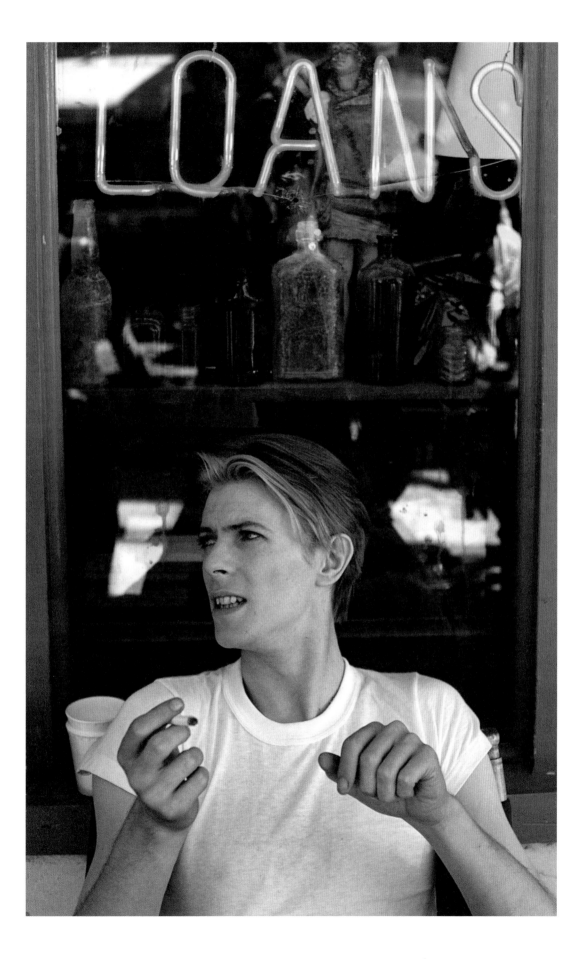

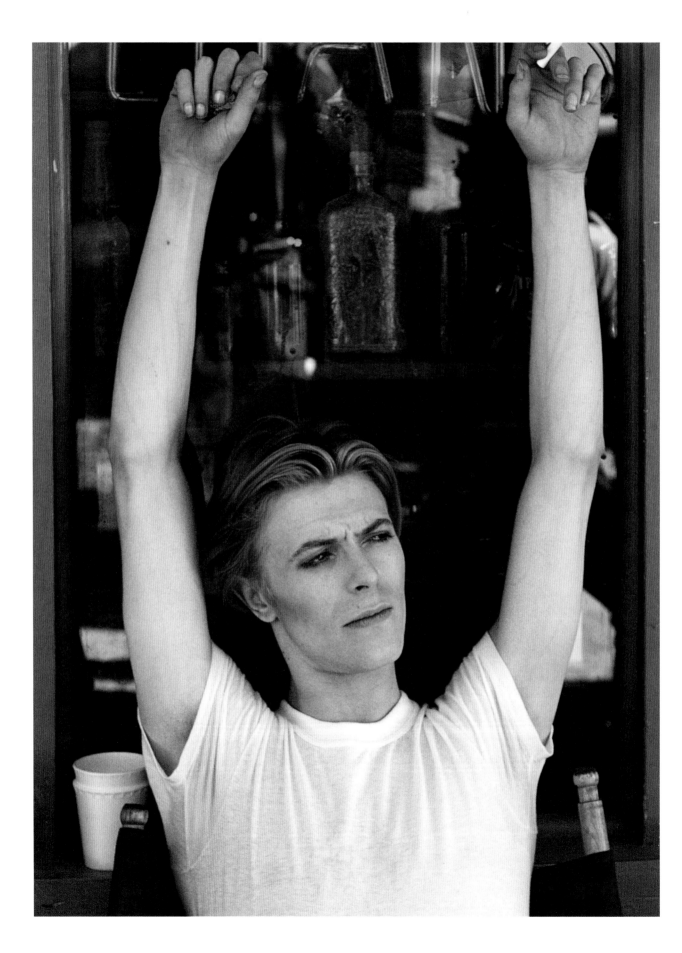

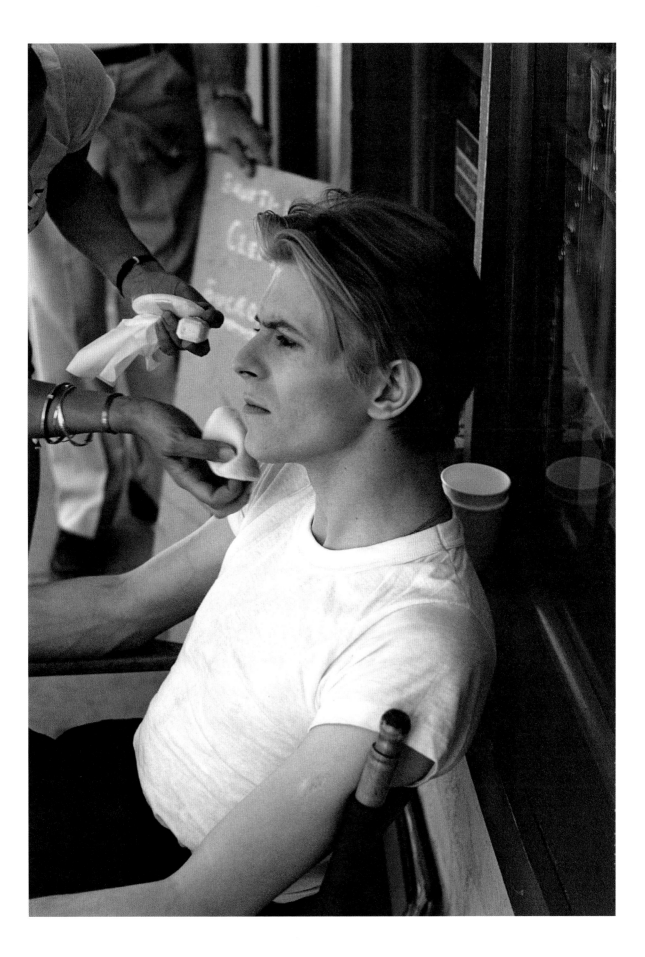

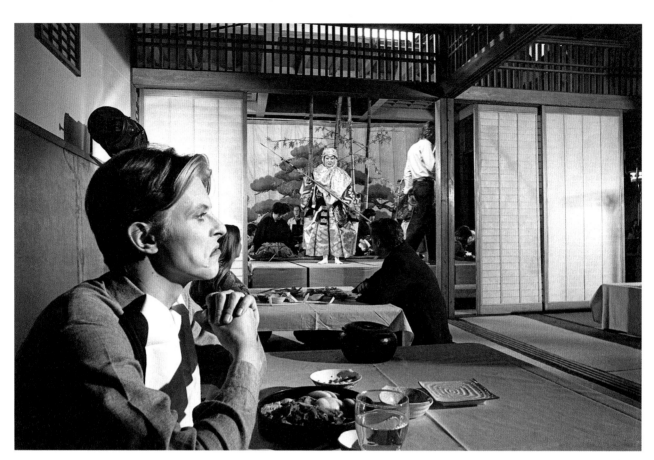

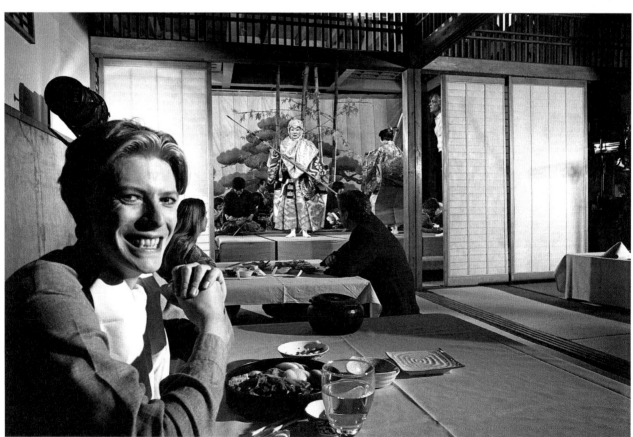

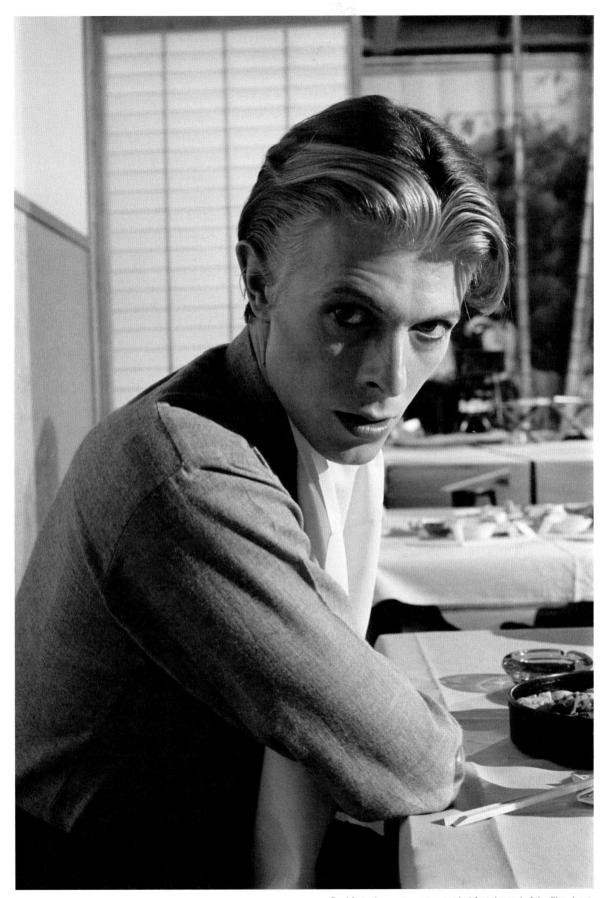

David at a Japanese restaurant in LA at the end of the film shoot.

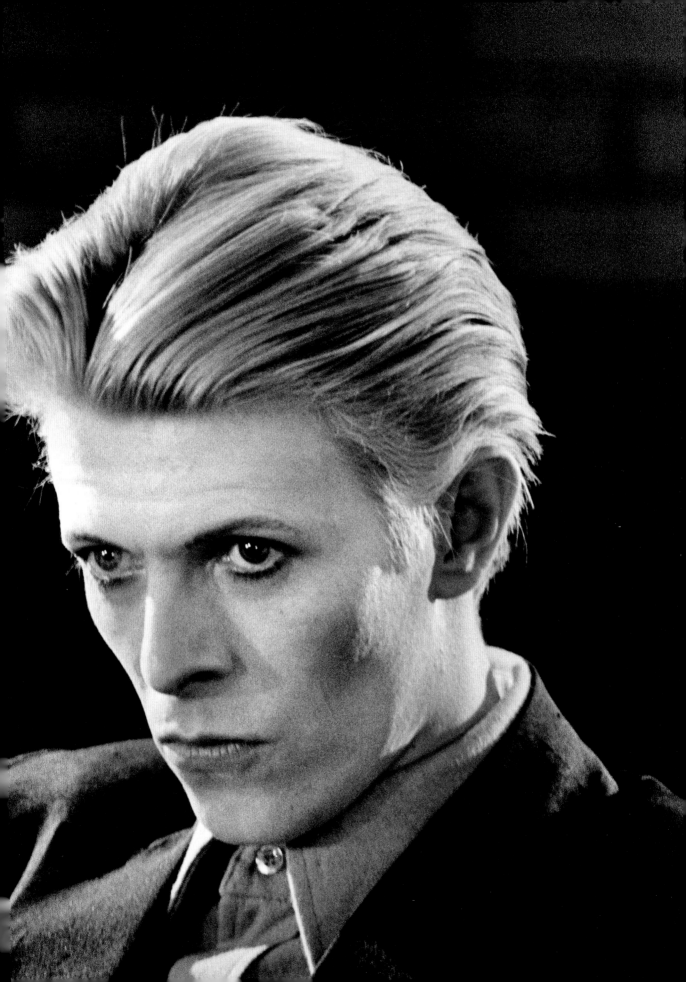

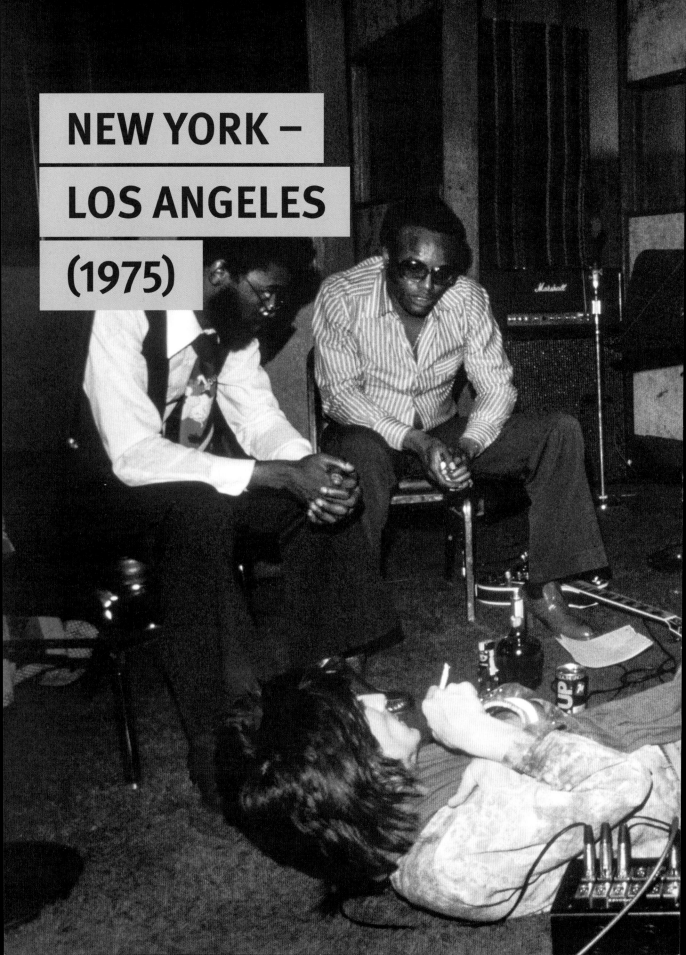

NEW YORK –
LOS ANGELES
(1975)

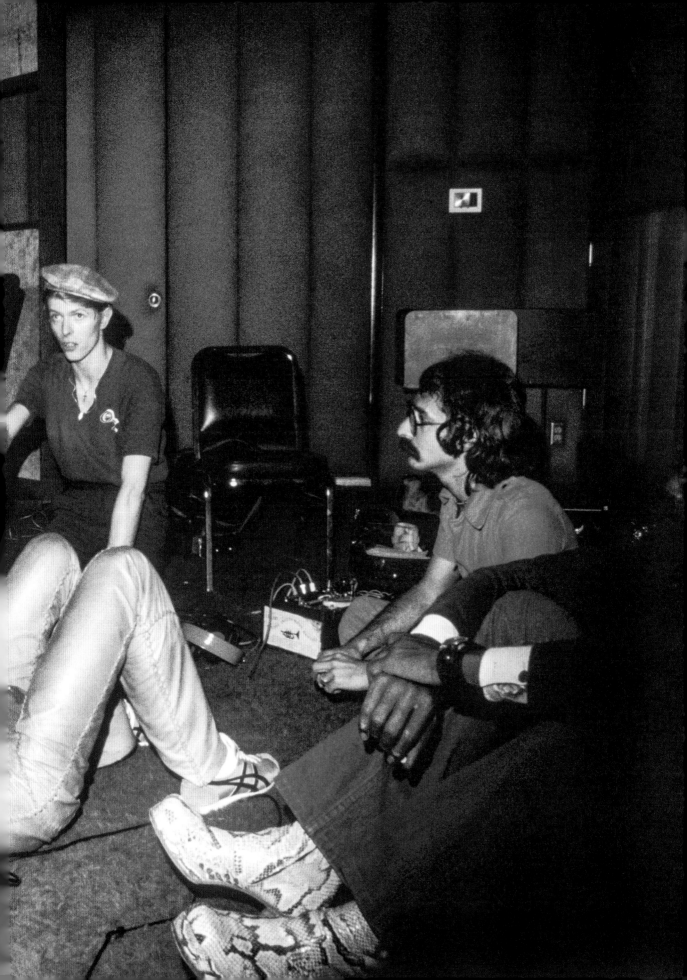

Dennis Davis on drums.

Roy Bitten on keyboard.

Bassist George Murray.

Bobby Womack on guitar.

'Golden Years', David Bowie, 1975

I began to think that I'd had my fun and I should probably be heading back to London and the real world. My visa was up and there was nothing for me to do, so I thought. But the lure of Los Angeles kept me hanging on and I decided to put off getting on with the rest of my life for a later date.

The first thing I needed was an extension on my visa, which meant leaving the USA and getting my passport re-stamped on re-entry. I flew to San Diego, hired a car at the airport, and drove across the border into Mexico. I rolled up in Tijuana, did a U-turn and drove straight back into the USA. Proud of the precision and simplicity of my plan, I strode confidently into the customs office. Then my heart sank. In front of me was a queue of roughly 200 Mexicans and they all looked like they'd been waiting a very long time. They sat or lay all over the floor, clutching their meagre baggage, some with

David and Harry Maslin mixing at the Cherokee Studios, 1975.

sombreros pulled over their faces as they slept. Those who were awake, without exception, bore looks of dejection and resignation. As a queue, it wasn't up to much – certainly not in my eyes anyway. We British are a race of master queuers, after all. But it was so long and disorganised that I couldn't begin to guess where the end was. I looked towards the counter for some official guidance and there he was, wearing a crisp, white, short-sleeved shirt, an official-looking badge and identity tag, a pair of baby blue eyes and what looked like the merest suggestion of a pout. He looked back at me approvingly, beckoned me over, and asked how long I planned to stay in the USA, to which I replied, 'Oh, three months. Maybe six'. He gave me a little smile, which I coyly returned, and he stamped me up for another six months. As relieved as I was to get out of there fast, I must admit I felt like a bit of a slut.

When I got back to LA, I moved into a small nondescript house that David had rented. So nondescript, in fact, that I remember very little about it, although it could have belonged to bassist Glen Hughes. Just after David, Coco and I moved in, and between shooting the final scenes of *The Man Who Fell to Earth* in LA, David started work on new material that would later become *Station to Station*.

David decided to retain the services of Carlos Alomar, Earl Slick and Dennis Davis, and to recruit George Murray on bass and Roy Bittan, from Springsteen's E Street Band, on piano. It was good to see Slicky and Carlos again; as well as being fun to work with, they were great friends too, and still are.

In LA, the city exerted its strange forces on us, and soon we were keeping irregular hours and

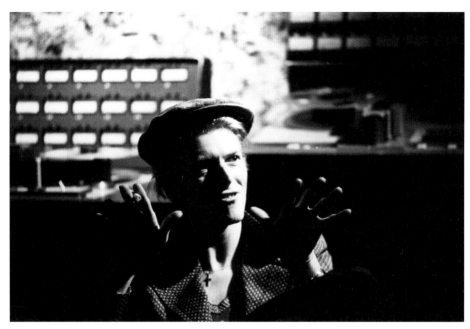

David listening to playback.

eating erratically, as before. Sometimes David would stay up for a few days at a time, working on new ideas for the album. He was recording at Cherokee Studios in Hollywood. I didn't visit too often when the band were recording; only when David was putting down vocal tracks, or if I was required to record some backing vocals, did I pay a visit to the studio. Occasionally, I would sit at the recording desk with producer, Harry Maslin. David would often ask me how things sounded. Strangely, this was never a situation I felt awkward with. David's pitch and timing was exceptionally good – this isn't flattery, it's a fact known by anybody who's ever worked with him – but I might say something like, 'I preferred how you did it before,' or 'Why not try so and so?' I was the only back-up vocalist on *Station to Station*, but it wasn't the most taxing of tasks. It was pleasing to be able to have some kind of input now and then.

Such was the case with the vocal arrangement for 'Golden Years'. I'd woken up in the middle of the night and gone downstairs in the nondescript house in Beverly Hills to see David sitting on the floor cross-legged (his favourite writing position) writing a new song. I sat

down beside him and he sung me the song-in-progress, called 'Golden Years', for which he was still working out the arrangement of the chorus. He wanted it quite loose, casual. I loved what he'd already done in terms of its flavour, especially the 'Come b-b-b-baby' bit. I extended the idea by dropping the 'golden years' phrase the second time around and replacing it with a long, up-and-down, swooping 'gold' phrase and adding 'wah, wah, wah' on the end. David loved it and let me fiddle around with the 'run for the shadows' section as well.

When we came to record the backing vocals for the song, David lost his voice halfway through, leaving me to finish the job. That meant I had to sing the rest of the backing vocals, including a series of impossibly high notes before the chorus, which were difficult enough for David but were absolute murder for me. Thirty-five years later, in 2010, David had seen me write about this episode and sent me an email saying something like, 'Eh?' Bearing in mind I had only made a small number of contributions to David's output, I got somewhat adamant – precious even– about my arrangement activities in my email reply. Various

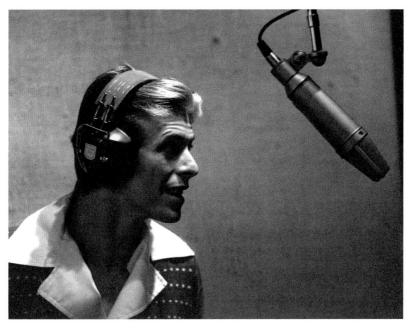

David recording vocals.

emails crossed between us until he must have sussed that I was a bit miffed and came back with, 'OK, you can have the wah wah wahs then'. I think I was too sheepish to remind him that I'd sung most of the backing vocals, too.

While *Station to Station* was being recorded, we moved out of Beverly Hills and into a house on Stone Canyon Road in Bel Air. It was a mock-Tudor affair with electric gates and security guards. Though it looked fairly substantial and impressive from the outside, inside it was somewhat shoddily put together. With thin partitioning walls and lightweight doors, it was the sort of place where if you farted in the downstairs cloakroom, you got a round of applause from the first-floor bedroom.

In the big downstairs room, we set up a stereo unit with a record turntable, a tape-cassette deck and two huge speakers. Sometimes we'd drive down to Tower Records on Sunset Strip and buy some albums. The album we became totally obsessed with in that period was Kraftwerk's *Autobahn* (1974) with its wonderfully designed, almost cartoon-like, cover of an autobahn from a

driver's perspective. Another album we bought, purely on spec, was an album by Slask, a Polish folk choir, which had an amazingly haunting track called 'Helokanie'. We'd try and mimic the sound with its high-pitched choirboy-type vocals, to what result I can't remember but we absolutely loved it. The track would later become the meat on the bone of 'Warszawa' from Bowie's 1977 album, *Low*.

With David's new status and connections as a movie star, we went to a couple of A-list parties. Once, at a daytime gathering at producer Si Litvinoff's beach house, I couldn't resist telling Julie Christie how beautiful she is. When she said, 'You're not so bad yourself', in my tiny brain it sounded like she'd proclaimed un-dying love for me, and I sort of awkwardly shuffled away. Even more awkward, was the moment at another A-list do with the great and the good of Hollywood. I looked up from the sofa I was sitting on and was met with the incredibly beautiful blue-green eyes of Charlotte Rampling, who was alone and leaning against a baby grand piano, like she was on the set of a Forties movie. She was probably thinking,

Brian Duffy.

An image David loved. Me with Coco in Madison Square Park, NYC, 2010.

'Isn't that the guy who delivers my cat food?' However, when I looked at her, she didn't avert her gaze for what seemed an eternity; so long was it that, coward that I am, I just had to look down, thereby losing a staring competition with one of the most beautiful girls in the world.

I'd also been to an extremely odd rock 'n' roll party at Peter Sellers' house for his 50th birthday, which featured a huge stage full of famous recording artists like Bill Wyman, Ronnie Wood, Joe Cocker, Keith Moon, and with David and Bobby Keys messing around on saxes. Problem was, all of them, at least during the time we were there, were too self-conscious to play anything together, resulting in such a horrible noise that the police came to break up the party. After a while, The Who's drummer Keith Moon, of all people, smoothed things over with the police to stop them carting Sellers away. The whole time, Sellers stood motionless with a slight smile on his face, like he'd passed wind in the middle of this mire, and the exact same demeanour that I later recognised as

Chauncey Gardener, his character from the film *Being There* (1979).

Around this time, David was beginning to be even more of a nocturnal creature. Coco and I would try to create some kind of order by occasionally cooking breakfast and getting David up before noon. But one was loath to wake somebody who'd been awake for three days straight. On a good day, Coco and I would knock on David's bedroom door with a glass of juice and a mug of tea and proclaim, 'My Lord, William of Orange and the Earl of Grey to see you', and he would reply, 'Enter'. Then I would hang out with him for a while, watching a film or some TV – the children's program, *Mister Rogers' Neighborhood*, was a show which eternally fascinated us. That's how it was. On a good day.

Some nights, we'd get to the studio – where there'd always be a huge platter of cheeses, fruit, a barrel of beer, wines, milk and juices – and David would sit at the mixing desk, sigh and

announce, 'I don't really feel like this tonight', and off we'd go back home or maybe to a club. One night we went to see Bruce Springsteen at the Whisky on Sunset Strip. I remember he did a wonderful cover of Manfred Mann's 'Pretty Flamingo'. Other nights, David would work at home, reviewing different tracks that would boom from powerful speakers in the cavernous main room and thunder through the thin walls of the house. Coco slept through the noise with earplugs. I coped by staying awake with David until I collapsed.

Once I tried another method of coping. I was sitting at a table with Coco and Eric Barrett, David's tour manager, in a funky rock 'n' roll joint on Sunset Strip called Rainbow. Somebody had given me a couple of pills called Quaaludes, popular downers at the time. I'd had them before, but they'd done nothing for me. So that night at Rainbow, I reasoned that if I took a few Quaaludes halfway through dinner, by the time I got back to Bel Air they might have kicked in and I would get a much-needed good night's sleep. So much for my theory. I wound up slumped face-down in my pasta. Coco and Eric had to carry my lifeless body into the LA night and I endured them ribbing me about it for weeks after.

At one point, David gave me the chance to stay in LA, with the idea to send me to the Lee Strasberg drama school, but I wasn't really up for it and have never really regretted turning the offer down. Acting is a pretty tough gig, even if you're totally committed to it. The other offer I had when I was in LA was one that I *have* often regretted not taking.

I was asked by the legendary photographer, Steve Schapiro, if I wanted to become his assistant. Steve had a studio in LA and had done some great stuff with David, but it was his documentation of American history, the civil-rights movement, Robert Kennedy, and sports and film stars that set him apart from a regular studio snapper. Had I been older and wiser, maybe I could have dealt with the pressures of Los Angeles better. But at the time, all my friends – apart from the Lippmans – were junkies, and I would have blown it and let him down. That would have been bad news because he was a great guy. A year or two later, when I was back in London, I asked the photographer Brian Duffy, who I'd met on the set of *The Man Who Fell to Earth,* if I could be one of his assistants. He replied, 'Yes, if you go and work in a colour lab for two years first'. My mouth said 'Sure', but my tiny brain said, 'Fuck that'.

It was now late 1975. I'd been away from home for nearly three years, and I was getting pretty homesick. I had a family in London who I'd hardly seen since 1972; Lolo was in France, and I had an apartment on Blackheath in London that I'd never actually lived in. Since David had no more projects planned and had returned to painting again – some pretty crazy stuff too! – and the atmosphere at the house had deteriorated, I became more than a little paranoid, like something bad was going to happen. It was time for me to go home.

> **Other nights, David would work at home, reviewing different tracks that would boom from powerful speakers in the cavernous main room and thunder through the thin walls of the house. Coco slept through the noise with earplugs. I coped by staying awake with David until I collapsed.**

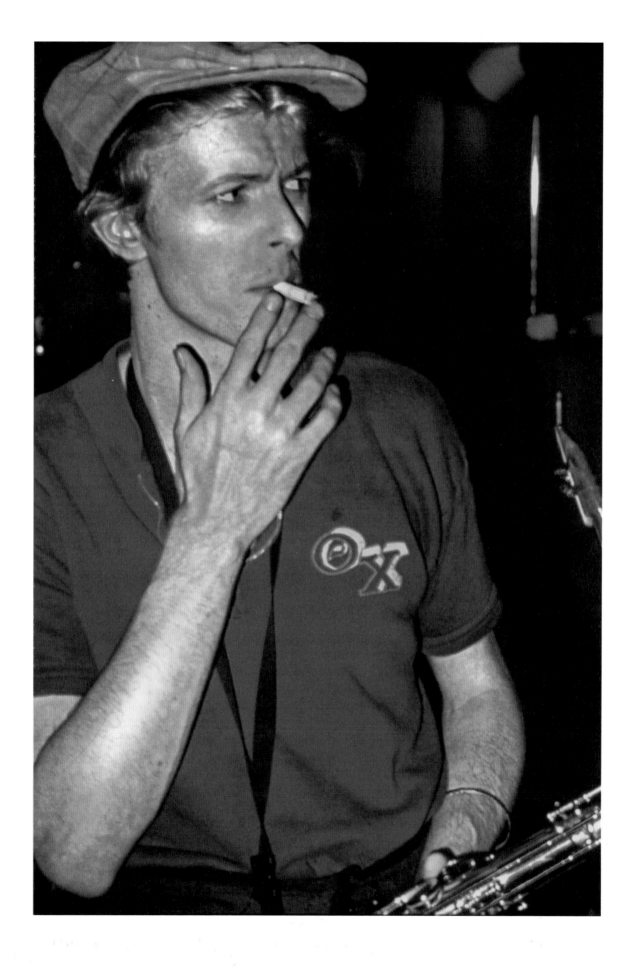

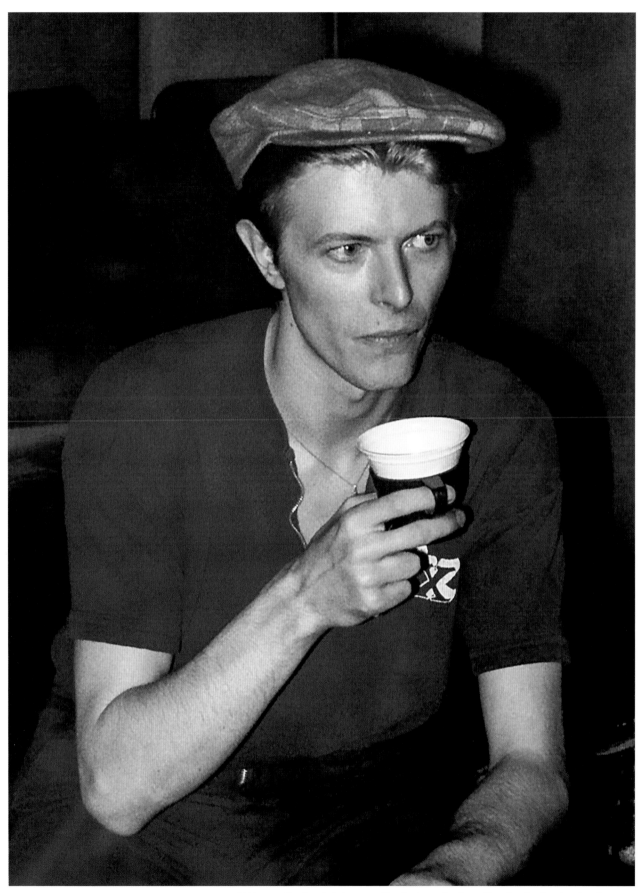

Taking a coffee break during recording *Station to Station* at Cherokee Studios, Los Angeles, 1975.

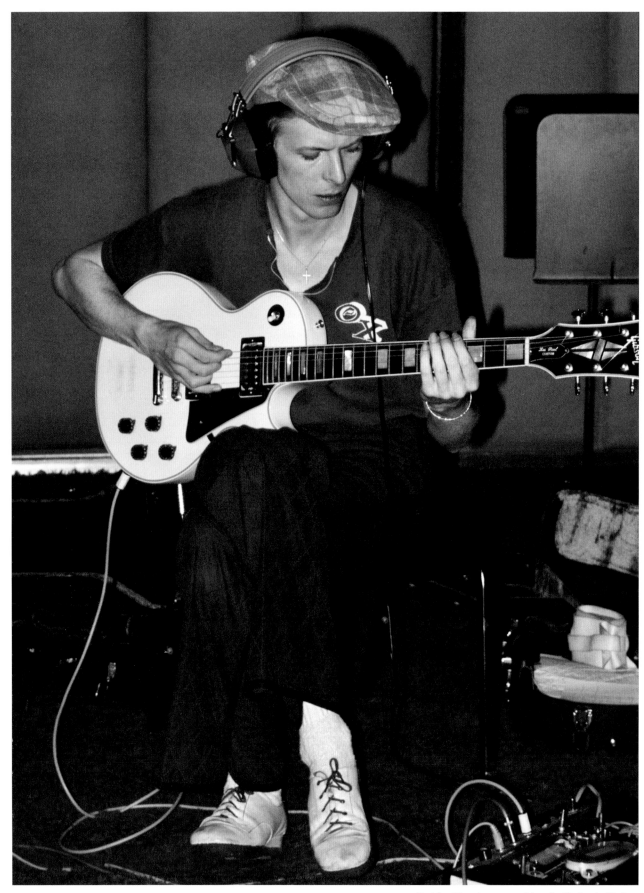

David putting down some ideas for *Station to Station*.

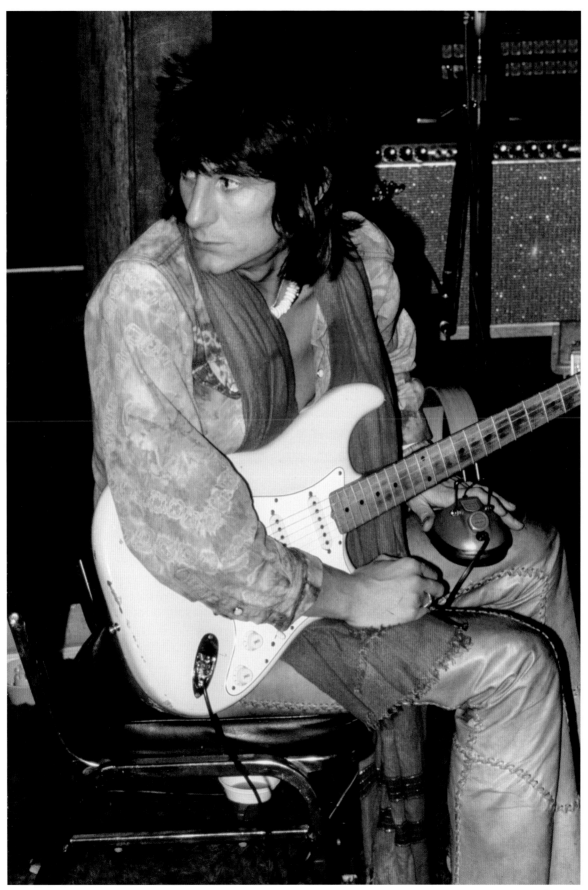

Ronnie Wood.

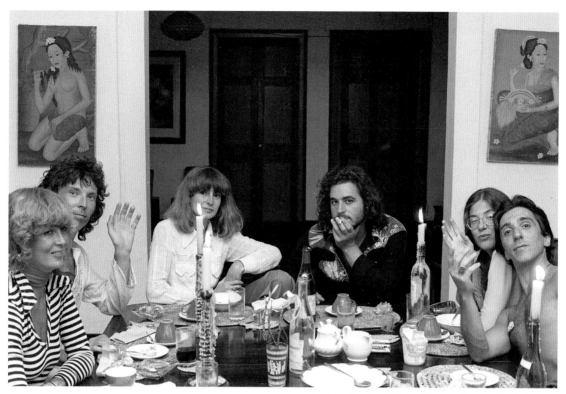

Halle, John, Sandra & Michael Kamen, Margo & Gui Andrisano.

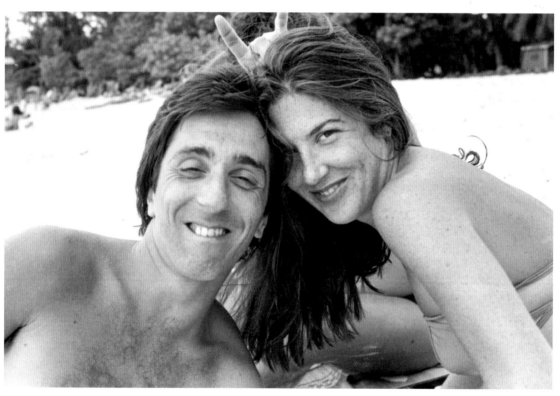

Gui Andrisano and Margo Sappington.

REHEARSING IN JAMAICA
'Funkin' for Jamaica', Tom Browne, 1979

After spending Christmas with my mother and sister, I started 1976 in the Caribbean. I went with Michael and Sandra Kamen, Gui Andrisano and his wife Margo (Sappington) and another couple from Los Angeles, John and Halle, who'd been one of the make-up artists on David's film.

We had a wonderful holiday in Barbados, staying in this big old house on the rocks overlooking the sea, and eating fresh fish bought direct from the fisherman who had caught them only hours before. We spent the days on fantastic beaches swimming in warm seas, then one evening I got a distraught phone call from Los Angeles. It was Michael Lippman.

Apparently, David had fired Michael, which is something I didn't see coming nor, more to the point, did Michael, who said, 'Geoff, you gotta talk to him'. Something had happened during the brief time I'd left Los Angeles and arrived in the West Indies; what it was and how it had escalated so dramatically, I'm not sure, but it was terminal. If I could have talked to David on Michael's behalf, I would have done willingly, as I found the thought of them falling out so badly truly depressing, but this was well before the convenience of cell phones and David was on the high seas cruising towards Jamaica to rehearse for his next tour.

A few days later, Gui and I flew to Kingston, Jamaica, where we had friends and also to meet up with David, who was rehearsing for his Isolar Tour at Dynamic Sounds recording studio, debuting the Station to Station material. The first night in the Kingston hotel we were staying at, I ran into a girl I knew from Beckenham. She was an air hostess with British Airways on a stop over, and she was with five or six other attractive hostesses. That evening Gui wasn't feeling too well so I went off with the girls to find somewhere to eat. As I was walking down a road with all these great-looking girls, now out of uniform, I heard someone say 'Eh!' I looked around but didn't see where it came from. Then I heard it again. This time I saw him. He looked about 60 with a lined face and not many teeth, leaning against a wall with a dusty old cap on the back of his head, chewing a match in the corner of his mouth. He beckoned me over and, with a furtive look, said something I didn't quite pick up. I had assumed he was going to offer me some spectacular weed, so I asked him to repeat himself. He took the match out of his mouth and said, just audibly, 'Ow com ya got so much pussy?'

The next day, I met up with David after his rehearsal. After hearing about the abrupt firing of Michael, I was a bit nervous my friend might not be in good shape, so I was really happy when I set eyes on David to see that he looked great, with a slight tan and that he'd put on a bit of weight. We went out to a club that evening and David had his personal trainer in tow. I tried, unsuccessfully, to bring up the issue of Michael Lippman but this was not the time for reconciliation for David. He was to spend the next few years dealing with breakups and drawn-out legal proceedings with MainMan (his old management), Michael Lippman (his new management), his interim 'stand-in' management, his marriage to Angie, debts to a host of recording studios, and numerous payment issues.

BACK HOME
(1976–1991)

'Come Down', Lord Tanamo, 1963

'Best ever "come down" tune!'

The summer of 1976 seemed to last two years. I was back in Beckenham, where it all began, during one of the hottest periods in England's recent history, with hose-pipe bans and, in some places, people queuing for household water. I was on a 'come down' from three years of alien activity and unhealthy substances, and it would take a long time for my brain to catch up to reality. Strangely, this was the first time I got into the game of cricket; it seemed to have the discipline and order I'd been lacking over the last few years. It was also going through a 'changing of the guard', from the old school Geoffrey Boycott, to the new Ian Botham and Viv Richards. This cricket was vibrant and exciting, and I'm still hooked. There was also a change musically. This was the year that punk really exploded (possibly as a reaction to Pink Floyd's *The Dark Side of the Moon*, 1973), similar to the explosion of rock 'n' roll some 20 years before.

My continued relationship with the beautiful Lolo just wasn't possible on a purely practical level. I was broke, her life was in Lyon, France, 500 miles away, and she had a young daughter around six years of age. If I'd had unlimited funds, it may have been different but I didn't have a job, or much of a future plan, to offer any kind of stability. So, no more meeting Lolo at international airports with orchid in hand, or flying back to France with carefully chosen 1930s and '40s clothes from flea markets in America. We never even had a conversation about a split, perhaps because the reasons were so obvious. *Je suis désolé* Lolo.

After making the massive adjustment/comedown (lifestyle and dietary) following my departure from LA and the rock 'n' roll existence, I still had no plans for the future. In fact, I don't even think I'd considered the future. In May, David played six nights at Wembley. Known as the Isolar Tour, he had a pared-down band of just five musicians, retaining Carlos Alomar, Dennis Davis and George Murray from the *Station to Station* recording and '74 tours. The staging was also simple; using stark lighting, which I'd heard David discuss before, the whole effect was strong and direct, although he looked even thinner than he did in LA. Although I wasn't involved in the show, I was flattered that he'd used five of my images in the Isolar Tour program. He'd used others for publicity shots, too, and for this he'd paid me. Unfortunately, the cheque inconveniently bounced. I didn't want to bitch too much with someone who'd taken me around the world, so I let it go. Two years later, in 1978, David used the shot of me, bare chested, presenting him to the camera in his spaceman attire in the Isolar 2 program.

I had to sell my flat on Blackheath, which made me little or no profit. Without realising it, some 18 months or so just flew by. Of course, I missed hanging out with David and touring, but not being around the various meltdowns and dramas in the process; David severing relationships with Angie and Michael Lippman (among others), who'd been part of his (and my) journey, would have been hard to witness. Also, as much as I love Berlin, there's something a little grim about Andrew Kent's black-and-white photographs of David in his black leather coat. The important fact is, I needed to establish my own gig.

A NEW GIG
'Bad Stuff', Upp (featuring Jeff Beck), 1975

Just when I was thinking of getting a straight, ordinary job, I had a change of luck. I was having a drink in a pub (as usual) with the guitarist Mark Pritchett one lunchtime. It wasn't just any pub, but the Three Tuns in Beckenham, home of Bowie's Arts Lab of a few years earlier. Mark had been a near neighbour of David's at Haddon Hall, and had also been a member of Arnold Corns, the band David put together featuring Freddie Burretti. Mark was with this other muso called Simon Goldenberg, who happened to be in Mark's current band. After the pub, we went to my mother's house for a little impromptu jam, and while Mark was playing a few licks on his electric guitar, wailing away in his own world, Simon started playing an idea of something on my mum's baby grand piano.

When his idea fizzled out, I joined it up with a half-arsed idea I'd had and, hey presto, we had an idea for a song. I said to Simon, 'Maybe we should meet up and write some stuff', and thus a writing partnership was accidentally born at the Three Tuns in Beckenham.

It was decided that we should have some purpose to our song-writing future. The plan was that I would be the singing vehicle of our efforts and that we would get a much-needed advance from a record company, or maybe from a publishing house, which would put us in a more comfortable financial position. After we'd written a few tunes, we hired some recording equipment: a two- or four-track tape recorder (I don't remember which), a mixing desk and microphones. I do remember it taking up quite a lot of space in John's lounge – my sister Rosie's very patient boyfriend. To be fair to Simon, he managed to commit something to tape that was enough to obtain money from a few record companies for further demos and, eventually, a deal with Island Music Publishing.

This took us to the next level, the next level being a proper dedicated recording studio which, strangely enough and unbeknown to me, had another link back to David.

> **This took us to the next level, the next level being a proper dedicated recording studio which, strangely enough and unbeknown to me, had another link back to David.**

My cousin Isobel told me about this studio that her and her boyfriend, Andy Clark, used to live above in Greenwich, which had moved to New Cross. She said she might be able to get a deal for me. Her boyfriend was a singer, songwriter and keyboard player in a great little band called Upp, which was championed and produced by Jeff Beck. The studio was called Underhill Studios and, spookily enough, had been where Bowie and the Spiders from Mars had rehearsed back in 1971, with Lou Reed and Iggy Pop rehearsing there the following year. The studio was run by drummer Jim Copley's dad, Les Copley. We were lucky in as much as, with Upp, we had the perfect house band at our disposal to hire as session musicians for our demos. They were all great players and pleasant to work with.

Another gentleman associated with the New Cross Underhill Studios was John Parry. John loved music and came into the studio now and again to listen to what we were doing. He also had a little drinks bar upstairs which was used by the 'great and good' of South London, especially the faces in and around Old Kent Road, like the landlady-cum-boxing promoter, Beryl Gibbons, from the Thomas A Becket pub. Sometimes we'd go up to the bar when we'd finished recording and say to John, 'Here are the keys, we've locked up downstairs and we're finished for the night', and John would say, 'Have a drink'. This wasn't optional. If you said, 'No thanks', you took the risk of someone getting you in a gentle but firm headlock, as refusing a drink upstairs at the Underhill Studios drinker was not house policy.

After so many years in London without much to show for it, finally, at the beginning of 1979, we were able to score a decent publishing deal with Island Music Publishing, and they also managed to find more money for Simon, who was already signed to them. Unfortunately, all this corresponded with me meeting 'the blonde with the big blue eyes', who was wonderfully irresistible but a compulsive liar, starting with the hair (not blonde!). We (actually, she) thought it would be a good idea to take a lease on a lovely house in the Kent countryside.

After having a lot of interest from Chrysalis Records, that fizzled out. I then got a singles deal with EMI, who brought a couple of producers over from San Francisco to record me. Apart from the fact we didn't really hit it off, after seeing the big Kent country house that we lived in, set in acres of land, and the blonde with the big blue eyes, they got it into their spaced-out heads that I was a drug dealer and spent most of our doomed working relationship asking for 'a taste'. Naturally, the recording at AIR Studios was a pile of garbage. In fact, the only interesting memories from that time were Sir George Martin popping in

with his family one night, and our tape-op being Renate Blauel, who would later marry Elton John. On reflection, I wished we'd let the little guy with the huge glasses – signed at the same time as us at Island Music Publishing – have a go at producing the same track when he'd asked. I rather think that Trevor Horn would have done a better job!

Sometime in 1980, I went to see David in Switzerland. I travelled with Sabrina Guinness, who was a friend of ours from Los Angeles. We went to visit him at his chalet in Blonay near Montreux. While we were sitting at the airport having a drink and waiting for our flight out, Sabrina looked wistfully into space and said, 'The last time I was here I was on my way to see Charles and the Queen [Elizabeth]'. I didn't press her on the details, but I sensed it hadn't gone too well. I remember that when we arrived in Montreux, we had dinner with the Chaplin family, with Oona (the last wife of Charlie Chaplin) and an assortment of her sons and daughters. After dinner, we went back to David's house and he played some video of one of the Mike Garson Band warm-up sets from the *Young Americans* Tour, which was the first time I'd seen myself on stage. I was singing 'Stormy Monday' and David said, 'Nice vocals Geoff', and I must admit, it wasn't bad. It just wasn't great either.

MUSIC SCORES
'I've Got No Time to Lose,' Carla Thomas, 1964

Since the publishing and recording advances had been spent, Simon and I had no income to keep us going. So, I thought it would be a good idea to create music for film production companies. With no better ideas, and time drifting away, this is what we did.

We somehow scraped together enough finance to buy some recording equipment. This, historically,

216

could not have been better timed. We were at the birth of sampling and MIDI (Musical Instrument Digital Interface), which allowed synths and drum machines to connect. Fortunately, Simon took to studio engineering like a duck to water. Armed with a Fostex 8-track reel to reel, a Yamaha DX7 keyboard synthesizer, a drum machine, a small mixing unit, Simon's guitars, and a decent microphone, we cobbled together a collection of various musical styles to use as a showreel.

I asked my old friend George Underwood whether he knew anyone making films. He only knew one person, Roger Lunn at a production company called Gregory Lunn Challenge, but this turned out to be a real piece of luck as they, Laura Gregory and Roger Lunn, were just starting out too. We were all at the beginning of a new chapter of our lives. Simon and I were happy to help them out and we did a few funny little jobs here and there for them and their associates; 50 quid here, 100 quid there. Eventually, with their help, we finally got a TV ad for Club 18–30, where we basically copied The Who's 'My Generation'. Being involved with Laura and Roger gave us much-needed experience.

When David was in London in 1983 filming *The Hunger* with Catherine Deneuve and Susan Sarandon, he was staying in a block of serviced apartments near Sloane Square. I went up to see him one day and he was playing some 45 rpm records from the Sixties. He decided to be quizmaster saying, 'OK, who's this then?', and I said, 'I think that's The Contours', or whoever he was playing. As luck would have it, I just happened to know all the tracks he tested me on.

Throughout our lives we would always discuss music we liked, past and present, starting from the time we were kids in David's little bedroom in Plaistow Grove when we would spin 78s on his Dansette record player. He turned me on to The Isley Brothers in the Sixties, with 'Twist & Shout', 1962, and I turned him on to James Brown (*Live at The Apollo*, 1963). He enlightened me in the Seventies to the wonderful album *Astral Weeks* (Van Morrison, 1968), and I made him aware of the sweet voice of Philippé Wynne of The Spinners singing 'Love Don't Love Nobody' (1974). I also remember sending David a vinyl of Prince's '1999' that year, 1983.

> **Throughout our lives we would always discuss music we liked, past and present, starting from the time we were kids in David's little bedroom in Plaistow Grove when we would spin 78s on his Dansette record player.**

At some point later in the day we decided to go to a nearby pub for a drink. On the way to the pub, David asked me what beer I was drinking these days. I said, 'I drink a light and bitter' and he said, 'I think that's what I'll have then', and so he did. I liked David asking me my opinion. One time, back in the '70s, he asked me who I thought was the best British singer at that time and I said I thought it was Paul Rodgers, lead vocalist of Free. A couple of days later, I read in the music press a statement by David saying that he thought Paul Rodgers was definitely the best singer around at that time. I was entirely happy that I could be trusted on two of the things so close to my heart: beer and music.

I went to see David on one of the sets of *The Hunger* in Mayfair, London. When they folded for lunch, some of us went to a local pub. As I was standing at the bar, Catherine Deneuve walked in by herself. I asked her if she'd like a drink and she looked, somewhat aloof, not at me but

somewhere ahead, high into the distance, and said, 'Give me a light beer'. So, I did. Had she said, 'Give me a light and bitter', I think I would have got down on my knees and kissed the feet of that girl.

When Laura and Roger got their first decent film budget for an Italian beer company, we were invited to score it, which was really trusting of them. We repaid their trust by winning a Gold Clio Award for best international music score. Laura asked me and Simon if we'd like to go with them to New York to collect the award, so we went down to my friend Lloyd Johnson's shop on Kings Road, picked up a couple of decent suits and off we went.

STARTING A FAMILY
'Daddy/It's you', The Vikings, 1964

In 1985, I met Sarah and got married. It was now time to start a family and grow up (a little). We lived in Maida Vale, London W9, in a one-bedroom flat with a balcony overlooking Elgin Avenue. Simon, my writing partner, lived about a quarter of a mile away in a three-story house big enough for us to make a small studio to work from. Simon and I were getting really skilled at scoring films in terms of the seconds we had to work with in advertising and, in general, I felt grounded and organised and life was good.

In January 1986, my daughter Iraina was born down the road at St Mary's Hospital in Paddington. Some years down the line, she would become the singer, song writer and DJ, Iraina Mancini, playing clubs and radio and spinning the old tunes that I listened to as a Mod in the '60s and the Salsa David and I discovered in New York in the '70s.

Three and a half years later, my second daughter Adriana was born (mother of Milo, my first grandchild). By then Simon and I were doing well,

My daughters, Adriana and Iraina in New York in the mid '90s.

and I'd bought a big apartment with high ceilings, again in Elgin Avenue. Sarah was a wonderful mother, and the girls were always beautifully dressed but not spoilt. She wasn't one of the pushy mothers hustling the teachers at the school gate. Sarah and I had our separate jobs with Sarah as a stay-at-home mother and me as the breadwinner. We were so immersed in our separate roles that we didn't have time to realise that we didn't really know each other; two strangers under one roof. We always had wonderful holidays in villas with pools in Spain or Portugal and I have some great photos and film of the girls in LA and Sri Lanka. I love the photos of the girls' tomato-smeared faces devouring pasta at our favourite place, Franco's Lido Azzurro in Santa Maria de Castellabate, southern Italy. I have

some hilarious film of Iraina narrating a tour of the Palazzo Belmonte, where we stayed. It was a period when she decided to call me Geoff instead of Dad. I remember a well-dressed lady at an airport on our return from one of our trips approaching Sarah and I, saying, 'Your girls are the most beautiful children I've ever seen.' We were speechless!

The holidays, private school, a sky-high mortgage and just general living, cost everything I made and more, and I was forever juggling finances. Pensions were cashed in and re-mortgaging, at ridiculously high rates, was a frequent occurrence, just to keep things going. To be fair to Sarah, she at least let me manage the finances but over the years it took its toll on me as sole provider. My partner Simon, on the other hand, didn't have the cost of children and he made me aware that he'd made enough to quit and retire. That, and the fact that Simon had something of a depressive personality, made my situation extremely volatile.

Our marriage of 23 years ended as it had started, two strangers under one roof. Fortunately, Sarah met somebody who didn't have to blag and scheme his way from one financial respite to another. Happily, I met the girl from the park.

PARADISE LONDON
'Try a Little Tenderness', (the sublime)
Otis Redding, 1966

In 1986, David invited me, George (Underwood) and our families to a place in Gstaad, Switzerland. George had two young children, daughter Mia and son Tas, and I had a newborn baby girl, Iraina, my first child.

David arranged an apartment for us with incredible views across mountains so that we could go skiing; that is to say, *David* went skiing. After a preliminary crash course (mostly crash) from David, I spent most of my time trying to remain upright as David took to the slopes. George and I were extremely impressed and surprised (if somewhat jealous) at 'The Jones Boy' elegantly gliding down the mountainside while we fumbled and fell like newborn foals on the slight incline at the bottom of the mountain. We all got terribly drunk that night on very good red wine.

The following evening, we all went to dinner with an acquaintance of David's who lived further up the mountain. It was a bit of a slog with George's kids and our baby but when we arrived, our host – whose name, I think, was Fred or Vlad – welcomed us into his luxurious home. George immediately spied a genuine Picasso on one of the walls. Fred or Vlad and his wife were an extremely handsome couple: tall and blonde, the epitome of taste and success (although, sadly, according to David, sometime later Fred or Vlad had a fatal accident up a mountainside). After dinner and another long slog back down the mountain, we got back to the apartment block and David realised he'd forgotten the entry code. He pressed a couple of buttons to no avail, then suddenly and dramatically snatched the baby from Sarah's arms, pressing every button available and shouting into the intercom, 'Open the door, I've got a two-and-a-half-month-old baby in my arms and it's 30 degrees below zero out here!' To be fair to David, it did gain us entry and my daughter Iraina not only survived but has the sensational and dramatic claim to fame that David Bowie saved her life (among other lives.)

When David played Wembley Stadium in the middle of June '87, George and I went with our wives and George's daughter, Mia. I don't remember much about the Glass Spider show, other than I liked it less than the Serious Moonlight Tour. To me, it was all a bit 'pantomime' and took something away from the great songs. But David was, as always,

brave. After the gig, some of us went back to a friend of David's apartment in Kensington to wait for him; there were only about 15 people in the gathering. Mick Jagger was there with Jerry Hall, Marie Helvin and the cricketer/politician Imran Khan. Mick was in a rotten mood and seemed agitated, at one point exclaiming in his mockney accent 'I 'spose I'll av to do another tour if that old queen's out there'. George, who'd met Mick before on the small private island of Mustique with David, had the temerity to ask him if he could introduce his daughter, to which Mick replied, 'Not now mate' (she was 11). I said to Imran Khan something like, 'What a shame the weather stopped play' (referring to the England–Pakistan Test series), to which Mick said grumpily, 'It's boring talkin 'bout the wevver innit'. George and I left quite soon after David had arrived, and we'd said our hellos and thanks for the gig etc.

Within a short space of time, Gregory Lunn Challenge grew into a respected creative force and we and our newly formed production company, Paradise London, went with them as their main music composers, scoring mini films such as the Guess? jeans ads and numerous car commercials for future big-budget film directors, like Martin Campbell. Simon and I had accidently stumbled into a golden age of cutting-edge advertising in London, working on spots written by creative agencies and shot by hugely talented directors. This was much more interesting for us than sitting around trying to write songs, and more lucrative. We found the beautifully crafted mini films, which cost hundreds of thousands of pounds to make and were shot by brilliant directors, inspired us to come up with great music, and for a long while we were highly valued. I would go to Milan, Paris or Madrid just for a briefing, or we would be flown to New York or Los Angeles just to do a spot. There is something quite special about being in the control room of a huge studio like AIR or

Angel and seeing and hearing a full orchestra playing. The money was good, too, in addition to the production fees. One spot we did for the US market had us down (legitimately) for writers, players, lead singers and backing vocalists for a major coast-to-coast campaign, and I remember a trickle of cheques (residuals) arriving at my front door. First, there were a few envelopes with cheques for two or three thousand dollars. This then escalated to batches of envelopes, and then one day a wad of them scattered on the front doormat for $20,000! This went on for some time. I would negotiate lucrative buyouts from countries all over Europe, the USA and even Uzbekistan. This, it turned out to be, was a proper job; in fact, the only proper, long-term job Simon and I had ever had. During this time, I would see David on occasion in Los Angeles or London. Whenever he was in town, he'd give me a call and plans were made. Naturally I saw more of George, as he lived two miles away, but the kind of friendships that George, David and I shared didn't go cold for reasons of distance or time; we just picked up where we left off.

ONLY YOU
'Love Theme' (*Wild Orchid* film score), MacCormack/Goldenberg, 1990

From our work scoring commercials, we got additional film and TV work in America.

We scored a couple of films for Zalman King who co-wrote *9½ Weeks* (1986). Zalman had noticed our work on a Guess? jeans spot that he'd seen on a lighting designer's showreel, and he invited me to Rio de Janeiro for a music briefing, where he was casting for his new film, *Wild Orchid*, 1989. I went with my then-wife Sarah and our two-year-old daughter, Iraina. We were flown first class and stayed in a beautiful hotel in Leblon, close to Ipanema. I went to meet Zalman at the production site, where I was met by an assistant

from the production office; we then went in search of the great man. As we were walking down some stone steps, this slim boyish figure rushed towards us and stopped momentarily. He had a definite, but subtle, off-kilter movie-star look with a glint in his slightly wild eyes. The assistant said to him, 'This is…', but before she could finish her introduction, he quickly looked me up and down, said 'Perfect', then rushed off again. When I asked the assistant what that was all about, she said, 'Zalman thought you were an actor; he's just cast you in the film'. When we finally caught up with him, he apologised for the mistake, looked me up and down again and said, 'I like the suit, I like the shirt, you've got the job'. (Issey Miyake – well spotted, Zalman.)

The first place we were taken to, straight from the airport, was the rehearsal rooms of the Folkloric Ballet. We sat in this huge space with high ceilings and windows open to views of a sunset over the Atlantic, as live drumming echoed and bounced off the walls, accompanying the incredible lithe dancers.

A few months later, Zalman invited me back to Brazil. This time, I went with Simon and we flew to Salvador, capital of Bahia, where Zalman was shooting. The first place we were taken to, straight from the airport, was the rehearsal rooms of the Folkloric Ballet. We sat in this huge space with high ceilings and windows open to views of a sunset over the Atlantic, as live drumming echoed and bounced off the walls, accompanying the incredibly lithe dancers. Our altered state caused by our jet lag and tiredness served only to enhance the whole experience.

Salvador is a magical place, and we were lucky enough to be shown around by some locals who were working on the film. The city had much less of a European feel than Rio, and much more of an African element, which was translated into the music we heard from street drummers or at drum schools we visited. One night, we went to an outdoor drum gig where the drummers and audience were partly under a shelter of a corrugated-metal roof. As the drumming grew to a crescendo, a tropical rainstorm broke out hitting the metal roof with crazy counter rhythms while the crowd danced ecstatically with wild abandonment.

We went to an editing suite where Zalman wanted to show us some of the rushes (raw film) from scenes he'd shot. As we were in discussion, Zalman – who was standing by an open window – went quiet and beckoned me to join him at his viewpoint. Down below us on the rocks, about 150 yards away with the sea pounding behind them, a young couple were naked and making love. They both had incredible bodies, and the guy would pause, stand away a little, then continue. I looked at Zalman and he had that wonderful Zalman smile with the glint in his eye. That was very Salvador. Very Zalman King.

Working in America was great but it involved a lot of travel sometimes, which presented its own set of rules and challenges. Michael Kamen was writing and recording the soundtrack for the Bond movie *Licence to Kill* (1989) at Dave Stewart's studio in Los Angeles, and Simon and I were in town working. I mentioned to Michael's assistant, Steve, how uncomfortable it was at customs when coming into the USA so often on a visitor's visa. He said he was just dealing with the same situation himself and

that we should speak to the US lawyer who was helping resolve the problem for him. I reckoned Steve knew what he was talking about, so I duly spoke to said lawyer. Actually, he spoke to me, saying a lot of stuff very quickly; stuff, I'm ashamed to say, that I didn't quite understand. I did make a few feeble attempts to clarify what I thought he might be saying but his answers seemed unclear. He did say it would cost $3,500 each for Simon and myself – this he did say very clearly. I'm afraid I rather took my eye off the ball on this one and forgot about the whole thing. It was only at the point of standing in the American Embassy in London's Grosvenor Square with my wife and small children, swearing allegiance to the American Flag, that I began to realise the brevity of two of the many words my fast-talking US lawyer had not made quite clear: 'card' and 'green'.

What we should have had were simple work permits but we were now in a situation where we should be living in the USA. Technically, this would have been possible, as our American agent had guaranteed us basic earnings of $100,000 each per annum, but we had homes and lives in the UK. Then, as fate would have it, our American agents fell out with each other, putting an end to our sponsorship and US livelihood. We were still holders of the much-coveted green cards but, uniquely, we had no use for them. Sometime later, I spoke to Steve, who'd put us onto the fast-talking American lawyer; it seems that he had the same misconception and was similarly dealing with the same problem. I also spoke to an American friend in London about the situation, who said he'd ask his dad, who happened to be a lawyer. His Dad said he could fix things for us for the seemingly popular fee of $3,500 each. I phoned the American Embassy in London and they said they'd send me some forms to fill in and it would cost nothing. Thus, we were the only people I knew who had legitimate green cards and gave them back. It's possible I still have a sworn allegiance to the American flag, though. Which is nice.

Sometime in 1990, we were scoring a car commercial in London for a small agency called Yellowhammer, directed by Ridley Scott Associates. We were happy with the front end as it was perfect 'sound to picture', as a car was

hoisted off a ship. However, the back end just wasn't working. When the girl from the agency came to check on our progress, her silence spoke volumes. Often, as music was the last ingredient in a production, there would be a bit of a panic, as was the case on this job. This put Simon and I in a bit of a spin until Simon remembered we'd recorded some 'wild' vocals on a session with one of our favourite singers, Miriam Stockley, to use when needed. As soon as we started to place Stockley's vocals in different orders, swapping them around a bit, we had something promising. Without much time to experiment, we decided to score the piece with a squeezebox, deep drums and various ethnic voices. The result of our panic composition was one of the best pieces of music we'd ever written and when the girl from the agency came back, she just said something like, 'Wow'.

When the commercial was aired, lots of folk wrote to the car company and the agency to find out where they could purchase the track, so we made an extended version and I hawked it around a couple of majors, including Virgin, who were just down the road from us. Even though they loved the track and knew there was an existing audience for it, they wondered where the album was. I was about to give up on the whole idea due to the lack of an album; then I remembered George Michael.

I'd met George through Michael Lippman, who was managing him at the time. George's cousin, Andros, had a small record label, so I met up with him and explained the situation. But when I played him the track, he didn't seem that keen, so again, I forgot about it. While I was on holiday a few weeks later, I got an urgent call from my lawyer, Robert Allan (a Brighton boy), who said that George Michael was trying to contact me. Apparently, George and his cousin Andros were watching television when the Fiat commercial with our music came on, and George said, with a certain amount of enthusiasm, 'I could really do something with that'. To cut a long story short, Andros got in touch with me, and we gave them the track. George couldn't put his name to it because he was having contractual issues with his record company, so he's credited as Laker Boy. The track 'Only You' by Praise, the band/project name chosen by George, had a huge record launch at a glitzy venue in London's West End, which was also held to coincide with the launch of Andros's small record label. I went along to the event and, naturally, nobody knew who the fuck I was, let alone the fact that Simon and I had written the track. However, most importantly, there were only two writers' credits for the track – MacCormack/ Goldenberg. As I was leaving, I thanked George for doing a great job on the remix and he said, 'What you guys gave us to work with was brilliant'. George Michael, such class.

> Without much time to experiment, we decided to score the piece with a squeezebox, deep drums and various ethnic voices. The result of our panic composition was one of the best pieces of music we'd ever written and when the girl from the agency came back, she just said something like, 'Wow'.

When the track was released, it jumped straight into the charts at number 19. It was fun listening with my kids to the new chart positions on Sunday afternoons and hearing it rise to number four in the national charts and number three in the independent. I remember passing some

builders in the street who had a radio playing and hearing our track blaring out and finding it somewhat incongruous that the accidental hit we knocked up in our little studio should become so public. Naturally, record and publishing companies became extremely interested in the idea of doing a deal with us. I asked my friend Michael Lippman to negotiate both recording and publishing deals for us, thus, he procured an album deal with Warner Bros. and a publishing deal with Virgin. The track also won us an Ivor Novello Award.

At Warner Bros., our artists and repertoire person, Michael Rosenblatt, was a nice young gentleman who introduced us to a couple of potential record producers. We chose Richard James Burgess. Richard had not only produced Spandau Ballet's brilliant song, 'To Cut a Long Story Short' (1980), written by Gary Kemp, but had co-written one of my other favourite tracks, Landscape's 'Einstein a Go-Go' (1981). Not being a band with a set list of songs, we treated the project like an extended advertising brief, the brief being 'make an album'. Of the eleven tracks, six were written before the project, two were remixes of our accidental hit and three were new. All the tracks were connected by segues, like the sound of a train or raindrops, together with an ethereal palette of ambient sounds and effects that we would normally use to score commercials. While recording the album at Orinoco Studios in South London, we used musicians and singers from all over the world to fit in with our eclectic and ethnic mix: Egyptian, Indian, African, Chinese and Bulgarian.

DAVID AND IMAN'S WEDDING
Le Mystère des Voix Bulgares, Bulgarian State Female Choir, 1975

Halfway through recording the album, I got a call from David at the studio, who said, 'I'm getting married, and I'd like you to do a reading at my wedding ceremony in Florence'.

David had met Iman, model, businesswoman and philanthropist, in late 1990 and a year later they were planning their wedding. To my shame I said, 'No, really, can't you get Eric [Idle] to do it?' To which David replied, 'No, people will assume he's going to be funny. Anyway, he's doing a speech at the reception. Come on Geoff, you've got such a great voice'. I quickly pulled myself together saying, 'Of course I'll do it'.

The wedding was a glorious success. I'd never seen my pal happier – Iman was definitely 'the one'. She looked fantastic, and David scrubbed up well, too. The ceremony was joyous and my reading went as well as it could.

I'd sung on stages by myself, performing at Madison Square Garden and all over the USA with David, but to stand on a pulpit facing the great and good of the worlds of fashion, music and other arts, and to deliver a reading on, arguably, the most important day of David and Iman's life, filled me with terror. Thankfully, my bolder self realised that to be trusted with this task was not only a great honour but a huge compliment to my ability, or at least the ability David thought I had. It also occurred to me – hadn't this always been the way with my friend? He'd say, 'You can do this', and I'd just do it because he said I could.

My other duty on the big day was to be an usher at the church along with a few other people, including, of course, George. We were all staying at the luxurious hotel, Villa La Massa, in Florence,

Inside St. James Episcopal Church in Florence where David and Iman were married. The lectern on the right is where I gave my reading.

but to travel the 12 kilometres to the church, St. James Episcopal, was anything but luxurious! The ushers were crammed into a large van with a maniac driver who was trying to keep up with the groom's limo, which had a police escort with flashing lights. All the while, our driver was driving one-handed (right) and shouting excitedly in Italian into a large walkie-talkie in his other hand (left), while bouncing off kerbs. By the time we got to the church, our nerves were somewhat frayed. One of the other ushers said to me he was worried he'd get it all wrong even though we'd all had a rehearsal the day before. I tried to pacify him by saying, 'I wouldn't worry, I've got to do a reading'; he tried to pacify me by replying, 'Fuck that!'

I noticed from the guest list that David had the wit to seat Bono, Ono and Eno all together. Surprisingly, I never met Brian Eno when I was working with David. Instead, I met him at the Paddington Rec., our local park in Maida Vale where we'd both taken our kids to play. We casually chewed the fat a couple of times without feeling the necessity to introduce ourselves.

When I saw Brian walking up the path to the magnificent church, with the noise of a crowd of over a thousand fans, police sirens, camera flashes and a helicopter hovering above outside, and all the hustle and bustle of anticipation inside, I handed him an order of service card and offered to show him to his seat. He looked at me with a slight puzzled expression and said, 'Don't I know you from the Rec?'

The wedding was a glorious success. I'd never seen my pal happier – Iman was definitely 'the one'. She looked fantastic, and David scrubbed up well, too. The ceremony was joyous and my reading went as well as it could. I was initially surprised at how my voice boomed out into the church. This, I found encouraging and I managed to pace the piece well and deliver the goods. Naturally, Eric's (Idle) speech at the wedding reception was hilarious and beautifully delivered. He asked me afterwards if I thought it was too long. I said, in all honesty, it wasn't. I thought it was touching that someone so talented should be that concerned.

Later Years (1997–2016)

'Ain't Nothing But a House Party', The Showstoppers, 1969

Bowie turned 50 in January 1997, so I bought a couple of bottles of wine and George bought some packs of beer and we headed over to Dave's.

Actually, it didn't happen quite like that. What happened was that George and I boarded a flight with our wives to New York and stayed at the newly opened Soho Grand Hotel in Lower Manhattan. David was to supply not only the beer and wine but also the entertainment or, more to the point, tickets and backstage passes to the entertainment which took place before a packed house at Madison Square Garden, in the form of a charity concert for Save the Children.

Our seats were situated stage left, close to the action. There were lots of familiar faces around, including the lovely Robin Clark and her husband Carlos Alomar from the 'Young American' days. I'd never seen either of them in an audience before, only on-stage, so it seemed kind of strange. Then the lights go down and there he is, standing in the middle of the stage in a frock coat, without a 'bipperty bopperty hat' but with bright-red hair singing, 'Little Wonder' to a drum-and-base rhythm. Actually, he's singing 'Li ull wunder', just like his Anthony Newley period. Our Davy's a cockney geezer givin' it large; eez got red 'air, just like bleedin' Ziggy, only it can't be Ziggy 'cos ee frew im out the Limo on Amersmiff Broadway back in 1973.

The band sounds great; big sound filling the Garden. David is moving around like a tiger circling the stage, playing with the mike stand, playing with the band, playing with time and us. Go on Dave, I know we've heard it before but sing it again! It's his 50th birthday party, it's his song, his stage, and he's smiling, loving it. He looks so happy, we're all happy and smiling – go on my son, we're all here, we're all with you. As we always used to say, 'leave 'em laughing!'.

At the end of the show, which included guest appearances from Placebo, Robert Smith, Lou Reed, Frank Black, and Billy Corgan, David finished the night with his original first hit, 'Space Oddity'; the song that should have been his breakthrough but left him hanging high and dry for a couple years, which, for him, must have seemed like an eternity. This he sung solo without the band accompanying him, just him and his twelve-string guitar with maybe Mike Garson on Mellotron. As the song was ending, he walked towards the audience on the part of the stage that extended into the crowd and played the ending chords of the song among them, just like he would have done all those years ago at the Three Tuns in Beckenham. It seemed to me a powerful full circle to an incredible body of work.

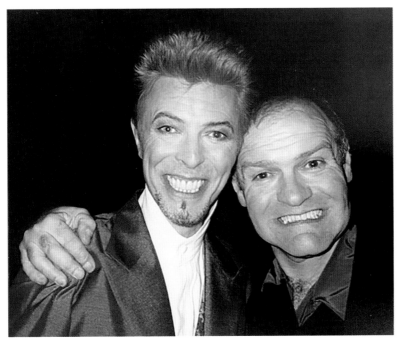
David with John Cambridge.

After the birthday gig, we (me, George, and our wives) were whisked off down Seventh Avenue towards Greenwich Village for a surprise birthday party for 'His Bowieness'. This wasn't the only birthday surprise for David; Iman had secretly organised the making of a one-off book of testaments from his family and close friends, saying what David had meant to us over the years. This she had done by sending out the pages to us, well in advance, to write our messages on and Fed Ex back in time to be put together by the printers for his birthday.

The party was held at artist Julian Schnabel's vast three-storey warehouse studio on West 11th Street. On arrival, we took a huge ancient, cage-style elevator up to where the party was taking place. As we approached the floor, there was a rather imposing well-built man with a beard standing there waiting to open the lift gate for us – he looked as if he would have been well cast in a Robin Hood film. As he opened the lift, he greeted us warmly; he was in fact our host, Mr Julian Schnabel, and either through conversation or by reputation,

he understood George to be an artist, too, so took us on a mini tour of some of his paintings near his studio. We were shown to a huge space the size of a ballroom that had tables covered with white tablecloths and white candles set for dinner, with the whole place buzzing with stars of music, fashion and film. Later in the night, David found his way to our table. As he walked through the maze of tables in the hall, people were vying for his attention, so by the time he got to us he resembled The Pied Piper, with all these famous faces barging each other out of the way to get to him. I remember him having a long conversation at our table with the drummer John Cambridge, who worked with him many years ago in a band David had formed called The Hype (which only lasted briefly) and had introduced Mick Ronson to him. Meanwhile, all these desperate people were queuing up behind him but David just ignored them and gave John his full attention. He knew that he'd not seen John for a very long while and that it was possible their paths may never cross again. This kind of discernment, I always found, was to David's credit.

FAREWELL TO PARADISE
'Duke of Earl', Gene Chandler, 1961

Our music production company had stumbled on through the end of the Nineties, as we tried to figure out how many different ways we could score the newly polished, executive luxury saloon car, cruising – uninterrupted by anything as vulgar as other traffic – around a Tuscan hillside, driven by somebody unbearably smug. By the end of the decade, Simon wanted to retire to the country. He'd made enough money and didn't have the mammoth, but pleasurable, expense of children. Also, he'd had enough of the constant noise late at night, every weekend, from the basement flat opposite his house. The disturbance came from Duke's residence, although I'm not even sure he lived there. Duke was an ancient Jamaican gentleman with a wicked smile and an encyclopaedic knowledge of 1960s' R&B, jazz and ska music. Sometimes I'd meet him in the street and we'd discuss the old tunes, and I'd say, 'Do you remember this one, or that one?' and he'd say, 'Yes, I has dis one or yes me has dat one'.

Often he'd say, 'Me has a liccle pahrtie tonight'. Turned out old Duke's parties were legendary in the hood, where he'd be playing the old tunes all night and selling cans of Red Stripe beer and a little bit of food (and other stuff) on the side. It really should have occurred to me sooner that this was the famous Duke Vin 'The Tickler' – Count Suckle's fellow stowaway on the boat that sailed over from Jamaica all those years ago in the Fifties. The same Duke that started the Sound System which brought the big tunes to our eager Mod ears, having a 'liccle pahrtie' in a basement, just like the basement blues parties we'd go to when we were teenage Mods in and around London's Somerleyton Road in Brixton.

> I gave David my condolences and I mentioned the fact that his mum wasn't that fussed about me. He mailed back saying, 'Problem is Geoff, she wasn't that fussed about me either'.

The industry had reached saturation point in terms of music production companies, and music publishers were encouraging their writers to get involved in scoring music for adverts, which they rightly assessed would produce a good royalty source and possibly a hit record. It also brought out a lot of bullshitters, packaging themselves as sound-design experts – to whom I always wanted to say, 'No mate, we're not fucking sound designers, we're failed musicians'. On top of that, everyone's friend had a small home studio in their bedroom at their mum's house and they were churning out demos for nothing and undercutting each other and everyone else. This devaluation of an industry would later befall my wife Jo's job as a textile designer.

In the year 2000, the new millennium, we were having a farewell drink in The Truscott Arms on Shirland Road, Maida Vale, the evening before Simon headed off to live in the country. Just then, David phoned me saying, 'Where are you?' He'd just finished recording at the BBC Studios around the corner. 'I'm in the pub,' I said, 'Where are you?' 'I'm at your house, looking at George's triptych,' he replied. (I'd commissioned George to paint a triptych for a curved wall.)

I went home and took him, Duncan, Coco and my family for a curry. Food was the usual factor for David coming to our house, as he was rather partial to a Sunday roast dinner, which was always a relaxed affair. On one such occasion, David asked my eldest daughter, who was around 13 at the time, what music she was listening to, to which she replied, something like Aaliyah or K-Ci & JoJo. David asked her if she ever listened to his stuff. She looked at him with slight dismay and

George Underwood's triptych that I commissioned.

simply replied 'No'. I was somewhat embarrassed but, thankfully, it really tickled David.

I was definitely embarrassed at a dinner party in 2002 at David's New York apartment when he brought up the incident I had almost forgotten about, and which I assumed he had completely forgotten about. The incident being the two melted 78s that I'd left in the sun back in 1955: 'Hound Dog' by Elvis Presley and 'I'm not a Juvenile Delinquent' by Frankie Lymon & the Teenagers.

This was a moment of maximum cringe value for me but great entertainment for the assorted diners, which included Iman, Lou Reed, Laurie Anderson, Fran Lebowitz, Moby and the artist Damian Loeb.

I was reminded of this occasion when I read Moby's excellent memoir, *Then it Fell Apart*. He wrote about that night and about how, after dinner, David put on a documentary about Lord Glenconner, the British aristocrat who bought the Caribbean island of Mustique. While the documentary was hilarious in its depiction of a certain breed of eccentric and antiquated English upper-class gentleman – for David and me, at least – for Lou Reed, it was a lullaby at bedtime, as he snored, head back, sound asleep.

The next time David came back to the UK was for his mother's funeral. She died on 2 April 2001, and I asked him if he'd like me to attend. He said no, but he'd like me to send flowers, which I did. I never thought David's mum approved of me. Every time I'd meet her, she'd say the same thing: 'You working?' and, just to wind her up, I'd always say, 'No'. Unfortunately, she liked my mother and would turn up un-announced at her house, mostly to have a moan about this and that. I gave David my condolences and I mentioned the fact that his mum wasn't that fussed about me. He mailed back saying, 'Problem is Geoff, she wasn't that fussed about me either'.

GM E-MAIL TO DB, MARCH 2011.

GEOFF TO DAVID:

Hi Pal

The bad news is – unfortunately – the road works at the bottom of Ladbroke Grove are hampering business at one of your good lady's prime London Operations!

The good news is – thankfully – it hasn't hampered Iggy's pitch – Gx.

DAVID TO GEOFF:

She was thinking of letting the lease run out anyway. She sees herself as more of a Maida Vale type really, so she'll get somewhere on Shirland Road probably, maybe on that parade of shops near Shirland mews.

Ig's doing well though. I saw him postering the other night up west dx

My 'new build' house in Elgin Avenue.

Returning David's 78s, 'Hound Dog' & 'I'm Not a Juvenile Delinquent', 50 years late!

ELVIS AND FRANKIE RETURN
'Walking The Dog', Rufus Thomas, 1963

I met my wife, Jo, in the park. Paddington Rec., of course. Actually, Jo wasn't my wife then; I was newly separated from my first wife who was living with my two daughters in the house in Elgin Avenue. This was a 'new build' house that took me about five or six stressful years of planning and rejection as it was in a conservation area. I'd been keeping my eye on a plot of land that had an old garage on it, as it was next door to our apartment and I could see it from my kitchen window. The house was designed by husband-and-wife team, Boyarsky Murphy, and was about 1,500 square feet with off-road parking and a terrace. The progress was covered by a TV programme called *Dream Homes*, so I was able to get huge discounts on various items and materials. It got quite a bit of press, including the cover of the 'Home' section of *The Sunday Times*. Anyhow, I'd moved to a small flat not far away. Neither my ex-wife or my daughters were keen on dog walking (picking up shit), so I'd walk round to the house and take our dog Elvis (a Westie) out for a walk. That's how I met the lovely Jo. Thanks girls.

As luck would have it, when I met Jo's parents, they had in their possession a box of old 78 rpm records from the Fifties. To my astonishment, in this collection were – un-melted and intact – Elvis Presley's 'Hound Dog' and Frankie Lymon and the Teenagers' 'I'm Not a Juvenile Delinquent'. As these items were not deemed to be of value to Jo's parents, I eagerly took them, commissioned a beautiful, velvet-lined wooden box, made to fit the two discs, and sent them (50 years late) to David in New York. He was equally surprised, and amused, and phoned me immediately to convey such.

I also sent him a box of 12 of my prints, images that I had taken of him over the three years from '73 to '76, that I was considering selling as 'limited edition' prints. He wrote, 'Just got the pack. Beautiful work, Geoff, just wonderful stuff. Thank you so much! They are the best'. Now, having sold my images around the world and exhibited in New York, Russia (St Petersburg) and the UK, I'm still warmed by people's positive reaction to what, in effect, are what I call, 'my holiday snaps'.

The girl in the park.

DAVID AND NEW YORK
'My Girl', Otis Redding, 1965

It was always great to see David when he wasn't working and had time to just hang out. If he was in London, we would sometimes see a movie or he'd have tickets to the theatre. Or he'd just pop around for Sunday lunch. We'd soon fall into the old routines of silliness, in the same way, happily, that I still do with dear George. But spending time with David was usually all too fleeting as he lived 3,500 miles away in New York and was almost always busy on another project, which is why I'd make the effort to fly over there or pass through, when possible.

The best time of all was when my girl, Jo, had booked a four-day package trip to New York in 2010, as a surprise present to me. It had already

beyond cheered me up, just meeting her, but as a bonus it was planned that we'd travel out for my birthday, on 27 February. I reasoned with Jo that, not only would it be very cold in NYC at that time of year, but – worse – snowbound, so we changed the trip to April. As it turned out, our flight was among the last leaving London before the ash from the Icelandic volcano, Eyjafjallajökull, covered most of European airspace, causing the highest level of air travel disruption since the Second World War. As Jo, very sensibly, had booked a package tour for flights and hotel, and with all flights back to Europe postponed, our four-day break became ten days. Because all the hotels in New York remained full of people who couldn't fly back to Europe, the travel company couldn't even downgrade us to a less-expensive place, so we got an extended stay, free-of-charge, at our

Me and David at MoMA in 2010.

hotel, The Soho Grand. Also, as luck would have it, it happened to be a period when David wasn't madly busy, thus, we got to hang out with him for the best part of a couple of weeks.

David rolled up at the Grand in his, by now, New York signature 'I'm just an ordinary bloke' clothes (flat cap and black zip-up jacket) and bounded up the stairs as if we'd only met the day before. He had a large SUV-type people carrier waiting outside to take us to the Museum of Modern Art to see the performance artist, Marina Abramović. On the way to the museum, we stopped to pick up Coco, and as I went to go fetch her, I left Jo and David to chew the fat, so my friend could meet my girl. David had asked Jo what she did for a living and she explained that she was a textile designer but wasn't really sure, at that point, what she really wanted to do. To her surprise,

David replied that he also wasn't quite sure what it was that he wanted to do.

The Abramović show was a sell out. David was about to dutifully queue when a senior member of staff recognised who was in line and came over to greet him, accompanying us upstairs to the show. David was a brilliant host and took us to lunch at the museum that day; on subsequent days he took us to the theatre, the cinema, out for dinner and afternoon teas and, hilariously, ten-pin bowling, at which (perhaps mercifully) both David's and my scorecard coincidentally ended in a draw.

FUNKY LITTLE BOAT RACE! Oxford & Cambridge, 2010
DB to GM. Cambridge win! Yay!!
GM. Light blue – with your skin tone dear? – I don't think so dear
DB. But it goes with my Eye

COLUMBIA

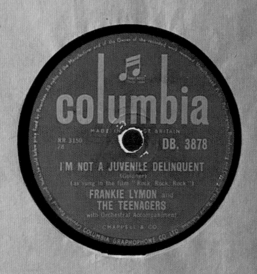

The Finest Name on Record

STANDARD 78 R.P.M. RECORD

I'M NOT A JUVENILE DELINQUENT

In November 2015, I mailed David in response to hearing his track 'Sue (Or in a Season of Crime)', saying something like, 'Good work, Oscar [a nickname). It reminds me of the psalms we sang in St. Mary's choir together when we were kids'. He responded with, 'It's not "I'm not a Juvenile Delinquent", but it is something'.

I missed the signs. Didn't get the clues or read between the lines. The 'Hurry up' from dear Eileen at David's office, for example, about some of my prints I'd asked David to sign. She'd said, 'Do you have a date when you need them by Geoff?' I'd replied, 'Oh, doesn't matter, any time will do'. 'Can you give me a date though Geoff?'

When the prints arrived, he'd written something on the last one which showed him fast asleep on the Trans-Siberian Express. I'd sent David the links to two tracks I really loved: 'Black Eunuch' and 'But She Was Not Flying' by Algiers, a band from Atlanta, Georgia. He messaged me back saying, 'Geoff, your music choices are so on the money, every time. I am so glad you've been my friend all these years. I miss you lots – now fuck off!!'

I wrote back, 'Yes, likewise pal. Off and Fucked'.

He replied, 'Mission accomplished,' which only later I would understand to be the most pertinent part of our exchange.

In December, David sent me an image of Freddie Burretti, Melanie McDonald and me in the back of a limo, saying, 'Lovely picture, took me back'. It occurred to me later that I was the only survivor of the three of us in the photograph. I sent him back another shot that I'd taken of Freddie outside Los Angeles Airport in '73 or '74, to which he replied, 'Oh, that's the best'. The date of the email was the 10 December, exactly one month before he died. I like to think he'd been reminiscing, perhaps looking back fondly at the cast.

Me, Freddie and Melanie, sent to me by David in December 2015.

The shot of Freddie Burretti that I sent to David in response.

235

There's a tiny fraction of time when one forgets that the person you're thinking of is no longer here. I call it the 'must ask mum' time; that briefest of brief moments when the dead become alive. It often happens to me with my late mother, sister and now David, as in 'I must tell him this', or 'I must send this to him'. The reality follows all too soon but if I could extend that moment, that mind trick, I'd just like to say:

Thanks for being a good friend for 60 years; for sharing some of your journey with me; for being funny and eternally inquisitive; for the birthday hampers; for lending me your wheels; for knowing that the guitar twang in Junior Walker's '(I'm a) Road Runner' is God-sent; for standing on a stage with just Garson's immaculate piano, singing, 'It's a god-awful small affair, to the girl with the mousy hair', and at that point me just being full of wonder and admiration.

And thanks for saying goodbye.

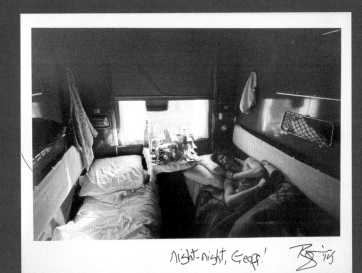

night-night, Geoff!

Afterword

Oh Geoff,

What a terrifically clever idea this is, I am all kinds of shades of green as I didn't think of it first. Take the two of us and pretend that we went to America, Japan and, wait for it, f•••••• Russia of all places, me as a rock star and you as cheerful backing singer and sidekick and then write a book about it. Brilliant!

Will you actually be able to get this stuff published do you think?

I'll come in with you if you like. I've pretty much got this whole Photoshop thing down now so I could fake up some credible photos. I can virtually take over the back office and get down to it pronto as we get quite a lot of time off at the garage at the moment as the boss is knocking down the old machine shed to put up a pole barn with gambrel truss. Not a bad idea I suppose but personally I don't rate the anti-siphon sidelap design as necessarily the best option for weather tightness. But you know Carl, all mouth and no trousers and anyway it's his wallet so why should I worry? I just work her. (I did a hood job on the nice little '79 Fiat Spider the other week. Just a bit of rust on the hood hinges and a bad steering bushing, binding it when turning right but it came up lovely. Took her for a little ride before the customer came for it. Very nice.)

I hope you don't mind but I did make a short list of possible additions to what you've done. You know me, I can't string two words together (the bit about me writing songs had me on the floor!) but I did have a couple of ideas.

You should establish the idea that we always liked music. Singing Frankie Lymon and The Teenagers' 'I'm Not a Juvenile Delinquent' on the corner of Cambridge Road when we were about nine or ten sounds genuine, doesn't it? You actually had a good voice, you know, so it's not stretching it too far.

How about you change the designer Kansai's son into a daughter called Emma? And that she, only four herself, took my son up and down the children's store KiddiWorld with no adult supervision whatsoever, as Tokyo is that child friendly? Or is that far-fetched?

You mention the ballet dancer Nureyev at one point. Let's say that I nicked a couple of his moves (simple ones but very effective) for the *Diamond Dogs* stage show from when I went to see him with – wait for it – Cliff Richard. No, make that Mick Jagger, then we could have us and Jagger laughing about who'd do the moves first. Like we were competitive or something. Do you like that? I wouldn't want to harp on the ballet thing too much though. You know what the blokes here will think.

I just can't buy you driving a Winnebago. You're a skinny little Englishman. No way.

Lastly, I think it would be more poignant if the faces of the fans at Berlin station, when seeing us arriving on the train from Russia, shabby and dirty so-called glam rockers, dropped in disappointment, only to break into smiles of understanding when the record label person pointed out where exactly it was we had arrived from, many of these kids having family of their own stuck in the East.

The long and short of it, Geoff, is that this is a great little book, full of warmth and good humour. It's so evocative of that time that I almost wish it had really taken place. Dream on, eh? If dentistry ever gets too mundane for you I'm betting you've got another career in writing. By the way, if the missus can do without you this weekend, I'm going to 'borrow' a rather flash Yankee car from the works. An early 70s Lincoln Continental, very nice. A couple of jars on the patio in The Angel, Henley-on-Thames? Nice.

All the best, David Jones 2007

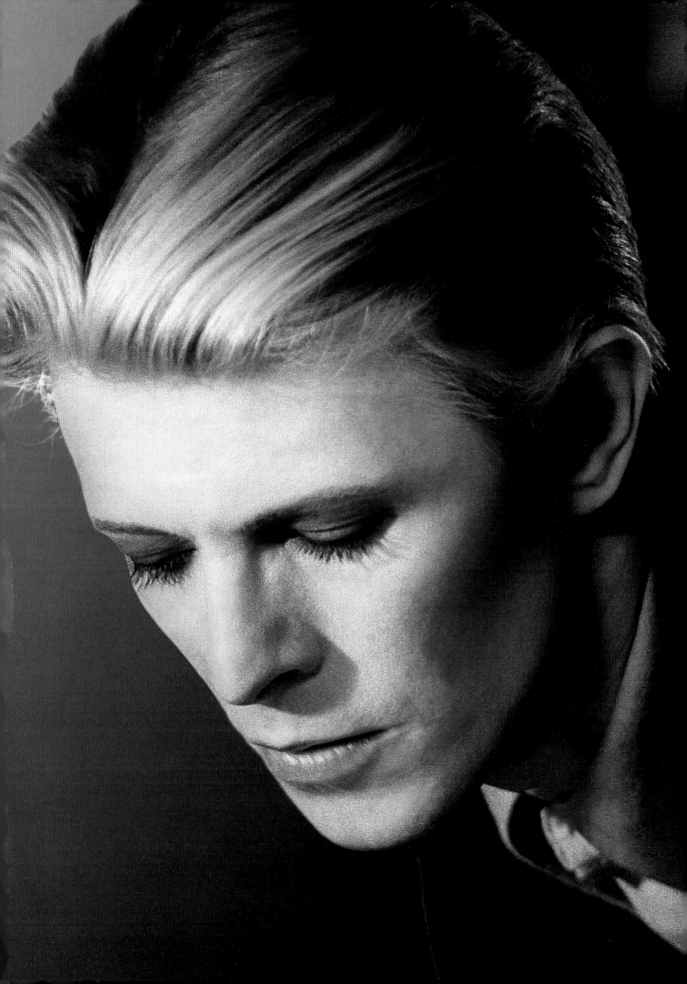

Image Credits

All images copyright Geoff MacCormack except for the following:

Masoyoshi Sukita – pp.4–5, 58, 60, 61
ARCHIVIO GBB / Alamy Stock Photo – p14
Alan White – p19
The Francis Frith Collection – p20
Photo by Don Paulsen/Michael Ochs Archives via Getty Images – p23
Barratt Archive – p26
Photo by David Redfern/Redferns via Getty Images – p28–29
Jo Clark – pp.34, 200, 233
Photo by Reg Lancaster/Express/Hulton Archive via Getty Images – p37
Trinity Mirror / Mirrorpix / Alamy Stock Photo – p39
Mainman, CC BY-SA 4.0, via Wikimedia Commons – p42
Mick Rock – pp.45, 104, 108
Bob Gruen – p47
P&O Heritage Collection – p54–55
Leee Black Childers – pp.70, 84, 85, 88
Barry Wentzell – p97
Terry O'Neill/Iconic Images – p110–111

Dagmar – pp.123, 124
Iconic Images – p124, 134, 135
Photo by ABC Photo Archives/Disney General Entertainment Content via Getty Images – p131
Lenscap / Alamy Stock Photo – p136
Chris Duffy – p151
Isle of Man Post Office – p182
John Walters / Daily Mail / Shutterstock – p212–213
Sarah Mancini – pp.218, 227
George Underwood – pp.222, 229
The Reverend Richard Easterling – p225
Hèlene Binet – p231

Every effort has been made to identify copyright holders and obtain their permission for the use of copyright material. Notification of any additions or corrections that should be incorporated in future reprints or editions of this book would be greatly appreciated.

© 2023 Geoff MacCormack
World copyright reserved

ISBN: 978-1-78884-217-4

The right of Geoff MacCormack to be identified as author of this work has been asserted by him in accordance with the Copyright, Designs and Patents Act 1988

All rights reserved. No part of this publication may be reproduced, stored in a retrieval system, or transmitted in any form or by any means electronic, mechanical, photocopying, recording or otherwise, without the prior permission of the publisher

British Library Cataloguing-in-Publication Data
A catalogue record for this book is available from the British Library

The author and publisher gratefully acknowledge the permission granted to reproduce the copyright material in this book. Every effort has been made to trace copyright holders and to obtain their permission for the use of copyright material. The publisher apologises for any errors or omissions in the text and would be grateful if notified of any corrections that should be incorporated in future reprints or editions of this book.

Senior Editor: Alice Bowden
Designer: Craig Holden

Printed in Slovenia
for ACC Art Books Ltd., Woodbridge, Suffolk, UK

www.accartbooks.com

ACC
ART
BOOKS